Advance Praise for *Sacred and Stolen*

"Not since Thomas Hoving made the mummies dance has there been such a lively and engaging look at the inner workings of a major museum. Based on Gary Vikan's decades-long tenure at the helm of the Walters Art Museum, this book brings his exceptional flair for scholarship and pop culture—which has seen Graceland described as a contemporary Byzantium—to showing how to make a great collection come alive. Having played a minor role in some of Vikan's adventures, I know at first hand that the work of a museum director is often more *Raiders of the Lost Ark* than *Father Knows Best*. Vikan's autobiographical account is a welcome addition to the often bone-dry literature about modern museums."

James Bradburne, Director, Pinacoteca di Brera, Milan

"The world of museums, art collectors, and trade in cultural heritage ranges from murky to opaque, though it is always intriguing. Gary Vikan's wonderful, insightful memoir lifts the curtain and provides an invaluable, honest, and engaging glimpse behind the scenes of the museum world. A must-read for anyone interested in museums, curating, and collecting."

Dr. Noah Charney, best-selling author of *The Art of Forgery*

"One-upping fictional art whodunits, Gary Vikan shares a variety of nerve-racking real life experiences to provide new insights into the world of art museum directors. Lurking behind all that Technicolor

museum glamour are many shades of gray, a fascinating cast of characters, and lots of intrigue."

> **Tom Freudenheim,** former Director of the Baltimore Museum of Art and the Worcester Art Museum; former Assistant Secretary for Museums, Smithsonian Institution

"In his fascinating memoir, *Sacred and Stolen*, Gary Vikan invites us into the mind of a leading American museum director as he wrestles with the issue of our day: whether or not to buy art that, by all indications, was looted. Vikan navigates the issue with humor, aplomb, and a common sense that is both reassuring and, at times, treacherous. You may not always agree with his decisions, but you'll find him an able guide to one of the most confounding and controversial issues facing the art world today. Rarely have we had such a candid window into the thinking that guides America's biggest cultural institutions."

> **Jason Felch,** co-author of *Chasing Aphrodite: The Hunt for Looted Antiquities in the World's Richest Museum*

"As a writer Gary Vikan has three virtues hardly ever found together. He genuinely loves art and is extraordinarily erudite on the subject; he cares about what's right and wrong; and he is wonderfully alive to the human capacity for absurd behavior. Gary's scholarship and professional ethics, combined with his impish sense of humor, make for delightful reading."

> **Dan Hofstadter,** author of *Goldberg's Angel: An Adventure in the Antiquities Trade*

SACRED
AND
STOLEN

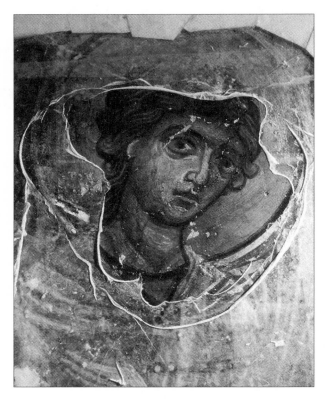

Angel, fresco, dome fragment looted from the
Church of Saint Euphemianos, Lysi, northern Cyprus;
Byzantine, 13th century.
Now in the Byzantine Museum, Nicosia, Cyprus.
(Photo courtesy the Menil Foundation, Houston)

The photograph shows the partial removal of the
clear paper facing attached by the looters.

SACRED
AND
STOLEN

Confessions of a Museum Director

Gary Vikan

Former Director, the Walters Art Museum

SelectBooks, Inc.
New York

This edition published by SelectBooks, Inc.
For information address SelectBooks, Inc., New York, New York.

First Edition

ISBN 978-1-59079-393-0

Library of Congress Cataloging-in-Publication Data

Names: Vikan, Gary, author.
Title: Sacred and stolen : confessions of a museum director / Gary Vikan.
Other titles: Confessions of a museum director
Description: First edition. | New York : SelectBooks, Inc., [2016]
Identifiers: LCCN 2016006973 | ISBN 9781590793930 (hardbound book : alk.
 paper)
Subjects: LCSH: Vikan, Gary. | Art museum directors--United
 States--Biography. | Walters Art Museum (Baltimore, Md.)--History.
Classification: LCC N516.B42 V56 2016 | DDC 709.2 [B] --dc23 LC record
available at https://lccn.loc.gov/20160069733

Shown on the cover:
Gary Vikan in the 18th-Century Gallery, the Walters Art Museum, Baltimore, Maryland, 2012. *(Photography by Sam Holden)*

Picture frame photo: LiliGraphie/Shutterstock.com

Jacket and book design by Janice Benight

Manufactured in the United States of America
10 9 8 7 6 5 4 3 2 1

Contents

Foreword

I t is impossible to read Gary Vikan's *Sacred and Stolen* without gaining the sense that few professions can be as complex, rewarding, and frustrating as that of a museum director. John Coolidge, Director of Harvard's Fogg Museum for twenty years, once remarked that the search committee that selected him was, in his words, looking for "Jesus Christ with a PhD." But as Gary's story unfolds, it's clear that a museum director must be more and do more than that. Success rests on versatility and the ability to do and be many things.

Sacred and Stolen is a romp, serious and hilarious at the same time, through events that capture the many things the author was required to be, as Senior Associate at Dumbarton Oaks, and as chief curator, then Director at the Walters Art Museum. We see Gary as connoisseur, art critic, and educator; Gary as instructor, who tells his readers a little more than less, no doubt in the hope they will come away more knowledgeable about art and human history. He is the sleuth, who uncovers the background of a stolen Renoir, a mysteriously returned silver bowl, and a remorseful museum superintendant infatuated with objects that connected him with the past. He is the straitlaced "Minnesota kid," intolerant of hypocrisy, double standards, pretensions, and false piety, ever aware of people with too fancy dress, or tones too glib. He is the moralist, concerned,

throughout, about doing the right thing (and resigning a presidential commission, on principle, in protest against the Iraq War).

Gary Vikan is a storyteller, and *Sacred and Stolen* is a passage through stories that illustrate the sometimes bizarre situations that museum curators and directors encounter.

His storytelling is at its best in his narrative about a set of Byzantine mosaics that were looted from the Church of *Panagia* Kanakaria in Turkish-occupied Cyprus, which turned up in the hands of an Indianapolis art dealer. Gary calls himself a "Kanakaria junkie," and his story, which epitomizes the title of his book, exposes everything that is both bad and good about the dark world of destruction and looting and the efforts made to have the mosaics returned to the government of Cyprus. Like all good stories, it has a hook to it, about men who knew too much to testify at trial, knowing that doing so might fatally compromise the case for return.

And finally, there is Gary the confessor, who lays bare the close calls and outright mistakes he says he made in the course of his career. He blames himself for "heavy-handed scholarship" in describing an early exhibition he held at Princeton. He declares his tactlessness and the scolding he got when he exposed a group of sculptures as fakes (although years later he would be shown as being right). He confesses near calls and scrapes, one so grave that a foreign ambassador called to say he held Gary Vikan personally responsible for creating an international incident. He acknowledges making a costly error in promoting an exhibition of the art of Georgia that collapsed (even the country's president, Eduard Shevardnadze, could not save it). And he almost confesses to accepting objects whose provenances were so ambiguous as to raise red flags about their legitimacy.

Any museum director, indeed any collector, would be familiar with this story. The passion to acquire, which can border on mania, can at times be in direct conflict with one's better judgment—the background voice that says, "No, no, look out. The dealer is giving

you a false story. The thing's directly out of the ground/church/ rightful and legal possession of another country!" Pulled in different directions, a museum has no choice: its investigation of an object's background must be diligent and complete. Secretly, one may hope to find enough ambiguity to suggest that the object one wants so badly may not be looted, or that its background is so clouded that it can be bought. And exactly such a thing happened with the acquisition by Gary for Dumbarton Oaks of a remarkable icon of Saint Peter, which examination after the fact showed to have had its surface painted over, almost certainly to disguise its passage from the Balkans. Was it stolen, then? Probably. But one could never know, and one could never know the icon's true origin. One can imagine Gary's sigh of relief. Not because he, and Dumbarton Oaks, had gotten away with something, but because an important work of art had been added to a great collection in an institution that would exhibit it, study it, and preserve it for the greater public good.

In the end, serving the public is what museums and museum directors are supposed to do, and Gary makes clear that in his view, the collection and preservation of art by museums across the world is in the public good. He would certainly argue that a country's cultural patrimony should not be looted. But he would argue also that art without a specific known origin should be given safe harbor and not driven underground, into the black market, dispersed among private collections, or, worse, forced to remain in countries where it will be destroyed. To Gary Vikan, the preservation and safekeeping of man's cultural heritage is, in every way imaginable, the ultimate test of doing the right thing.

—ARTHUR HOUGHTON

Former curator of ancient art at the Getty, former appointee to the President's Cultural Property Advisory Committee

Introduction

Our head of finance came into my office at the Walters Art Museum very early on Wednesday, June 10, 1998, with the cash—lots of cash—in strapped packets of $100 bills. A small group had gathered with me that morning, including our brilliant, hyper-kinetic Curator of Ancient Art, Ellen Reeder, and one of the contract staff she had found to help with the current exhibition, *Gold of the Nomads*. The contract person spoke Russian and Ukrainian, which was essential for the meeting that was to begin at 9:00 a.m. with Ivan Yavtuschenko, Deputy Director of the National Museum of the History of Ukraine in Kiev. Ivan was built like a small bear, always wore deeply tinted glasses, and smiled perpetually, even when he was cheating me and when I was insulting him. Also essential for that meeting was the $20,000 our CFO walked in with. I could tell that our moneyman was very upset; the previous afternoon our banker had grilled him about requesting that much cash, dropping broad hints about money laundering. Money laundering! I had enough to worry about already.

There on my conference table next to the coffee and pastries was the pile of strapped $100 bills—unmarked old bills, as Ivan instructed. After some disingenuous greetings, as I marveled at the long, pea-green fingernails of the young redhead Ivan brought along, we went directly into the money transfer. (By then, Ivan's son and translator, Orest, had eaten most of the pastries and had put

all of the sugar packets and creamers into his briefcase.) I had an ingenious way to prove I had given Ivan the cash. It was a foolproof receipt, even for someone as devious as Ivan. I had bought a Kodak disposable camera, and I asked my secretary to take photographs of Ivan and me and the fanned-out money as we both held up the front page of that day's edition of *The Baltimore Sun*. We captured the players, the day, and the cash on film. And we're smiling like crazy. This, I thought, was straight out of James Bond.

As we're having a jolly time fanning the cash and taking pictures, the redhead with the long fingernails asked me for some water. I went out to get a Styrofoam cup and filled it with tap water and came back into my office. And there she was, behind my desk, sitting in my chair. No one ever sat in my chair except for me, so I reluctantly put the cup down just to her right. But instead of taking a drink, she dipped her fingers into the water and expertly began to count the bills in one of the four strapped bundles as if she worked at a casino, which maybe she did, I thought.

Six weeks earlier, on May 1st, I had a tense meeting with Françoise Cachin, Director of French Museums, at her office just off the *La Place des Pyramides* in Paris. My goal was to get *Gold of the Nomads* into the exhibition hall of the Grand Palais in a partnership deal, and this entailed money and promises. My promise was to deliver a stunning selection of ancient gold from Ukraine, and the price to her government would be $200,000. This was fine, and after some haggling, I convinced her to commit as well to the $100,000 "loan fee" that our Ukrainian partner museums insisted would go to upgrade their galleries, although none of us believed this. I did not mention the $20,000 in cash for Ivan since I had decided to bury it elsewhere in the budget.

Because it was a bribe—or, as I prefer to call it, a cash incentive, given to Ivan for pressing our case and obtaining for our show the astonishingly beautiful Golden *Grivna* ("breastplate") with its

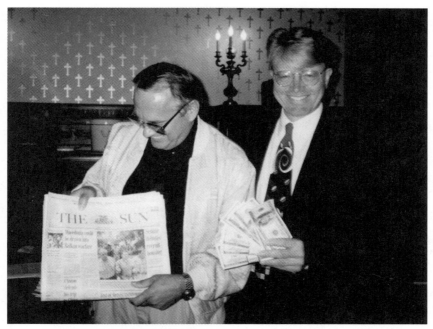

Gary Vikan presenting $20,000 in strapped $100 bills to Ivan Yavtuschenko,
Deputy Director of the National Museum of the History of Ukraine in Kiev.
The director's office, the Walters Art Museum, June 10, 1998.

scenes of animal combat and Scythian daily life. This precious and
ponderous ornament is to ancient jewelry what the Parthenon is to
architecture; there is nothing else like it in the world. How did we
hit on $20,000? That was the cost in those days of a Toyota van Ivan
wanted, and I was pretty sure it was so his son Orest could set up a
taxi business in Kiev. This, I suppose, made me a start-up investor.

I flew later that day to London to meet up with a group of my
trustees who had come to celebrate the opening of a Walters exhi-
bition at the National Gallery called *Masters of Light*. We stayed at
Claridges with the director and trustees of our partner museum in
San Francisco, the Legion of Honor. On the evening before the
public opening, we were toasted at a lavish dinner in the Sainsbury

Wing by Director Neil McGregor. Many pictures were taken and we were happy and proud. The following afternoon I was off to Tbilisi, Georgia, to negotiate an exhibition of national treasures, called *The Land of Myth and Fire,* with representatives of President Eduard Shevardnadze. It was a dazzling and glamorous time for me as a museum director, and I loved it.

But it was also a messy time. The bribe to Ivan did no good; we waited but never got the Golden *Grivna.* And fifteen months after that trip to Tbilisi, the Georgian show went down in flames, very publicly, all over the newspapers. The head of the Georgian Orthodox Church, Patriarch Ilia II, was fiercely opposed to us. He claimed that we would make copies of their sacred works of art, send back the copies, and keep the originals.

Most Georgians believed him, and I was told a curse had been placed on my family and me by some dangerous people "up north," in the Caucasus—the land of revenge and black magic. Finally, President Eduard Shevardnadze caved in and canceled our show, just ten weeks before the opening. Yet even then, I can't say that I despaired. After all, this was just part of the game. And I was a player.

THE ART MUSEUM PORTRAYED IN *Sacred and Stolen* is not one of the crowded press conference and the fancy donor dinner at the National Gallery for the opening of *Masters of Light.* That is the orderly part of this world; it is already familiar, and it is often little more than elegant theatre. This book is set backstage amid the messiness of museum life the public doesn't see, but should. We are, after all, public institutions spending public funds. Mine is a world of looted antiquities, crooked dealers, deluded collectors, fakes, thefts by museum staff—and a world of bribes that don't work and

exhibitions that fail. This is a world where people like you and me fall in love with art they shouldn't fall in love with, and then do some very stupid things. It's a white-water world where controlled chaos often reigns right up to the moment of the ribbon cutting.

As I look back over the four decades of my professional life, I imagine myself as a bobbing cork swept along by powerful currents that were sometimes totally beyond my control. I was often bemused, occasionally exasperated, but always entertained. And from the beginning, I was on a sacred quest. I wanted to create for museum visitors a sense of awe before great works of art matching what we feel as we enter a Gothic cathedral—a sense of the divine, of the "numinous." And I was an evangelist of the aesthetic: I wanted to make it free to all.

It turned out to be both an opportune and a treacherous moment to pursue my ambitions. Just as I was beginning my museum career, the international art market was flooded with Byzantine art stolen from the churches of northern Cyprus in the aftermath of the 1974 Turkish invasion. The art of Byzantium is my specialty; this meant that through much of the '80s, as I struggled to capture the numinous, I was becoming increasingly entangled in the sinister world of illegal art trafficking. And this eventually landed me in the witness box of a federal courthouse in Indianapolis and, later on, it led to an appointment by President Clinton to serve on his Cultural Property Advisory Committee.

Sacred and Stolen is also the story of a Minnesota kid who started out as a printer's devil in his father's small-town newspaper and ended up as the director of a gem of a museum in Baltimore, with stops along the way at Carleton, Princeton, Harvard's Dumbarton Oaks Research Library and Collection in Georgetown, and the Menil Foundation in Houston. And it tells of his struggle to reconcile his passion for acquiring and displaying sacred works with his knowledge that many of them were stolen.

I left the Walters in 2013 after twenty-eight years; in the words of the *Baltimore Sun* editorial, I was the "happy warrior" of the art world. It's true, I was. And I like to think that what Rod Grierson said about me in the acknowledgments in the *Gates of Mystery* catalogue years earlier also captured the truth—that I was able "to see with the eyes of the art historian, the theologian, and the man in the street." I was lucky to have lived my life in art museums as I wanted to live it, with a taste for adventure, an attraction to the new and unknown, an eagerness to fan the flames of excitement, and a bemused comfort with the chaos that often ensued. The truth is I loved it. Most of the time.

THESE ARE MY BEST RECOLLECTIONS of important events in my life, some of which took place decades ago. More than three dozen people have read and commented on parts of *Sacred and Stolen* in advance of publication; many figure in the narrative. Any errors or omissions, though, are my own.

GARY VIKAN
Baltimore, Maryland
May 2016

Finding My Religion

I was born in 1946 in the small farming town of Fosston in the far northwestern region of Minnesota where, as they still say, "the prairie meets the pines." I was the youngest of five children of first-generation Scandinavian-American parents, Wilma and Franklin Vikan.

The National Geographic Magazine was my first exposure to the fine arts, if I discount the two sepia reproductions of engravings of Gothic cathedrals—Amiens and Reims—in our living room and Warner Sallman's ever-popular *Head of Christ* in the basement of the nearby Hope Lutheran Church. And so it happened that the first great painting in my life, the first one I fell in love with and felt I somehow owned, was the luscious *Venus with a Mirror* by Titian that I met in a *National Geographic* in my bedroom.

One evening in the fall of 1955 I discovered I could not stand to have the wonderful image of *Venus with a Mirror* absent from my life. The possibility of this loss came about because I had made a terrible mistake.

As far back as my memory stretched, I shared my bedroom with my brother Dean. Since he was eight years older than me, it was really his room. Dean was an honor student, co-captain of the

football team, and the best cornet player in the school band. With his engineer's boots, ducktail, and green '39 DeSoto coupe, he was straight out of *Rebel Without a Cause,* and although he was rarely rebellious, he cut a fine, defiant-looking figure.

He loved to hunt and fish, but his real passion was airplanes. In the fall of 1955, he was only a few months away from learning that he had been accepted into the second class of the United States Air Force Academy. Dean loved to assemble bombers and fighter planes out of balsa wood, putty, paint, and decals, and this décor dominated the room.

But there was one part of the room I owned: the long shelf below the double window where my mother stacked the issues of *National Geographic.* Since no one else seemed as taken with them, I considered them mine. I didn't read the articles, but I remember examining over and over all the illustrations with great care. For a while I was set on going to college in Mexico City because I was enraptured by the photos of the new university library with its huge, gorgeous murals. I loved even more the colorful photo spreads on life in tribal Africa with fascinating images of naked people. After studying these, I then decided I wanted to be an anthropologist in the field.

But best of all was an article on the National Gallery of Art in Washington, DC. I can see clearly, as if I had just gazed at it yesterday, the illustration of *Venus with a Mirror,* a painting of people who looked real to me but who were involved in behavior that was anything but realistic. Possibly I even recognized it as great art—and was not only drawn to it because a blonde woman with exposed breasts is captured in a private and intimate moment as she gazes into a mirror held up by a naked little boy with tiny bird wings on his back. Or perhaps my initial attraction was based on feeling that things like this were especially unlikely to happen to little Lutheran boys where I lived.

Whatever the reasons, I was smitten. Needing a page marker for quick access to the illustration of Titian's marvelous painting, I tore off a bit of the magazine's back that displayed a large Hormel canned ham and did this frequently whenever I lost my bookmark.

I did not think about my fondness for this painting or the oddness, if that is what it was, of my fervent and frequent viewing of it until the incident in 1955. That evening all the other Vikans had gone out. Dean had a date, probably with the farm girl he would later marry. Since I had a great interest in the aerodrome he had constructed, I was glad to have a chance to further explore his favorite possessions.

Dean had cleverly covered our ceiling with little reflective stars and suspended some airplanes with string to create the effect that they were buzzing overhead in the starlight as we slept. He arranged the rest of them hangar-like, with great care and no doubt some military logic, on shelves in the corner just beyond his bed. Since Dean was meticulous and known for a hot temper, I was always very careful with his airplanes.

But that evening as I reached toward the top shelf in our bedroom to pull down Dean's huge B29 Superfortress, the object of my wonder slipped from my hands. It whacked a lower shelf, and I looked in horror at its broken wing that revealed raw balsa wood and putty where there used to be smooth fuselage and silver paint. I quickly put my brother's wounded B29 back where it belonged and tried to prop it up to make it appear as if the wing were still intact.

Later that night I stood in misery in front of the damaged plane with my mother and shouting brother. Dean was really angry at me, and this required consequences. Suddenly I was permanently banished from our bedroom and sent to my sister Bonnie's room.

I soon found I didn't care which sibling I roomed with, but I cared a great deal about the issues of *National Geographic*— especially, of course, the one with the Titian painting—that were

now imperiled. I think it was the first time I was fully aware that images could have a special hold on me, and the first time I felt I must find a way to keep an image I loved safe and available.

Although my hometown was a five-hour drive from the Twin Cities and the Minneapolis Institute of Art, which has its own share of Renaissance paintings and plenty of naked women, I had never heard of the Minneapolis Institute of Art. Even if I had, I can't imagine myself or any other family member at that time in 1955 going to the museum. In the meantime, I realized I still effectively owned the shelf of magazines, and since my brother was often out I still had access to them from my new address down the hall.

IN FOSSTON WINTER LASTS FROM late October well into April, and in those days, forty below zero was not unusual in January and February. When it got that cold, my hair, lathered up with Wildroot and plenty of water into my own version of a ducktail, would freeze solid during the two blocks from our home to school.

The Vikans lived in a grand Victorian house with an abundance of oak paneling on the corner of 2nd Street and Eaton Avenue. Then, as now, there were only about ten streets in the whole town, because even at its population peak in the '60s, there were no more than 1,700 Fosstonites. They were all white (except for a handful of Ojibwa) and mostly of Norwegian or Swedish extraction with a smattering of Finns and Germans. Our house was previously owned by Dr. Abraham Shedlov, likely the only Jew in town and the one who delivered little baby Gary on November 30, 1946. (Well, not so little: At 11½ pounds I set a Fosston record.)

Everyone in Fosston was "we," and everyone else, whether in the Twin Cities, Washington, DC, or at the United Nations in New York City, was "they"—and it was the "they" of the world who actually

directed events. We kept track of those directed events mostly by way of our new Sylvania television set. With the aid of a very tall rotating antenna it pulled in one snowy channel, WDAY Fargo, some 110 miles to the west.

My father, Franklin, was the youngest of eleven children of a Norwegian immigrant named Knut Knutson Vikan. After a few years as an itinerant "grubber" (a digger of tree stumps), Knut homesteaded in the 1890s with his wife Betsey in the Turtle Mountains of North Dakota.

In contrast to Franklin's modest beginnings, my mother Wilma's family lived in a comfortable style that was both urban and urbane. She was next-to-the oldest of seven musically gifted daughters of an immigrant Swedish butcher named Ernest C. Johnson and his wife, Christina, in the region's largest town, Grand Forks.

But for reasons not understood, in 1923, when my mother was 13, Ernest in rapid succession borrowed on his life insurance policy, bought a Cadillac, and "blew his brains out" with a pistol. The Johnson children were kept together by their diligent mother, who became a baker, and her entrepreneurial girls who delivered Mom's baked goods and also performed as "The Johnson Sisters" at hotels and supper clubs around Grand Forks. I think we Vikan children all assumed that our drive to achieve in school and at music was bound to our mother's difficult victory.

While my mother was by nature cheery and comforting, my father was often gloomy and distant. For fifty years "Frank" was the Editor and Publisher of our local weekly newspaper, *The Thirteen Towns*, named after the thirteen townships that originally made up East Polk County, Minnesota. For some, working on a newspaper with its deadlines is exciting, but for my father it mostly brought tension. He was constantly "over the barrel" or "under the gun" as Thursday, our weekly publication deadline, approached. The reasons for this were many. Perhaps it was because the relative humidity

that week was unusually low and "static in the air" would cause the sheets of newsprint to stick together and not feed into the huge flat-bed printing press in the basement. Or maybe it was because the one person on staff who knew how to set linotype got the flu. Or perhaps I had left a hammer on the bed of that big press and when I started it up, it jammed and bent the steel guide-rails for the rollers all to hell. This meant a full day of unusually intense anxiety as our local blacksmith struggled to hammer them straight again.

The chronic strain over a litany of possible catastrophes, and the fact that my father trusted no one ("if you want a job done right, do it yourself"), made him look for escape, and he became a quiet and earnest drinker. Sometimes he would disappear into the countryside around Fosston on a "bender." He went on these extended drinking excursions with his bachelor farmer friends we somehow never met.

All the Vikan children at one time or another worked at what we called "The Towns"; I started at fifteen as a printer's devil for forty cents an hour. I'm certain my father thought that was too much. Journalism, if that is what the *Thirteen Towns* was really about, did not stick with any of us. But it was at The Towns that I became enamored with the excitement of the deadlines that are so defining of art exhibitions.

Fosston High School, on the other hand, was our shared passion, and Dean's achievement profile became the profile for our entire family. All five children were either a salutatorian or valedictorian. Gail, the oldest, graduated in 1954 and I graduated in 1964. Between us were Dean, Linda, and Bonnie. We were all named FHS honor students, and that meant each of us gave a short *salve* or *vale* speech on the night of our graduation.

All the Vikan children except me were very good at music, too. I started on Bonnie's saxophone in the fourth grade and somehow moved up though some oversight to the oboe three years later. I was

simply terrible at all aspects of playing the oboe except making the reeds, which added nothing whatsoever to the quality of my performance. Our band director eventually stopped choosing music that included oboe solos and made me drum major, and finally made me the student director to keep me away from the oboe.

But the truth was that I loved music. I bought many 45s of Elvis, Jerry Lee Lewis, and Little Richard at the Rexall drugstore just around the corner from The Towns, and found Tchaikovsky, Schubert, and Sibelius LPs at Schmitt Music during our occasional visits to Minneapolis.

The other major focus in our lives besides *The Thirteen Towns*, the band, and our studies, was church. Given Fosston's population makeup, it's probably not surprising that four of our seven churches were variations on Lutheranism. Our family's place of worship, Hope Lutheran Church, was the largest and very close to our house. I felt that we more or less owned it. After all, my mother played the church piano, my sister Bonnie played the organ, Gail sometimes played the flute, and my father sang bass in the Hope choir. My contribution was that I was coerced into service as an altar boy, a job I detested. Not only did I have to wear a white smock with a huge red bow, but it was nearly impossible to light those damn candles under the gaze of the assembled congregation when the wicks had been snuffed down flat by that jerk of an altar boy who had preceded me.

By the time I was thirteen, the belief in the unseen that came with Hope Church seemed to me comical and absurd. But I still loved Bible stories and that selfless hero Jesus who was ready to take you back no matter what you'd done. One result of my fall from faith was that I now found my Bible classes very funny. This, along with my congenital restlessness, meant that I soon became a nuisance around church. Eventually this earned me the distinction of being the only Hope kid ever to be expelled from summer Bible camp.

Oddly enough, while belief in God exited my life early and forever, the Bible and religion stayed close to my heart. Together they shaped much of my career as their package of spirituality was transferred first to classical music and then to medieval art.

I suppose I needed some kind of religion. I was an anxious kid even before I started to work for my anxious father and periodically had his gloomy sense of doom and imminent disaster. From as far back as I can remember, music, and classical music in particular, offered both the inspiration and the comfort that I had first associated with church. In high school I would set my AM radio dial to WBBM in Chicago, a 50,000-watt clear channel station. The station had an all-night classical music show hosted by the mellow-voiced Jay Andre called *Music 'til Dawn*. Jay's "quiet hours in the Windy City" became a spiritual home for me. At the same time, they were a window to an attractive world "out there" that was very different from the one around me. In a more prophetic way, so was *Venus with a Mirror*, although I could not have said why until much later.

MY FIRST REAL SENSE OF the role art would play in my life came about a decade later when I met Titian again, by way of a tall, skinny kid from Panama named Mario Small. With a few casual comments, Mario extracted me from an academic dead end and launched me on my career.

From a very early age I could do numbers in my head, and in high school I loved to fiddle around with my chemistry set. I easily got top grades in math and science, and I won the Bausch and Lomb Science Prize for our region of Minnesota when I was a senior. Because I had this set of talents, I chose to attend Carleton College in Northfield, the same small town near Minneapolis where my sister Gail had gone to college. While she picked St. Olaf, the

school for Lutherans with musical talent, I chose the college across town for scientists in the making. I pretty much took it for granted that I'd one day end up a research scientist or mathematician—that I'd wear a tweed jacket with elbow patches and maybe drive a sports car and smoke a pipe.

I quickly gave up on that career path, though, shortly after arriving on campus and meeting all of those really bright kids from Minneapolis and Chicago and places like that who had gotten 800 on their SATs. Since I loved music, I thought it better to sign up for a course on the sonata-allegro form. I suspect that the class was pretty easy for anyone with any musical talent, but it was not easy for me. I just could not remember melodies. Strike two.

About that time I met Mario Small who had remarkably come all the way from Central America to Carleton not to become a scientist but to learn how to paint. To me that was odd. Mario said he was taking a class in art history, and in the class he sat in a darkened hall and looked at slides of paintings and famous buildings and tried to memorize them. Now that seemed truly strange. Apparently, I learned, there was a history of art taught at Carleton just as there was a history of music offered. This class was very difficult for him, Mario said, "probably because I'm from Panama," whatever that meant.

But since it sounded like fun, I signed up for *Art 101: Ancient to Medieval* in the fall of my sophomore year. And I discovered almost immediately, to my amazement and relief, not only that I really liked to look at slides of the Parthenon, Chartres Cathedral, and Giotto's Arena Chapel, but I was very good at remembering what I had seen and even good at writing about it. Was that, I mused, because of all those hours looking at issues of *National Geographic*? Or was this some sort of brain-wiring payback for my failure at music? In any event, I was saved.

I still have my first term paper: "Chartres, the Jeweled City, and the Heart of a 13th Century Peasant" from the fall of 1965. Not only

did I get an A+, everything I have ever believed about medieval art and art in general, I laid out in that essay at the age of eighteen. I was totally captivated by Henry Adam's *Mont-Saint-Michel and Chartres*, both for its detailed evocation of a great cathedral I had not yet visited and, more importantly, for its interpretation of that cathedral in terms at once poetic and spiritual. At that time, I did not have the word "numinous" to describe how Chartres made me feel. I had only general notions of awe and mystery, of ineffable spirituality—all somehow engendered through the black and white photographs available to me then. I was transfixed by the audacity of this great building as I imagined it towering above its medieval village. I was certain that if God *did* exist, this is where he would be.

Henry Adams gave me a vocabulary for the ineffable. And as for "numinous," a word made popular in the early 20th century by the great German theologian and Adams' contemporary, Rudolf Otto, I later learned it comes from the Latin *numen*, "a nod of the head," as if a deity were nodding to make his will known. Did Henry Adams ever use the word? I don't know, but he and Otto were certainly of the same moment and spirit. The medieval world as Henry Adams evoked it offered me a compelling spiritual message beyond the Titian in the *National Geographic*. It was more than an inviting window onto another place, far from Fosston, it was a source of spiritual nourishment. It had what the classical music had offered me that I heard between midnight and dawn from the station in Chicago.

I discovered that if I took every art history course available at Carleton over the next eighteen months, I could graduate as a *bona fide* major at the end of my junior year. It all happened that fast: after those two false starts in science and music, I was suddenly on the art-history superhighway. I had never seen Carleton before I arrived as a freshman, and I had never been to Princeton before the day in September 1967 when I arrived at the age of twenty as a first-year

graduate student. I chose Princeton because I knew Jimmy Stewart had gone there and because pictures of Nassau Hall showed that it was covered with ivy. I took the notion of Ivy League very literally.

HENRY ADAMS WAS NOT ON ANYONE'S syllabus at Princeton, where our job as graduate students was to research, discover, and argue our thesis—not to feel and emote. We were in the business of creating knowledge. At first I struggled, thinking that the more footnotes I included the better the paper. But in the spring of my first year in Bob Koch's graduate seminar on late medieval typology, the pairing of Old Testament heroes and events with their New Testament "types," I became an authentic graduate student.

My research topic was an exquisite little painting of the *Annunciation* by Jan van Eyck in the National Gallery that shows the Virgin Mary standing with the Archangel Gabriel in a miniature Romanesque church. The tile floor beneath them has scenes from the Old Testament, mostly from the life of the supernaturally strong, long-haired Samson. I waded through a millennium of obscure Latin medieval texts for weeks in the library of the Princeton Theological Seminary to construct a dense web of connections between Samson's story and stories of the Virgin Mary—who, in the painting, is literally standing on her hairy Old Testament "antetype."

I presented my findings on a beautiful Saturday morning in March 1968 in the graduate seminar room in Marquand Library. Sweet praise poured forth from all sides when I had finished, and then Bob Koch offered me the prospect of the ultimate acknowledgment: "You *must* show your work to Panofsky." By then I knew two important truths: the first was that the top historian of later medieval and early Renaissance art in the world was the German-Jewish émigré Erwin Panofsky, who was at The Institute for Advanced

Study just beyond the Graduate College on the outskirts of Princeton; and the second was that Panofsky had a tradition of anointing the star graduate student in each class with the gift of one of his books. What could be more wonderful than to be so ordained?

But my joyous delirium was brief. As I walked out of the seminar room and turned the corner toward our study rooms, one of my fellow students ran up to say: "Have you heard? Panofsky just died." There was probably a lesson in this, and I pondered exactly what it was. I do know, though, that it never crossed my mind to drive down Highway 95 to the National Gallery to see that beautiful little van Eyck in person.

The successful graduate student becomes a master of mimesis—of imitating one of the senior professors. I was such a master, and my model was Kurt Weitzmann, the preeminent member of the Department of Art and Archaeology at the time and, along with the late Erwin Panofsky, one of the most formidable scholars in the formidable generation of German art historians trained between the two world wars. Kurt Weitzmann was "KW" to his students behind his back and "Professor Weitzmann" to his face. None among us would have dared call him Kurt, and I don't recall that the junior faculty did either. He had arrived from Berlin in 1935 with joint appointments at the institute and in the Department of Art and Archaeology. KW was not the elegant intellect that Panofsky was, but rather a methodical archaeologist of iconography, modeling his approach on that of 19th-century biblical philologists.

The "Weitzmann method" involves painstaking analysis of narrative picture cycles in order to capture the hypothetical archetype. It is an almost quantitative method, for which the historical setting, use, and the spiritual import of any specific work carries only secondary meaning. I don't know if I was aware of it at the time, but KW's approach was pulling me still further away from that quality of medieval art that drew me to art history in the first place. And

even if I was, it would not likely have mattered, since KW was now my world.

Kurt Weitzmann was hugely and appropriately admired by medievalists across the globe as the great scholar that he was. To be one of his students carried prestige, and I was proud of this. The sign of my status as a Weitzmann "made man," which I received in my second year at Princeton, was the key to the green metal door on the second level of Marquand Library. Behind that door KW had his private office and the "cage." The cage was literally that—a walk-in, wire mesh enclosure with a lock to which KW alone retained a key. Inside this cage were his personal notes and photographs of the hundreds of illuminated manuscripts and medieval ivories that he had studied all over the world.

These photographs and notes were precious, and we all knew that. But there was an even more important repository *inside* the cage in a big white refrigerator with a padlock. In it were the color slides and transparencies that KW brought back from the Princeton University-University of Michigan expedition of the later '50s and '60s to the Monastery of Saint Catherine at Mount Sinai. (Saint Catherine's is a 6th-century walled fortress in the Sinai Desert where most of the great icons of Byzantium are preserved. Its remote location meant that it escaped the devastation during the Iconoclastic Controversy of the 8th and 9th centuries when much of Byzantium's early figural art was destroyed.)

Only those special people who had KW's blessing could step inside the cage, an honor I finally received in 1972, four years after I got my green-door key. That locked refrigerator, though, was quite another matter: Its cool temperatures would keep those precious images from fading, and its padlock would keep them safe from tampering. And *nobody* got their hands on its key.

By the time I got to Princeton, Kurt Weitzmann had already had two heart attacks. One of them we understood had nearly

killed him. So by then, on his doctor's orders, he left the manuscript room at 10:00 p.m. before we did, and the ritual never varied. His wife, Josefa, would rattle around her desk shortly before ten o'clock, then pass by KW's closed office door and rattle the coat hangers just outside. Then she would exit the manuscript room by the back door.

About three minutes later, KW would leave and lock his office, put on his coat, and follow in Josefa's footsteps, eventually catching up with her and surpassing her by ten feet or so. They'd continue to walk this way until reaching their apartment on Nassau Street, perhaps a fifteen-minute walk from the library. But just because they were not in step did not mean they didn't talk; while ten feet apart they kept up a constant, grumpy-sounding chatter in German all the way home.

The most earnest of KW's students, and I was certainly one of them, imagined that they at age 25 or so were miniature versions of him—little Weitzmanns in the making. KW was, after all, the best of the best in the world at being what we were working so hard to be, and we idolized him for that. Forget the fact that by the time he was our age, he had written major catalogues on Byzantine illuminated manuscripts and Byzantine ivories, and that he had all the language skills at age 15 that we were never going to have. And forget the fact that in his mid-60s, and much constrained by his heart problems, he could still outwork us. No children, no pets, no car, no cooking, no TV, no football games—just work and more work. And somehow we aspired toward that life.

IN MAY 1973, I WAS anxiously awaiting the first review of my first exhibition: *Illuminated Greek Manuscripts from American Collections*. Much had changed in my life in the five years since the day in the spring of 1968 when Erwin Panofsky died. I had become a

Weitzmann disciple, and then one of his star students. And like all Princeton graduate art historians of that time, I had earned my research year abroad, and I took this in 1970–1971.

Upon returning to Princeton, I married Elana Klausner, a graduate student in French and Russian in the Department of Comparative Literature. Elana's background could not have differed more profoundly from my own. Her parents were both from Vilnius. Her mother's side perished in the Holocaust while most of her father's family emigrated to Israel in the '30s. Her parents, Isaac and Anna Klausner, were among the last Jews to leave France, by way of Marseille and Casablanca, in May 1942. Their first-born, Edmond, who was three at the time, was a Manhattan psychiatrist and a gifted jazz pianist when I met him in 1969. No doubt some of the Klausner attraction partook in the same package of exotica that earlier drew me to the *National Geographic*, WBBM, and Nassau Hall. In any event, when we married in September, 1971, I left the last vestige of Lutheranism behind and became a Jewish convert.

It was lucky for me that my arrival back at Princeton, post-fellowship and in need of a job, coincided with KW's decision to retire after his work of four decades. The official date was to be the end of the 1973 academic year, but KW and the department had a plan to celebrate this milestone in his career that required that someone be hired in the fall of 1971 to implement this. And that someone turned out to be me. There would be an exhibition of illuminated Greek manuscripts at the Princeton University Art Museum, accompanied by a scholarly catalogue written by KW's students with me working as coordinator and editor. KW could not have guessed that by giving me my first exhibition, he was inviting me to draw a comparison between that very exciting public world and the insular scholarly world that he inhabited, and to make a choice.

I found that this exhibition project suited me perfectly. I liked the excitement of the printing deadline and the public opening, I

loved the collaboration with my fellow students, and I was eager to discover what the reaction would be to our work. At the time this seemed to us all to be innovative and full of scholarly import and potential public impact. I remember vividly and fondly the early morning drive up to Stinehour Press, across the Tappan Zee Bridge in southern Connecticut, with a rare Byzantine manuscript put at risk in the trunk of my chronically overheating MGB, in order for me to do a color check for the catalogue's cover illustration. I loved the entire tool kit of art exhibitions—the catalogue design, the labels, the casework, and even the lighting—and I liked to write without footnotes for an audience that was not confined to PhDs.

But I also quickly became acquainted with the post-opening let down that I never really got used to. After the festivities of the opening, with the fancy dinner at the Princeton Faculty Club and the drunken after party at the Nassau Inn, things pretty much fell silent, and nothing happened. The museum staff moved on to the next project. The Department of Art and Archaeology got back to the grind of being the department, and the exhibition space was empty—I mean literally empty of people. I had recently bought my first SLR camera, a Nikon, and every time I went into the exhibition space to take pictures I found it devoid of visitors. And those few who did come to see the show when I was not there were mostly academics who, in my view, were overly fussy and critical and who didn't properly appreciate our efforts and, more importantly, our accomplishment.

A few weeks into the show I received a call from the museum's PR department. Some justice, at last: *The Philadelphia Inquirer* was sending a reporter to cover the exhibition and I was chosen to escort him. I was ecstatic and remember the tour vividly. I stopped at every case and had something weighty to say about all sixty-seven items displayed, even though in retrospect I think it was likely that to this

reporter, as to almost any non-initiate in things Byzantine, those wrinkly parchment books with their small, badly-damaged miniature paintings must all have looked pretty much the same.

But no matter; at the time I thought of myself as every bit the equal of any senior curator at the Metropolitan Museum of Art and *Illuminated Greek Manuscripts* as a blockbuster in the making. I must say, I found the reporter annoyingly passive. I asked when I should look for the review. Within the next several days, he said, and then he was gone. There was no follow-up call; nor was there any fact-checking. I was too naive to recognize this as ominous.

In those days there was a drugstore on Nassau Street opposite the university, just west of the great iron gates in front of Nassau Hall, where faculty and students could pick up *The New York Times*, *The Washington Post*, and *The Philadelphia Inquirer* first thing each morning. It was no more than three days before I started to troll the drugstore as I waited for the arrival of the Philadelphia bus with its precious cargo. I would intercept the packet of newspapers on the sidewalk, pull out a copy before the wrapping was cut, and run in to pay for it. I learned very quickly just to flip to the arts section, and if I found nothing in the first two pages of that section, the whole newspaper went into the trash.

This went on for several days before I figured out that all I needed to do was to open the paper and check the art section which, if still missing my review, would go immediately back where it came from, and I would be on my way. I don't recall when I first suspected that the review might never appear, but I continued ripping into the *Philadelphia Inquirer* on Nassau Street in front of that drugstore until the last day of the exhibition on May 20th.

The non-appearance of the review was sort of like Panofsky dying just when I needed him to live. There was clearly a lesson there, and this time I got it. I was never again going to be part of a dud of an exhibition like that one, where any hope of emotional

engagement with the works of art—of capturing and evoking the numinous—was snuffed out by heavy-handed scholarship. By 1973 Kurt Weitzmann's padlocked refrigerator, the one that was still off limits to me, had completely trumped Henry Adams' numinous cathedral. Now, I realized this. I knew that I must return to the mentorship of Henry Adams, and find a way to bring medieval art to life and to make it even more engaging than classical music.

Chapter Two

Sailing Toward Byzantium

D uring the 1974–1975 academic year Elana and I were in Romania. This came about because I needed a job, or at least another fellowship following my year as a Kress Fellow at the National Gallery in 1973–1974. My PhD research centered on a manuscript in Greek that had been written around 1580 by "Luke the Cypriot" in the Romanian Principality of Walachia (north of the Danube, south of the Carpathians). Luke was then the Bishop of Buzău, a town northeast of Bucharest. He was later given the title of "Metropolitan" of Walachia, which meant that he was the head of the Orthodox Church in that principality. Luke the Cypriot was one among many Greek scribes and ecclesiastics who took refuge in what is now Romania after the Fall of Constantinople, and there created what scholars call *Byzance après Byzance*. What set Luke apart was not only his extraordinary ecclesiastical career, but also that he was the founder of a major school of scribes who based their calligraphy on 14th-century Byzantine script.

In the summer of 1973, a Princeton friend who heard my story about needing a position for 1974–1975 had the brilliant idea that my dissertation work might reasonably include some fellowship time in Romania, just as his had included some fellowship time in Russia.

I told him that the manuscripts that the transplanted Greek scribes wrote in Romania were *all* sent elsewhere, like to Mount Athos, Jerusalem, and Moscow.

And, in fact, the specific manuscript that was the focus of my PhD had made it all the way to Virginia Beach, Virginia, to the living room of Helen Greeley, who was the granddaughter of a US military man with a passion for old books, Colonel David McCandless McKell. I had photographed it there in September 1971. But my friend said this would not be a problem; there was an organization called IREX, the International Research & Exchanges Board, that made it its business to support scholar exchanges between the US and the Soviet Union and its Eastern Bloc allies. And they needed me because, as one might expect, the competition for time in Ceauşescu's Romania was not very stiff, and they had a quota to fill. Mainly American sociologists went that way to study village life, and science and technical folks were coming this way. I would be a novelty as the first IREX art historian going to Romania.

So there we were, for most of a year, in Bucharest with not a whole lot to do but discover what Communism was about, make Romanian friends, explore the countryside, and write. Yes, life in Romania then had its absurdities, but I brought my own. Despite the close proximity of the subject of my PhD research to Princeton, I wrote my dissertation in Bucharest using the 35mm color slides I had taken of every page of the manuscript in 1971. These photographs were my only source for reading the Greek text, which had never been edited or translated. While Bucharest is about fifty miles from the Romanian town where the book was written, it is nearly five thousand miles from the manuscript's present home in Virginia.

But after all, I needed a fellowship for the 1974–1975 academic year, and the one I got from IREX required residency in Romania. So I wrote the first draft of my PhD there on my father-in-law's portable Royal Typewriter, without the benefit of White Out.

This meant that I did what the Romanians did when they mistyped something: I used a razor to excise a thin layer of paper with the mistake on it from the surface of the page. This was one of many odd expediencies of life under the brutal Communist dictator Nicolae Ceauşescu, who was the head of state from 1967 until he was overthrown and killed in 1989.

Romania was then a land of comical fatuities. We had leased a powder blue Renault 6 in Paris for our time behind the Iron Curtain, and by May, seven months in, that car was a pathetic document of the craziness of life under Ceauşescu. It was missing its hood ornament, its gas cap, the word "Renault" in chrome that was once attached to its hatchback, and who knows how many parts from under the hood. (The car was by then in the annoying habit of sputtering to a halt, and could only be revived by my taking the carburetor apart and cleaning the little brass needle with my spit.)

Why had the car suffered so? Because the Romanians had over time stolen all sorts of bits and pieces of it. Romania then produced its own version of the Renault called the Dacia after the ancient name of that part of the Roman Empire. The reason our car was missing various external parts and probably some internal parts, and maybe even its original tires, was because this Romanian Renault was so poorly made that when Dacia owners spotted a real, French-made Renault, they would come back at night and swap out or steal pieces. Had we stayed for a few years in Romania, we probably would have ended up with a Dacia, all the way down to the engine. The Romanians were clever at that sort of thing and highly motivated.

The Dacia was itself a document of Communist absurdity. It came in one model and, as I recall, in only two colors: brown and black. Normal people could only get the brown version because black was reserved for the *securitate*, Romania's enormous and much-feared secret police. Of course this meant that *securitate* agents were easily identifiable, although there were other clues. They all lived

in close proximity to one another, and insofar as I could tell, they all wore long black leather coats no matter what the weather was. They were hardly secret police. Of course they didn't need to be secret since they had all the bases covered, and no one, including the Vikans, could get away with anything unless the police let them.

We were all convinced that the *securitate* had bugged every chandelier and every telephone in all of Romania. And maybe that was true. So when we spoke in our apartment with our Romanian friends, we covered the phone with a pillow or two and turned on all the water taps and the radio. And we pointed at the chandelier as a way of acknowledging that we knew we were being sneaky and on some level were taking a chance. (Who could do all that listening?) We also assumed we had our own spy at the ready to report on us. In our case, it was a young woman named Alina. She was about our age, namely in her late 20s, a divorcée, and she was very pretty and very friendly. She claimed she taught German somewhere, but if she did, it hardly filled her day. Alina lived in the house we lived in, a grand pre-war house on the very grand *Strada Spătarului,* near the Armenian church. She was in the basement with her younger brother Puiu, an endearment meaning "little chicken"; Puiu, whose real first name I never got, was a student and he, too, was very friendly and charming.

The sister and brother had a makeshift kitchen, a bathroom, and some kind of living room down there in the basement with a back entrance. *Doamna* ("madam") Gal, a roundish, gray, sweet old widow, lived upstairs with us in the other half of the main floor of the house. Her territory included the main kitchen, a small sitting room with a TV, a bedroom, but no bathroom—which meant she went downstairs to use the bathroom. *Doamna* Gal also became a close friend, as did her two mutt dogs with American names: "Bobby" and "Lady."

Elana and I got what was left: the living room with its Venetian chandelier and enormous ceramic stove that provided heat for much

of the house, a bedroom, and the master bath. But we did not get a kitchen. For us the window ledge was our refrigerator and our stove was a two-unit gas hot plate strapped to the top of the bidet in the bathroom. Romanians joked that it took two Communist chickens to make a Communist chicken sandwich, and that was true.

There were no locks on any doors, and those clever dogs could open the door to our part of the house and come in any time, day or night, which they did. So did Alina, who especially enjoyed coming to see us while we were still in bed or while one of us was in the bathtub. Every Thursday morning Alina would be visited by a German-Romanian named "Willy," who drove a beige Mercedes. Willy, whom we never really met, lived in Timişoara, which is in the far west of Romania. When he paid his weekly visit he always delivered a chicken sent by Alina's mother, who we were told also lived in Timişoara. Elana and I were pretty certain that Willy debriefed Alina on those visits about what the Vikans had been up to that week, which was nothing.

This spying thing was more than a little nutty. Elana had become friendly with a Hungarian-Romanian scholar of Dostoyevsky named Albert Kovac, who had married a Russian academic. These were extremely nice, talkative people, and we often saw them socially. The Kovacs had a daughter who was about to go to college, in Moscow we hoped, and they sought Elana's advice on their daughter's future and lots of other things. But since they were with good reason quite paranoid, these conversations could not take place in our apartment or theirs, even with two pillows over the phone, all the water running, and the radio on full blast.

And they wouldn't talk in our car, either, since they believed it was bugged. They would only talk about what they considered sensitive matters when we were outside and far from the car. For instance, we could have a conversation when we were out rowing around in a boat in the middle of Lake Snagov, twenty miles or so

north of Bucharest, or when we were standing out in the middle of a plowed field up near the Soviet border. This seemed to me very strange, especially given that the topic was where this kid of theirs should go to college. But that's the way it was under Ceauşescu.

And then there was the day, in December 1974, when the *securitate* descended on us in our half-house on *Strada Spătarului*. They stepped out of their black Dacias in their black leather coats. I know it was on a Wednesday because Wednesday was when "Nuţia" cleaned our part of the house in exchange for a pack or two of Kent cigarettes that we got cheaply and in abundance from the embassy, explicitly to be used as currency for just such everyday needs. (The Romanians were convinced that under the label of a single magical pack of Kents then in circulation in Bucharest was the promise of a prize—which was, I believe, a Dodge Dart.)

So when those thugs in leather came into our sitting room, Nuţia hid in the bathroom, petrified, but they never went in. The *securitate* told us that we had to move out that day because we were capitalists and we were corrupting *Doamna* Gal by paying her money for the right to stay in that house.

The US Ambassador intervened and we got a reprieve until March, when we did move out. We moved into a newly built high-rise in the south end of town overlooking the brand new *Parcul Tineretului* ("Park of the Youth") with its stubby little trees and its already crumbling sidewalks. To judge from the black Dacias parked in front, a bunch of *securitate* agents lived there and could keep a good eye on us. What made that second Bucharest home of ours quite creepy was that it was near a huge crematorium that looked like a Byzantine church, and you could set your watch by the black smoke that belched out of that building every day at exactly 3:00 p.m.

This apartment was new and that meant two things: the elevators never worked and sometimes the water didn't work either. In the case of no water, we would find an unattended spigot somewhere

and fill our reserve gas cans and carry them up six flights. Oddly, everything in this garish new apartment was red: the carpet, the curtains, the furniture, the lampshades, and even the glassware that for some reason came in sets of thirty-six—far more people than could fit in the apartment. And there were several different colors of red, shading from pink all the way to orange.

However, we now had our own fancy TV that got great reception and so we could watch *Columbo*, which the Romanians loved. It had a wire in the back, and all the screws that held the back panel in place were covered over with fresh putty. This suggested to me that we were being listened to and maybe watched from that TV. We also had a really big radio with a blond wood case that was very pretty—though the radio, too, was odd. This was first because a little pink plastic fan was glued to its top and second because it had a list of stations it could receive, and they were all in the Eastern Bloc. This meant from our perch on the 6th floor in the south end of Bucharest we could bring in signals from Krakow, but we somehow could not manage to pull in any stations from Greece that is much closer.

Unlike the elegant *Strada Spătarului* neighborhood, the area we were now in was sparsely populated and rough, not because of criminals running around, but because of the dogs. These were mean, scrawny dogs that ran around *Parcul Tineretului,* and if you weren't careful, they would sneak up on you with the clear intention of biting. I recall the time I had to run to the car and get up on the hood until they skulked away.

I vividly recall a beautiful May day in one of the most unlikely places I thought I'd ever be: a stone farmhouse in northern Romania, near what was then the Soviet border. It had thick walls with two windows facing south. Elana and I were having breakfast

with the farmer and his wife and a man who was standing nearby with a saxophone. I had been sailing toward Byzantium by that time for five years and, if there was a moment when I knew I had arrived, it was then. At that breakfast of tomatoes, cucumbers, salami, a feta-like Romanian cheese, a few huge spring onions, and a shot of *ţuică*. *Ţuică* is a bad idea in the evening, but it's a really bad idea in the bright sunlight of the morning. *Ţuică* is a powerful Romanian moonshine made from plums, and I suppose that if it were French, it might be magical and mellow, but this was Romania—Communist Romania—and this evil drink was harsh and had the makings of a bad dream. It was clear and warm and had pepper in it.

Our host, who was clearly as drunk as the saxophone player next to him, asked us if we had children and we said no. He asked us how long we had been married, and we said four years. And that's when we raised our glasses of *ţuică* and toasted, at his insistence, to our forthcoming family. I suspected where the conversation was going, because the idea of family was top of mind that morning. He, the father of the bride, and the drunken crowd outside those stone walls were in the fading hours of a wedding party that had started the night before. And now, we were new members of the wedding revelry, and because they were tired and hung over, we were the source of new energy and a good excuse for another shot or two of *ţuică*.

We had put off our trip to Bucovina in the northeastern part of Romania until the second half of May because we knew the weather would be good. And it was. This is where the Carpathians are low and grass-covered, and there are lots of sheep. In those days shepherds made their shoes on the spot by wrapping their feet in sheets of leather and then using strips of leather to bind the wrapping in place. It took some real skill and was amazing to watch.

This is also a place where all the blouses women wore were handmade; they were locally distinctive and individually decorated, and this is what we were most interested in buying. The trouble was,

these shepherd families were very proud, with none of the cynicism of Bucharest Romanians. They would not accept our Kent cigarettes in exchange for something we wanted, and the very the idea that they would sell something seemed pretty foreign to them. While we were able finally to buy two magnificent handmade blouses, this meant long conversations over *ţuică* and *slanina*, which is their version of *prosciutto*, but could easily be mistaken for raw bacon, because it is. There were few cars, no tourists, and a pace and texture of agricultural and religious life that was, I assumed, as close to medieval Byzantium as one could find anywhere.

Bucovina is a small region five hours drive north of Bucharest; it is now divided between Romania and Ukraine. The Romanian half is renowned not so much for its blouses but because it is there that Romania has in abundance what no other part of the Christian world has: churches painted on the outside. They date mostly to the 16th and 17th centuries, are generally small, and are often set in monasteries. (The Church and Ceauşescu had come to a *modus vivendi* and so the country's religious monuments were well maintained.) The most famous among these painted churches is in Voroneţ, and it is called the "Sistine Chapel of the East," though only by Romanians. But they have a powerful case. The west facade of this tiny church is covered with a stunningly beautiful fresco of the *Last Judgment* that was painted in 1547, six years after Michelangelo finished his version of the *Last Judgment* on the west wall of the Sistine Chapel. Both are dominated by powerful blues, and both are masterpieces, one of the Catholic Renaissance and the other of timeless Eastern Orthodoxy.

And I have a preference. For me, Michelangelo was a master of the heroic seeable; by contrast, the anonymous artist of Voroneţ was a master of the divine un-seeable. Standing before that fresco on that spring day in 1975, I felt transported in the way that I felt transported upon entering Chartres for the first time.

Elana and I had stayed the previous night in a tiny nun's cell at the back of the beautiful white cloister of the Agapia Monastery, just over a mile from that farmhouse with the thick walls and the wedding party. We had taken a walk up into the forest of fir trees just above the monastery that afternoon, and discovered there, in "Old Agapia," a small church with a service in progress. We entered the dark *pronaos* (porch), lit only by memorial candles set in metals trays, and immediately were offered *colivă* by an old woman dressed in black and wearing a head scarf. *Colivă*, which is boiled wheat sweetened with honey, raisins, and cinnamon, is offered in memory of the dead, and this typically happens on Saturday, the day Jesus lay in the tomb. That lady in black didn't ask us if we wanted some of this sweet boiled wheat; she just thrust it toward us. This was my first encounter with *colivă*, as that Saturday night would be my first sleepover in an Orthodox monastery, and the next morning would be my first experience of a traditional Orthodox wedding.

It was chilly and damp that night, and I tried to dry out the quilts of the little bed we shared by holding them against the wood stove that was very hard to get fired since the wood, too, was damp. I finally retrieved our Chinese toilet paper from the car to use for kindling. We had just returned from a wonderful dinner on the terrace of a large, chalet-like restaurant, *Hanul Agapia*, a short walk from the monastery. We sat on the terrace because all the tables inside were preset for an enormous wedding party.

While we ate, two buses arrived, and the bride and groom got out first. The occupants of the groom's bus then gathered on one side of the street and the occupants of the bride's bus on the other as the two bus drivers let the air out of the tires. I took that to mean this was going to be a long and serious celebration.

The next morning we saw the bride and groom and some occupants of the two buses sprawled out on the hillside beside the restaurant. The buses were gone. At a little general store nearby, we picked

up some East German tomato juice, which was the best you could get, and some more Chinese toilet paper. When we opened the hatchback of our car, suddenly, the bride and groom and the bride's mother were right there behind us. They had seen the international sticker for France, "F," on the back of the car and jokingly asked if they could come along with us to Paris for their honeymoon. I took that to mean that they did not think we were undercover *securitate*.

What the groom really wanted was a ride for his drunken new wife and his drunken new mother-in-law back to a farmhouse a mile down the road. And we were off, soon turning left into a large walled courtyard in front of the bride's father's farmhouse where we were greeted in the most joyous fashion by the drunken wedding party and then escorted into the house for breakfast by the saxophonist playing some raucous Romanian folk song.

THE LARGEST GATHERING OF ROMANIANS that I saw that entire year was at the Patriarchal Cathedral on Saturday night at midnight, May 3rd, exactly two weeks before that night of the wedding in the Agapia Monastery. It was another Byzantine first, and it left me with a powerful visual memory.

It was the Saturday of Orthodox Easter. The cathedral and the grounds of the cathedral were packed with Orthodox believers. The celebratory moment is called "Holy Fire," a sacred ritual going back to the 4th century that gives collective expression to the Resurrection of Christ at the stroke of midnight. A candle flame enters the darkened, crowded nave from behind the icon screen, and is gradually passed to the entire congregation who carry small candles. Then the congregation goes outside to walk around the cathedral three times. Someone gave me a candle; I received the flame and joined the procession.

Patriarch Justinian took up his position on the steps of the enormous west porch of the cathedral, and before the klieg lights of Romanian television, he shouted a short phrase that has been shouted in just that manner and at just that moment in the Orthodox Easter celebrations for centuries: "THE LORD IS RESURRECTED." And we all responded in unison: *ADEVĂRAT A ÎNVIAT*—"HE IS TRULY RESURRECTED." This was repeated several times.

The couple next to me advised me to take care to keep my candle lit so that I could light a candle with it in my home; they said this would bring a blessing to both my home and my family for the year ahead. I made it back to our high-rise with my candle still lit, and from the 6th floor, in a city with minimal public lighting, I watched tiny flames spread out from the Patriarchal Cathedral of Communist Romania in all directions. This is an image and a feeling I will never forget.

Chapter Three

Saving a Gold Key
From the Toilet

From 1975 to 1984 I was a scholar, pure and simple, at that most luxurious enclave for Byzantine studies, Harvard's Dumbarton Oaks Research Library and Collection, at the top of Georgetown in Washington, DC. In 1940 founders Robert and Mildred Bliss, whose family fortune came from the patent laxative, Fletchers Castoria, had turned over their historic DC estate, Dumbarton Oaks, with their art collections and expansive gardens and a large endowment to Harvard University. Their vision was that it would become a research center supporting scholarship and publications in the areas of their three passions: Byzantine, Pre-Columbian, and landscape architecture studies. Initially a welcoming home for many World War II émigré scholars, Dumbarton Oaks has since blossomed into an international leader in all three research areas, with several generations of Fellows having now passed through its doors.

My path to DO (as we insiders call it) had been neither typical nor smooth. I had applied for a Junior Fellowship there in 1973 as I was completing the *Illuminated Greek Manuscripts* catalogue. I was

convinced that with that publication in the works, my Princeton background, and the support of my all-but-omnipotent professor, Kurt Weitzmann, it was a sure thing. But I was turned down, and that really disappointed and angered me. Sure, I ended up in DC the next year, but not where I belonged. Instead, I was four miles away at the National Gallery as a Kress Fellow.

Still, I often used the DO library and photo collection. And then one day, I got a call at my little cubicle at the National Gallery from Joan Southcote-Ashton, who ran the photo collection, and who seemed be the keeper of protocol and general good conduct for all of Dumbarton Oaks. She told me in her precise English accent that my bellbottom jeans were simply inappropriate. So not only did I not get the fellowship, but I was being hounded in my little National Gallery nest for having violated the DO dress code. This was not a good start.

Then, on Valentine's Day in 1975, things turned around when I received a telegram at the American embassy in Bucharest from the Director of Byzantine Studies at DO, Bill Loerke. He was offering me a two-year contract to write a catalogue of the sculpture in the collection—about fifty pieces, ranging from Hellenistic Egypt to Renaissance Germany. The idea, according to Loerke, was that I would help build a bridge between the DO scholarly community and those on the staff who focused on the collection.

Of course I jumped at the opportunity (my only one at the time), though with some trepidation, owing not only to my 1973 fellowship rejection and the subsequent shellacking for my dress code violation, but because I had few good feelings about Dumbarton Oaks to begin with. And to be clear, I knew full well that to be a Byzantinist you eventually had to pass though those splendid wooden doors at 1703, 32nd Street NW. There was no secondary version of DO, and if you didn't make the cut, you would be nobody, and your career would go nowhere.

But I understood Dumbarton Oaks, from my first awareness of it, to be a place of secrets and favoritisms. After my general exams at Princeton, I was honored at a celebratory dinner that included a former DO Fellow who loved to spin dark and sinister yarns about people Mildred Bliss favored and those she did not, and whom she invited to afternoon tea and whom she invited to the annual Spring Symposium and whom she did not. So I wondered why I would want to go there but knew that I must. And thanks to that Valentine's Day telegram, with its offer of a third cataloging project, I was on my way.

And as it turned out, I soon grew to love DO. What a privilege it was to be surrounded by the leading Byzantinists in the world, who, much to my surprise, were welcoming, open, and supportive. I especially enjoyed lunchtime conversation in the Fellows Building. Topics might include the etymology of the Romanian word for "orange," *portocală*, and its counterpart in Turkish and Greek; the population of 6th-century Constantinople; the availability of stand-up cataract surgery in the Forum of Constantine; and the origin of the *vik* in Vikan. I guess when you're the best of the best (it was a room full of Weitzmanns), you can leave competition and intimidation behind. I don't know how, but they certainly did. And I felt very special.

BUT THERE WAS ANOTHER KIND OF SPECIAL PRIVILEGE I gained access to at DO that would change my life, and it began in the third week in March, 1977, with the death of my friend Marvin Ross. I had gotten to know this legendary curator and Monuments Man because he occupied a small office opposite mine over the entrance to Dumbarton Oaks. It was Marvin Ross who had discovered the famous *Isenheim Altarpiece* by the German Renaissance master Matthias Grünewald hidden in a castle in Alsace in 1944. For some

reason known only to him, Marvin wore a camouflage hunting cap to work each day. Since he preferred telling stories to doing research, he had lots of visitors to his little space. And because he had made it clear to everyone that he suffered from numerous afflictions and diseases, including cancer, it came as no surprise when Marvin died that spring at the age of 72.

More surprising was my summons shortly afterwards to the office of the Honorable William R. Tyler, former US Ambassador to the Netherlands and now Director of Dumbarton Oaks. Hercule Poirot of the English television series reminds me of Bill Tyler; he had those rosy cheeks that French farmers often have—appropriately enough, as he owned a chateau in Burgundy. But people at my level at DO almost never saw Tyler, and I don't recall that he had ever acknowledged me (he didn't go to lunch with the Fellows). I was then nearing the end of my two-year contract to catalogue DO's sculpture. Two other staff members, both Byzantine Junior Fellows, were summoned with me. We were all in our early 30s, each of us a bit nervous and eager to know why we were standing in Director Tyler's office.

We soon had the answer. A local lawyer representing a wealthy Texas woman named Dominique de Menil had called Dumbarton Oaks with an odd problem. In a vault in the bedroom closet of Marvin's apartment in Northwest DC was a stash of more than 800 small Byzantine artifacts, mostly bronzes—crosses, rings, stamps, coin weights, and such. The Texas woman claimed that they belonged to her. It seems that her deceased husband had bought them fifteen years earlier from a well-known antiquities dealer named John Klejman, and that Marvin Ross had been on retainer to Mrs. de Menil pretty much ever since, researching the collection for publication. What Mrs. de Menil's lawyer offered as evidence for taking them away (I don't recall seeing a bill of sale or title) was a set of research photos commissioned by Marvin in the '60s. Apparently the objects had never made it to Texas.

So our job, as defined by Director Tyler on Mrs. de Menil's behalf, was to go over to Marvin's apartment and match up those little Byzantine doodads in his bedroom vault with the photographs. Which is what we did, while sitting on the deceased curator's bed. Sure enough, all 800 or so items matched up with their pictures, and soon made their way to the Menil Foundation in Houston.

We three Byzantinists-in-the-making were not alone that day in Marvin Ross' apartment. There was the lawyer, of course, but there were also two gray-haired ladies who were identified to me as Marvin's sisters. They were sitting in his study and were clearly very angry with the lawyer as well as with our little crew from Dumbarton Oaks. The basis of their grievance seemed obvious: the rich lady's lawyer was eyeing not only the objects in Marvin's bedroom vault, but also the books and papers he'd assembled over many decades. Dominique de Menil had paid Marvin Ross for years to write a book he never wrote. Now, as compensation, she was claiming his personal library. Or at least, that was what I assumed.

DOMINIQUE DE MENIL REENTERED MY LIFE a year later. My two-year catalogue-writing contract at Dumbarton Oaks turned into three, as happens at places as wealthy, slow moving, and indulgent as DO. But there I was again, in the spring of 1978 (the catalogue still unfinished), soon to be without a job and with no fellowship prospects. This time my salvation came in the form of a phone call from KW with the joyous news that he had recommended me to Dominique de Menil as just the right person to carry on Marvin Ross's research and publish that collection of little bronzes I had seen in his bedroom a year earlier.

I was hoping for this, but hardly expecting it. Kurt Weitzmann had been all over the newspapers in those months for having

organized *The Age of Spirituality* exhibition at the Met, the largest show ever devoted to the art of the Late Ancient world. I imagined this had gotten Dominique de Menil's attention. I eventually became aware that she always went to the top, whether in the world of art or scholarship or spirituality, including consultations with the Dalai Lama. Only recently did I learn from Dominique's biographer, William Middleton, what Kurt Weitzmann said about me when she called him about who might take over Marvin's work. According to Dominique's notes: "Weitzmann says Gary Vikan is his most gifted pupil—he is in touch with everything he does."

KW recommended me for this job because I could do really good catalogues. My editing of the catalogue for *Illuminated Greek Manuscripts from American Collections* that was produced in time to honor his retirement from the art department in 1973 got the attention of the committee giving out Kress Fellowships at the National Gallery for the 1973–1974 academic year. I then applied for and received the privilege as a Kress Fellow of editing *Medieval & Renaissance Miniatures from the National Gallery of Art*, which came out in 1975. These two catalogues apparently impressed Bill Loerke at DO, and so he hired me in 1975 to write the *Catalogue of the Sculpture in the Dumbarton Oaks Collection*.

Now, as a matter of principle, as you tackle one catalogue after another, there is a tendency to make each successive publication more ambitious than the one before—which means that the process will take longer and longer unless there is a public exhibition planned, with the real deadline of an opening injecting some discipline. Vikan catalogues one and two were both driven by exhibitions, and both came out on time. The Dumbarton Oaks catalogue, though, was not, and while I was hired to write it in two years, which would have it coming out around 1978, it did not appear until 1995. But no matter, before KW figured out how good I was at procrastination, he steered me to Dominique de Menil. Her collection

totaled more than eight hundred individual works from which I generated seven hundred pages of catalogue over fifteen years. That catalogue, perhaps 85 percent complete, still sits on my desk, nearly forty years after I started it. This is how academic life works.

I HAD NO IDEA WHAT TO EXPECT on my first trip to Houston in the summer of 1978, but I was excited and optimistic. I imagined that something magical awaited me, and I recall rereading Dickens' *Great Expectations*: little Pip, off to see Miss Havisham. What did I know of Dominique de Menil in those days before the Internet? Only that she was immensely wealthy, French, a widow, and an art collector of works mostly modern and contemporary. I knew that her fortune somehow came from oil, but only much later did I learn that she was, when still in her 20s, a script assistant on the Josef von Sternberg production of *The Blue Angel*. This alone, had I known it, would have dazzled me.

I arrived at the Menil compound in the fancy River Oaks section of Houston in the murderous heat of July. Dominique herself drove me from the airport in her black Mercedes to her Philip Johnson mansion. She sat me down in her living room, put on a Bessie Smith record, and produced a glass of whiskey from her not-so-secret "secret" Surrealist liquor cabinet. (It was filled with tiny Max Ernsts and Alexander Calders, and micro-sized maquettes of works in her collection.) I assumed that after more than three decades in Texas, this elegant oil heiress took it for granted that all Americans wanted a whiskey after a long plane flight. As for Bessie Smith, this was revealing of Dominique's deep affection for American Black culture, which took the form, academically, of her enormous "Image of the Black in Western Art" project, now housed at Harvard.

I was then shown to the nearby guesthouse by Dominique's Indian house man, Mani. I remember a Max Ernst over the bed and a Picasso nearby. But mostly, I remember a long cord with a red button. Mani told me that I was to press the little button in the event of a break-in, and the Houston police would appear all but instantly. Somehow, I doubted that. Mani made us breakfast in the main house the next morning, just Dominique and me. And I recall that he burned the toast. Dominique, who dressed and looked like a wispy nun and ate almost nothing, carefully scraped off the burned part of the toast before she passed it to me.

My first task was to make some sense of the lifetime of Marvin's personal notes that filled a row of file cabinets beneath a de Chirico in the guesthouse study. I tossed papers away freely, which made sense given Marvin's habit of recording in his illegible handwriting every random thought on a scrap of paper. But in the process, during that first day of housecleaning, I came across something interesting—in fact, two interesting things. One was a 35mm color slide of a small gold key whose end loop had apparently once been hinged to a handle of some sort, but had been broken open. And the other was a canceled check for $200 dated 1967, made out to George Zacos and signed by John de Menil. The subject line on the check, at the lower left, bore two words: "gold key." So where was that gold key and what was its story?

There were lots of Byzantine keys in the cache in Marvin's vault, but they were all bronze. And while many were hinged to a flat handle of some sort, or a ring, apparently so that they could be conveniently folded into the palm of the hand, none among them had been ruptured like the gold key. And I had never seen a Byzantine gold key before. It was clear as well that the ward, that is, the working "flap" of this gold key, was much more sophisticated than those of the bronze keys. It almost certainly was intended for a lock that, by Byzantine standards, was very complex. So what was missing

was certainly exotic if not, when purchased, very expensive. And not only that, it presupposed a second piece to which it was once attached, presumably a gold ring. I was intrigued. And thus began my quest to find that all-but-magical gold key.

By then I knew that George Zacos had supplied Dumbarton Oaks with most of its exquisite Byzantine gold jewelry, beginning in the early '50s. Marvin Ross, I had been told, was the connection between Zacos and Dumbarton Oaks, which made sense given that DO had commissioned Marvin to research and publish this gold jewelry in a catalogue that came out in 1965—shortly after the de Menil purchase when, I supposed, Marvin was free to take on another major project. I also knew that George Zacos, an Istanbul-born Greek, had been brought up in the Grand Bazaar, and that most of the interesting Byzantine objects he had to sell were brought to him by *araìdjis* (Turkish for "beachcombers"), who scoured the beaches on the Sea of Marmara side of the city during the winter months as the waves sifted through the excavation dirt dumped there by trucks.

I also eventually learned that John Klejman, who had a shop on the Upper East Side in Manhattan, was one of several dealers of that time who fronted sales for George Zacos, or, in this case, bought items from him. This meant that the gold jewelry at Dumbarton Oaks and the bronzes from Marvin's closet almost certainly came from George Zacos. I envisioned Zacos in his shop in the Grand Bazaar, putting aside the occasional gold piece that came in and saving it for Dumbarton Oaks. Over the years, he probably tossed the small bronzes into shoe boxes with keys in one, crosses in another, stamps in another, and so on.

Back in Washington, DC, a few weeks later, while thumbing through Marvin's catalogue of the DO jewelry, I came across something at once startling and wonderful. It was a 9th-century gold monogram seal ring with an ornamental groove at the base of its

hoop. It made perfect sense to me as the fitting for the now-lost Menil key. With a little investigation, I learned that this gold ring had come to Dumbarton Oaks in 1958 by way of George Zacos. But more amazing still, I found a note in the object folder in Marvin's inimitable scrawl recording that he, too, had made that connection to the Menil key in early 1977 during the last months of his life. Everything seemed to fit. Even the ring's monogram seal, which identified the owner of the Menil-DO key ring as "Panaretos." A lead correspondence seal of the 9th century in the DO collection (likely from Zacos as well) carried the name of Panaretos *kurator*, that is, "curator" or "keeper." In Byzantine society of the time that meant someone very special who was in charge of something very special.

From the beginning I never believed that George Zacos had ruptured the key ring himself. After all, the key sold separately was just $200, while the key and ring united made for a compelling and unique piece of functional Byzantine jewelry. That the two pieces ended up in two different collections nine years apart suggested to me that Zacos' runners had found the key and ring separately, perhaps some months or even a few years apart, but likely on the same beach, and that the ensemble was purposely ruptured centuries ago, though kept together.

Through a little research, I learned that there was an imperial workshop in Constantinople specifically for making gold keys, and that it was customary during the Middle Ages in general (as with the Pope, to this day) to destroy the seal rings of important people at the point of death, in order that the rings could not be appropriated and misused. So in just a few weeks, that chance discovery in the guesthouse in Houston had taken on great significance. But I had no clue where the Menil gold key in that 35mm slide had gone, nor did anyone at the Menil Foundation. For months, nothing further was discovered.

IN THE MEANTIME, I WAS getting to know Dominique de Menil.
I felt that I had entered an elite inner circle of wealth and sensibility
that I found enormously seductive. Here anything was possible and
my prospects were limitless. When did I know I had "arrived"? It
was in June 1979 in Basel during lunch in the apartment of George
Zacos.

A friend at Dumbarton Oaks had told me that Zacos had some
things I should see. I knew that he was aware of my cataloguing
project of those bronzes he had sold to John Klejman nearly twenty
years earlier. As it turned out, Zacos had continued to fill those
shoeboxes of his during his self-imposed Swiss exile from the Grand
Bazaar. It was obvious I should have a look, and Dominique decided
she would come along.

We converged at a high-rise just behind the Basel train station.
George Zacos and his wife, Janet, lived on an upper floor. I was told
that this was because he had once been stabbed in the back by one
of his runners and sought the safety of Switzerland and living in a
high-rise. The Zacos art inventory projected beyond their apart-
ment in the form of a huge bronze curtain rod above the entrance. It
appeared to be early Byzantine in date, and I imagined it could once
have been placed above one of the atrium doors of Hagia Sophia.
The curtain hooks were enormous index fingers with fingernails,
bent at a 90-degree angle and pointing up. Classy, I thought.

Dominique de Menil had arrived before me. I can still see her
on the Zacos living room sofa, wispier than ever, dressed in an aus-
tere outfit of grays and blues. Dominique lived with paintings by
Picasso, Ernst, and de Chirico, but George and Janet Zacos lived
with the glory of Byzantium, which I found even more exciting.
We sat for a while before lunch and talked—and the Zacos classi-
ness continued. Janet showed off the Byzantine gold ring she wore

as everyday jewelry, a spectacular piece, and complained that at 24 karats it was so soft that it would bend as she flexed her hand.

Lunch conversation was dominated by two topics linked solely by the theme of criminality. First Janet, an attractive and articulate Turkish Jew from the Prince Islands in the Sea of Marmara, gave us an extended lecture on the sweeping power of the American Mafia. How did she know these apparent facts about the American criminal underground? I have no idea. Nor was it clear to me why she cared so much, or thought we would care. George, ever admiring of his refined and beautiful wife, happily presented himself as the peasant of the Zacos family. He was big and boney and totally unguarded in his speech.

Without any coaxing, George launched into the story of the Sion Treasure—that notorious hoard of spectacular early Byzantine liturgical silver discovered by villagers in the area of Lycia in southwestern Turkey, smuggled out of the country by George, and sold to Dumbarton Oaks in 1963 for $1 million. George said that as a Greek, he felt increasingly uncomfortable in Istanbul after the anti-Greek riots of September, 1955. He was looking to get out via the "sale of a lifetime." Then, as if by magic, Janet walked into his shop in the Grand Bazaar one day in 1962 with some startling news she had picked up from a foreign-language newspaper. (Her language skills, George said, were much superior to his.)

She told him a young girl in a small town some distance from Istanbul (did he say Kumluça?) had dug up a silver chain, and that chain was attached to some big pieces of silver. The child ran to the local coffee shop to tell her father. The idea was to keep this wonderful news quiet, but word spread quickly. The villagers dug and dug, and pretty soon many big, heavy pieces of Byzantine silver had made their way into the homes of various local families. That is when George Zacos swooped in and bought up, very cheaply, most of the treasure from the villagers. (I recall that there were tales

recounted by others of hot pursuit by the authorities, and maybe gunfire, which I didn't believe.) The treasure was brought to Istanbul and the problem was how to get it out of the country. According to their story, George flew to Geneva and Janet stayed behind, shipping the booty out in parcels in some country's diplomatic pouch. And every shipment was signaled to George by a telegram to the effect that "another Russian silver service is on the way," with its weight recorded.

Once the treasure was reassembled in Geneva, George's loyal clients from Dumbarton Oaks showed up, Director John Thatcher and Director of Byzantine Studies Ernst Kitzinger. The players were familiar to one another and had been doing deals for Byzantine artifacts in precious metal for years, but never on this scale and with this amount of risk. And there was some last-minute drama that George recalled with such intensity that it was clear that at the time he was really shaken. After the $1 million had changed hands, Thatcher and Kitzinger boarded the plane—but then they came back down the stairs to the tarmac. George watched, terrified, assuming the two had gotten cold feet, though apparently it was just a matter of a forgotten briefcase.

The Mafia and a pair of Turkish antiquities smugglers: I suppose that was the connection. Did widespread criminality make Janet Zacos feel better about what they had done? Interspersed in these two narratives was some conversation about the luscious Peruvian silver from which Janet served lunch, and about those wonderful little round loaves of bread that we were enjoying. This, George proudly told us, was *Schlumberger Brot*, and it is so good and so special that he had driven across the border into Alsace that morning to buy some because that's the only place where true *Schlumberger Brot* is baked—sort of, I thought, like pursuing New York bagels. He said that these precious little loaves had been introduced decades ago by a wealthy Alsatian family of that name. I glanced at Dominique who,

I assumed, had made the connection to her family history, as I certainly had. But neither of us mentioned it.

After lunch and before we got down to work, George had something to show us in the residents' storage space in the basement of the high-rise. It was a locked, wire mesh cage where most tenants stored bicycles and camping gear. But George had a stack of small ancient bowls from a shipwreck somewhere off the coast of Turkey and a smattering of small ancient bronzes. I don't know how it happened, but all of a sudden Dominique was sorting through that stack of Byzantine bowls for Christmas gifts for her children. And it was only June! They were $1,800 each, she had a large family, and she was eager to get the bowls with human figures on them, or at least animals. Which she did, and it didn't take long.

As I recall, she wasn't much interested in the ancient metalwork except for a small bronze "circle with bumps." I say circle with bumps, because that's what I saw, but Dominique in a very Dominique-de-Menil way saw something much more, an ancient ceremonial circle dance, the hora, she said. And bought it. So that, I realize in retrospect, broke the ice.

Upstairs, for the next two hours, we looked at the two hundred or so Byzantine small bronzes that were laid out on the plush living room carpet. They were clearly of a family with the more than eight hundred bronzes that I was then working on, and I knew I needed somehow to include them in my research. I was tiring quickly and went back to the dining room table to have a chat with Dominique. My aim was to figure out how we could get George to have photographs made of these two hundred "new" bronzes, so that I could include them in my study.

I said to her: "What are we going to do about these bronzes?" Dominique did not respond to me, but got up and went back into the living room. She asked George: "How much?" He seemed surprised, but was ready, as I suppose an experienced dealer would be.

The quote was in Swiss Francs, but in my head I got to a figure in excess of $200,000. Fine, Dominique said, and then she gave two conditions: first, that she would pay in two installments, for tax reasons, I gathered; and second, that George would pack the pieces in tissue. She then offered me a small Byzantine bronze sealing stamp off the carpet for the good work I had done in brokering the deal. I refused, because of the squeaky-clean Lutheran still in me. And then Dominique got up and left. It was that quick, that simple.

Then followed the most amazing moment in an amazing day. George looked at me after Dominique de Menil left his apartment and said: "Who was that"? I hadn't guessed until that instant that he might not have known: that Dominique would not have told him before I arrived or that he wouldn't have figured it out on his own. And then Janet remarked, as a reflection of her own bewilderment, that "she looked like a nun." Were they worried that they might not get paid—that the quick deal for more than $200,000 was a delusion? No, they were not. But they were in the dark.

So I reminded them of the *Schlumberger Brot* of Alsace. And I asked George if he knew the name Gustave Schlumberger, a French Alsatian who nearly a century earlier was among the founders of Byzantine studies. George said of course, as I knew he would. And did you know, I asked him, that his relative Conrad Schlumberger was the father of the woman who just bought all those Byzantine pieces from you? Schlumberger, I said—as in the huge French oilfield services company. George and Janet got it right away. And I felt great. I was in the circle.

THE GOLD KEY REENTERED MY LIFE a few months later, in the early fall of 1979. I received a call from Mary Jane Victor, Dominique's Collections Curator, with some very interesting information.

It seems that it was generally understood in Houston that one of Marvin's sisters was the "good sister" and the other one was the "bad sister." The good sister, with a little prompting by Mary Jane on my behalf, let it be known that the bad sister had "taken something gold" off Marvin's desk after he died.

This was all I needed, besides her phone number and address. She lived in the small town of Riverhead on Long Island. So I called Marvin's bad sister, who was by then a widow. I identified myself as his friend, and told her about that wonderful discovery he had made in the last months of his life, and how appropriate it would be to make this unique Byzantine key ring whole in Marvin's honor. I described an exhibition I was just then putting together for Dumbarton Oaks called *Security in Byzantium*, featuring sealing and locking implements, and how this reunited gold key ring would be its star. By happy coincidence, the annual Byzantine Studies Conference was converging on Dumbarton Oaks at the time of the show's opening, which was less than two weeks away.

Without ever saying she had taken the gold key, Marvin's sister subtly acknowledged that she indeed had it, and that while it was "hers," she was willing to discuss the idea of the exhibition and the reuniting of her key with the Dumbarton Oaks ring, in her brother's honor. I had done my homework and knew that I could fly from Washington, DC, to the MacArthur Long Island Airport, near Islip, rent a car, and drive the thirty miles or so to Riverhead by mid-morning. So there I was just a few days later, standing in a phone booth in MacArthur Airport. The opening of the exhibition and the beginning of the conference (and Dominique's arrival in DC) were just three days away. The rental car had been secured and I decided to call Marvin's sister to tell her I was on my way. "Don't come!" was what I immediately got from the other end of the line. No reason was given, but I was just *not to come*.

Fortunately, she had spoken before I had a chance to tell her that I was already on Long Island and only a half hour away. I seamlessly continued to retell the tale of Marvin's great discovery, and to marvel at this rare opportunity to celebrate his brilliance before his scholarly colleagues. There followed much give and take (mostly take, on my part) and much repeating of Marvin superlatives. I ended my plea with "I'm already in Islip and have rented the car." Finally she grudgingly agreed to see me, so I quickly hung up and took off for Riverhead.

I pulled up shortly before 11:00 a.m. at a simple white frame house. I remember exactly what bad sister said the moment I walked through the door, before I sat down. Her mood had darkened and her message was crystal clear: "If you ever come back here, if you ever call, if you ever send a letter, or if a lawyer ever sends a letter on your behalf, I'll flush that gold key down the toilet." My first thought was that I had made a big mistake; my second thought was that I couldn't leave, because if I did, the key was certainly lost; and my third thought was that she was afraid—afraid that she might be in trouble with the law for having taken the key off her brother's desk. I was afraid, too, since in one quick flush the key would be gone forever.

Though uninvited, I sat down. Strangely, I never had the sense that she was going to kick me out of her house, or call the police or anything that forceful. I think that on some level bad sister had convinced herself that the key *did* belong to her, since it had (in her view) belonged to her brother and, just maybe, she could sell the key to the wealthy Mrs. de Menil. In any event, I just started talking, and pretty much didn't stop talking for more than an hour. She seemed never to tire of hearing how clever her brother was, and how thoroughly underappreciated he was by the likes of Dominique de Menil, who, in her view, had ransacked Marvin's apartment and

had stolen *from him*. I can't say that bad sister ever warmed up to me, but I was pretty certain that her hostility level went down somewhat. After all, here was a naïve, 32-year-old academic from Minnesota who was in way over his head. How evil could he really be?

It was nearing lunchtime, and I thought I was home free when she offered to make me a sandwich. As we walked toward her kitchen I recalled my conversation with Dominique de Menil about the gold key and my plan to get it back. I saw a side of Dominique that meshed with the side that I sensed through her lawyer that day in Marvin's apartment. If Dominique de Menil felt that she was in the right and had been wronged, she was filled with moral indignation. In this case, she was adamant that since that gold key was rightfully hers, she was not going to "ransom" it back with some cash payment. She would, however, consider giving bad sister a new refrigerator. How Dominique de Menil came to that compromise with her sense of justice I have no idea, but that is what was conveyed to me. So what came next was comical. The instant we stepped into bad sister's kitchen, she proudly showed me the refrigerator she had just bought. I settled for the sandwich, which I recall was ham and cheese.

I thanked her and we returned to the living room, but with the *status quo ante* in place: the gold key was hers, and she wouldn't budge. Then, a glimmer of hope came in the form of her daughter, who suddenly showed up at the house, presumably to check on her mom's well-being. After running through the celebratory narrative yet again, I decided, by some flash of insight, to try two hypothetical scenarios on the mother-daughter team. Granted, the key is yours, I conceded: How much do you want for it? The answer "plenty!" came so fast and with such enthusiasm that I knew I was on the right track. So then I turned things around and said that "for the sake of argument," the key might legally belong to Dominique de Menil. If so, what then? Bad sister's response was again immediate

and emphatic: "I'd give it back, of course." At this point I was wondering why I hadn't tried this two hours earlier.

Having established this either-or scenario, I posed the next obvious question: "How are we ever going to figure out who really does own the key, you or Dominique de Menil?" Here the daughter piped up and suggested we could ask a lawyer. And so I wondered out loud where, at 12:45 p.m. here in Riverhead, might we find a lawyer to express an opinion on this question. Then a miracle of sorts occurred, every bit as unanticipated as that new refrigerator. Bad sister's daughter was divorced but had a boyfriend (or so I intuited), and that boyfriend happened to be a lawyer. So she scooted upstairs and called her lawyer friend, who, by the best of luck, was at his desk and answered his phone. And sure, he'd be happy to see us. With that announcement, things began to move. We were quickly on our way down the back steps of the house, having decided that I would follow mother and daughter to the lawyer's office in my rental car.

The office was on the second floor of what was clearly one of Riverhead's primal structures, which means four stories or so of red brick with extra-large windows looking down on the town square. The young lawyer struck me immediately as the personification of common sense, adding immensely to my growing feeling of confidence. I recounted my story, that included the color slide and the canceled check, the brilliant discovery that Marvin Ross had made shortly before he died, and the "certainly reasonable" assumption that mom had made in picking up the gold key off her brother's desk that the key must belong to Marvin, and so now it belongs to his family.

I recall very clearly that when I finished, the lawyer laughed, though not in an insulting way. No, what was immensely funny to him was that he was being asked to render his professional opinion on the legal ownership of a thousand-year-old Byzantine gold key. Firmly and quickly, though at the same time gently, our pro bono legal counsel said what was clearly obvious to him: The gold key

was without question the legal property of Dominique de Menil, notwithstanding its physical presence for thirty months or so here in bad sister's house in Riverhead. Did I sense a sigh of relief from bad sister and her daughter?

The final question was this: how to get the key to its rightful owner. I noted that Mrs. de Menil would be that very Friday in Washington, DC, at Dumbarton Oaks and, as her employee, I was both an appropriate and an efficient agent for making the transfer. The lawyer didn't doubt either claim and suggested I take the key along right then. But no, I said, being gracious and noble in my victory (and *not* wanting to return to the house), just send it along tomorrow. Insurance? I thought $2,000 but I said $200, citing the Zacos check and not even accounting for inflation. Why? Because I didn't want to rekindle any notion of ransom or reward in the bad-turned-good sister. In any event, insurance or not, the key was irreplaceable. And the American postal system was to be trusted. Or at least that's what I thought at the time.

Back at DO on Wednesday, exhilarated by my success in Riverhead, I completed the installation of the *Security in Byzantium* exhibition, putting a small photographic print of the key on the Lucite block where, in a day or two, I would place the real gold key. No delivery came for Vikan either Thursday or Friday, though this was more irritating than worrisome, since the Byzantine Studies Conference had by then begun, Dominique de Menil was in town, and the show had officially opened. But when nothing came on Saturday, I began to worry, especially after I called my lawyer friend and learned that he had sent the key out himself, special delivery, on Wednesday. Sunday was a day of increasing embarrassment and agitation. No box, no key, and by the afternoon, no Byzantinists. The conference was over and they were all on their way home, except for Dominique de Menil, whose flight to Houston was Monday.

I had convinced myself by Sunday evening that her gold key was lost forever "in the mail"—whatever that means. On one level, I sought consolation in the fact that it really wasn't my fault, since how could I take responsibility for the US Postal Service? And, thankfully, I had not told Dominique or anyone else at Dumbarton Oaks my secret: I could have had that gold key in my hand that very day in Riverhead.

It was now late morning, Monday, October 29th. I was standing in the long entrance hall of Dumbarton Oaks in front of the wall case exhibiting the gold seal ring. In place of its companion piece, the real gold key, there sat the little Lucite block with a color print of the missing item, now lost forever, I assumed gloomily. After a journey of a thousand years, after being dug out of the beach sand of Istanbul, the gold key was now somewhere between Long Island and Washington, DC, buried in some vast postal warehouse. Maybe its label had come off—damn that stupid lawyer!

I began to confess the whole story to my colleague Susan Boyd, Curator for the Byzantine Collection: the tale of the gold key that I could have brought back but did not. Then, quite unexpectedly, through the front door at the end of that hall appeared Dominique de Menil, whom I absolutely did not want to see just then, or for a really long time, until the story of the now-lost key had blown over. She was wearing that signature white sable coat of hers, the one I was told her friend Magritte liked so much. Despite her age at the time, 71, her eyes and mind were wonderfully keen. Which meant that she spied me instantly and headed my way. But as she marched down the hall, a second figure appeared through the front door behind her, stopping at the security desk. He was wearing a uniform and, even from where I stood, I could see that he was delivering a small box.

I ran past Dominique to grab the box, which had Riverhead as its return address, and fell into step beside her, striding toward

the wall case. As Sue Boyd opened the case, I opened the box from Riverhead. Inside was the Byzantine gold key that for more than a year had been my quest. It was heavier than I expected, but what I did expect was true: it fit perfectly onto the Dumbarton Oaks gold signet ring. The act of joining was quick and without ceremony. Yet it occurred to me and, I think, to Dominique de Menil, that the two had not been one in more than a millennium. It was a moment of pure magic. And I knew we had bonded.

Chapter Four

Trouble with Fakes

F or some reason I'm very good at spotting fakes, which is lots of fun. But sometimes it makes for big problems. And I've had plenty of opportunity for sleuthing, given that my entire professional life has been in museums formed by private collectors buying from dealers and not by way of archaeological digs or, in the case of the Louvre, through Napoleon's plunder of archaeological sites. This means that at places like Dumbarton Oaks and the Walters there were plenty of opportunities for fakes to slip in, and they did. Also, I have always been attracted to fakes. Because a fake is a fake, and unlike academic arguments for dating and localizing a work through its style or subject matter, which can go on for decades and never be resolved, the determination "fake" is usually definitive and final. Sometimes, the conservation lab, with this or that test, can solve it. But mostly for me it has been my "eye" and intuition, and then some detective work. Of course, lots of people—dealers, collectors, curators, and museum directors—get really angry when someone spouts off about fakes they have sold or bought or are exhibiting. It's about money, for sure, but mostly it's about reputational embarrassment. And they will let you know.

My biggest fakes adventure began in late 1976 when I received a letter from the chief curator at the Hirshhorn Museum. I was mid-way through my second year at DO, Elana was teaching French at a local private school, and we were just scraping by, with baby Nicole's crib filling most of the living room of our tiny garden apartment. We were desperate for a little extra cash, and I had not yet latched onto the Smithsonian Resident Associates Program, for which I began teaching in 1977 all manner of things Byzantine for $55 a class. At the time, this Smithsonian gig was referred to around the Vikan household as "Talking for Dollars," after a popular TV game show of the '70s called "Bowling for Dollars." Pins knocked down, minutes talked, meant money. But $55 an hour was less than $1 a minute, and that's not counting the hours of prep time that got it down to probably four cents a minute, which was about minimum wage at the time.

So that letter from the Hirshhorn was very exciting, given that it meant real money. Like $300 all at once. All they wanted me to do was to examine and then write up three pieces of Coptic (early Christian Egyptian) sculpture that Joseph Hirshhorn had picked up along the way and that they now didn't know what to do with. It should be easy, I figured, since I had already learned a lot about Coptic art writing up the dozen pieces the Blisses had collected.

Those three limestone sculptures in the basement of the Hirshhorn seemed to me on first view to be straight-out fakes. All three were apparently *stelae* or grave markers with portraits sculpted in relief of a male, presumably the decedent. Two were bust-length and carved into shallow niches, while the third, a youth with a Dutch-boy haircut, was nearly full length and in high relief.

Why did I think that they were bad? In part, I decided this because all three figures had simpering, vacuous expressions that

seemed to me totally at odds with the forceful integrity that I was familiar with in the faces on genuine Coptic grave markers. Of course, that was just my intuition. Much more easily demonstrable as indicating a fake was their condition. All three were painted in bright colors over precisely carved surfaces, and none among them showed any weathering. Naturally, this seemed very odd to me, given that they were supposed to be nearly 2,000 years old and were apparently grave markers. Under ultraviolet light all three glowed bright blue. I took this to mean that there was no weathering or normal aging, nor was there any evidence of repair (also very odd given their reputed age), which would show as areas of discontinuity under UV light. Rather, each of the three was "of a piece" and, to my eye, clearly modern.

I went back to Dumbarton Oaks and checked out the definitive book on Coptic art by the esteemed German scholar and theologian, Klaus Wessel, *Koptische Kunst: Die Spätantike in Ägypten.* This was the obvious place for me to begin, and what I quickly discovered amazed and puzzled me. I found that those seemingly faked limestone reliefs in the basement of the Hirshhorn matched up in some way—either stylistically or in subject matter—with nearly one-third of the Coptic sculptures illustrated in Wessel's book. This meant that either I was wrong and those Hirshhorn pieces were genuine, or that all their look-alikes, and there were dozens of them in Wessel's handbook of Coptic art, were fakes.

I felt I was on to something big, and so I started some investigating. The first interesting thing I learned was that not one of those Wessel look-alikes had a history before 1958. I also discovered that many had been purchased by a small German museum, the Ikonen-Museum in Rechlinghausen. And with a little more detective work, I found out that Klaus Wessel was the museum's advisor on things Coptic. All of this I figured out in no more than a few hours.

According to Wessel, this spate of works recently coming out
of Egypt was the result of a fantastic new find in a place called
Sheikh Ibada (pronounced, as Elana was fond of saying, like "shake
a body"). This amazing "discovery," Wessel believed, filled in the
blanks between ancient Egypt and early Christian Egypt. I was all
but certain, though, that the whole Sheikh Ibada group was fake—
or at best, substantially re-carved in modern times. So I went on a
quest the following summer to see all the Sheikh Ibada sculptures
I possibly could. Some were easy to get to, like those in the store-
rooms of the Brooklyn Museum and the pair in the Art Museum
at Princeton University, bought, according to KW, by someone else
when he was on sabbatical. But there were many more in Europe,
in Rechlinghausen (nearly four dozen in all), Berlin, and Paris, and
almost everywhere else that there was an installation of Coptic art.
Before long I was up to 120 look-alikes to those Hirshhorn fakes,
and still counting.

The encounter with Sheikh Ibada in the (then) Skulpturengal-
erie in Berlin is the one that sticks with me, because it got me into
some trouble. The curator and buyer was Victor Elbern, a formida-
ble giant in the medieval art world. And in his galleries was where I
found two large relief sculptures of naked little "Coptic" boys hold-
ing up crosses, one boy in his left hand and the other boy in his
right hand. Klaus Wessel was very keen on these two sculptures
because they proved, for him, that the early Christians of Egypt
segued comfortably from pagan subjects (naked boys) to Christian
subjects (naked boys with crosses). Even for a lapsed Lutheran, that
nakedness was scandalous.

But what I noticed by that time, after having seen at least eighty
Sheikh Ibada fakes close up, was that the chisel marks on many of
these sculptures (no matter what their apparent date or function)
were made by the same chisel, at about 1.5 centimeters wide. Weird,
I thought. Though maybe not so weird. Plus, there was so much

screwy iconography (naked boys with crosses), no weathering, and no history before 1958. But Shiek Ibada had enthusiastic and smart defenders, including Klaus Wessel, and now, Victor Elbern.

Curator Elbern happened not to be around during my July 1977 visit. I was told that he went each year to a regenerative spa some place in Italy to enjoy the mud baths. So I sent him a letter a few weeks later with my thoughts. He responded quickly and with the authoritative Germanic voice of a scholar of high rank and keen sensibility—as one who was accustomed to being right and to being acknowledged as right. Elbern suggested that I should "be prepared to use more caution in defining a fake." And what did I care about this criticism? Not much.

So I unloaded on him in a second letter with a detailed condemnation of pretty much that entire Coptic room of his, including my measurements of the 1.5-centimeter chisel marks on his naked-boy sculptures. This time, in response, I got a scolding, which was my first but hardly my last for calling out fakes. Usually the scolding invoked the cautionary dictum of Max Friedlaender, the consummate connoisseur and the gentleman I was not. The idea according to Dr. Friedlaender was that it was a "mistake" to call a fake a genuine work of art, but it was a "sin" to call a genuine work a fake. And therefore I was obviously in the sinning business. This second time Elbern wrote back to me in German and quoted in the spirit, if not the voice of Max Friedlaender, an *amerikanischen Kollegen* who he said had recently written to him about the dangers of calling out fakes:

> *I feel very strongly that one has no right to label objects forgeries unless he has the right kind of proof. It is so easy to say an object is false, so hard to prove it, and so much harder to disprove it.*

So this unnamed American colleague of Victor Elbern's, and presumably of mine, was telling me to behave myself.

WHILE THIS SHEIKH IBADA DISPUTE with Berlin was simmering, my sleuthing of fakes got me into hot water much closer to home. It was the spring of 1981 and I was again on the staff of Dumbarton Oaks (after two years with Dominique de Menil), this time with an open-ended appointment as Associate for Byzantine Art Studies.

I had been called into the office of the Director, Giles Constable; I thought I had done a good thing, but I was expecting to be scolded, or worse. After all, when was the last time DO had been covered on the evening news? Back in May 1938 when Nadia Boulanger premiered Igor Stravinsky's *Dumbarton Oaks Concerto* in the Music Room? Or in October 1944 when the Great Powers, at the conclusion of the Dumbarton Oaks Conference, announced the formulation of the United Nations? The splash this time was nothing more than a passing micro-buzz in the local DC media market created by one of the tiny exhibitions I put together in the hallway outside the Music Room. The show was called *Questions of Authenticity Among the Arts of Byzantium,* which goes a long way toward explaining why I was in trouble.

My little forgery show included mostly mundane and ugly fakes that were, if not already familiar to those who followed such matters, easily and universally condemnable. This usually meant no controversy and no push back. But the very first work in the show was different. It was a marble relief sculpture showing the *Healing of the Blind Man,* which was believed to have come from Istanbul when it was acquired by DO in 1952. From the beginning, it was understood to be a fragment of a larger work—apparently an early Christian altar table, which are fairly common. At least that was the conclusion of Ernst Kitzinger, who had a major hand in its purchase, as he was then on the faculty of Dumbarton Oaks. Not only that, he had published the piece in a long article in 1960 in the *Dumbarton*

Oaks Papers and invoked it frequently to help demonstrate his thesis that there was a "renaissance" under the Theodosian Dynasty, around 400, when Christian artists working in the emerging world of Byzantium adopted classical figure style.

That all made sense to me until the morning of January 1, 1980. I was at home, hungover from the previous night's celebrations and unable to sleep, so I began reading term papers. Among the several things I did at DO that were counter to its culture (and in this case counter to its published Mission Statement, as articulated by Mildred Bliss herself) was to offer courses to undergraduates and graduate students at area colleges like Catholic University and Johns Hopkins. One of my students had chosen to write on the *Healing of the Blind Man* relief, which I welcomed, since there was something about it that just didn't seem right, but I couldn't put my finger on it.

The student wrote something in his paper that prompted me to look again at the lower edge of the sculpture. And, given the liberating power of a hangover, I saw something obvious and damning that I had never before seen—or at least had not recognized. The lower border has a simple bead decoration, which is fine. But the odd and condemning thing I finally noticed about those beads was that there is a large central bead with a cross on it, and precisely nine beads to the left and nine beads to the right. And at the far edges, left and right, the last of the nine in each direction is finished off completely with no hint of the beginning of a tenth bead.

Bingo! This means that this is *not* a fragment at all, but a complete and independent composition that was created to *look like* a fragment. Once I recognized this, it was obvious that the DO relief was a fake. This invited me to look for the models that the forger was copying, and I found them in short order in museums in Berlin and Istanbul. Clearly, I concluded, the *Healing of the Blind Man* relief is a modern pastiche.

I was really proud of that discovery and led off my little show with this work, and it was also the first work in the exhibition catalogue. Fine, but not so fine, and for two reasons. First of all, Ernst Kitzinger, the towering German-Jewish émigré medievalist and faculty member at Harvard, was the "symposiarch" of the DO Spring Symposium that year. And my little show would be up during the symposium, which would draw scholars from around the world with Ernst Kitzinger kicking things off at the podium in the Music Room. Everyone would see this little exhibition and read about the fake—about *his* fake. And most would likely know that Kitzinger had based his "Theodosian renaissance" idea in part on this single work. And now it was being labeled a fake by a junior, mostly unknown DO staffer.

This problem appeared to worsen after I heard about the whispers that circulated when the piece was bought in 1952—that it was thought back then by some to be modern, and quietly labeled "Kitzinger's fake." I learned this from KW, who for some reason was not so fond of Ernst Kitzinger.

But the second problem—the real problem—was what I learned about from Giles Constable that morning in his office: Ernst Kitzinger had threatened to withdraw from the upcoming Spring Symposium—from *his* symposium. That would be a scandal that would rank at or at least near the top of all scandals in the history of that ever-so-proper institution. And it would be my fault. (This made me think that I should have accepted the assistant professorship at Princeton that I had turned down six weeks earlier. I had turned it down because I was having too much fun at DO.) To my credit, I had written to Professor Kitzinger (whom I hardly knew) at Harvard with my conclusions some weeks earlier. And I had framed the catalogue entry on the *Healing of the Blind Man* as if my idea that it was fake was a hypothetical, a hypothetical that could explain the puzzling things about the work that were inconsistent with it being

an authentic fragment. Given Kitzinger's immensely good reputation (he was then 68) and with my relative lack of reputation (I was then 34), I figured that mine was the most at risk in this debate. But that's not how Ernst Kitzinger saw it. He paid a visit to Director Constable and laid it on the line. And then Giles called me in.

But what was to be done? Sure, I acknowledged that we had a problem—in fact, a big problem—and that if I did not exist, this problem would not exist either. But we couldn't put the genie back in the lamp. And in any event, it didn't seem fair to me, nor was it in harmony with the scholarly standards of Dumbarton Oaks, to suppress my discovery. But since I felt it was my job to be flexible, I suggested to Giles that I take the *Healing of the Blind Man* out of the show and that we "deep six" the catalogue—that is, put all the copies in a box in the basement and forget they ever existed. Or better yet, put them in the dumpster. But of course, it was not that simple. My disingenuous little plan put Constable and Kitzinger in the position of censors, and after all this is Harvard, and such things simply cannot happen at Harvard.

As the drama played out that day, we, Kitzinger and Vikan, agreed through the mediation of Giles Constable that we would respectfully agree to disagree about the authenticity of the now-notorious *Healing of the Blind Man* relief. And like gentlemen and scholars, we would meet privately to discuss the matter. This was Kitzinger's idea, and I liked it.

So we convened in the small study room in the basement of DO at the far end of the hallway on the left (the room where the coins and seals were then kept). Professor Kitzinger, who had arrived before me, was sitting at one of the desks, and I sat down in a chair to his right, near the door, which I closed. He turned toward me, but before he could say anything, he got a gushing nosebleed. The only good news was that Kitzinger was of a generation that carried a handkerchief, which, when employed, made it hard for me to hear

and understand him. But finally it was made clear: We should meet another time, he said. Of course, we never did.

IN TIME THE TRUTH USUALLY prevails. Since 1981, DO's *Healing of the Blind Man* relief has remained in deep storage. And as for that Sheikh Ibada dustup in Berlin in 1978, things turned out a bit differently. It was August 1983, just over five years after my scolding by Victor Elbern, when I received a letter from Hans-Georg Severin, who had taken over from Elbern at the Skulpturengalerie in Berlin. I had sort of lost interest in those naked boys with crosses by that time, but I did like what Severin had to say. He had found my letter of March 9, 1978, in the files of his predecessor "concerning the so-called Coptic sculptures in our museum." And he went on to say, in nearly flawless English, that "I am very glad to see that we are unanimous in all essential points." Bravo! And then he concluded by assuring me that all of those pieces of "Coptic" art in his galleries— all of those Hirshhorn look-alikes—"will be removed from the exhibition within the next few weeks, and will be published as forgeries, on the next occasion."

Chapter Five

Seduced by Saint Peter

I sensed right away that something was missing, but at first I couldn't identify what it was. Susan Boyd and I had been admitted to a secure transit warehouse in Amsterdam's Schiphol Airport and were staring down at an enormous Byzantine icon of Saint Peter lying flat on a large wooden packing table that bore the marks of many slashes of box cutters. Packers and airport security stood back silently so we could perform my examination. And yes, I had a feeling that something was off.

For a saint to be a saint in Byzantium, he must have a *vita* and an icon. His *vita* is his life story, which is typically an imaginative mix of fact and fiction authored by an acolyte. Its aim is to convince the faithful of the importance and healing power of the saint and, by extension, of his (or her) cult center or holy site—which would then become a destination for pilgrims and their votive gifts. The saint's icon, by contrast, is how we recognize what he looks like. And, while the saint's facial characteristics, clothing, and attributes (a book, a spear) remain constant, the material form of his icon can vary widely, from panel painting to ivory carving to cast bronze and to fresco or mosaic.

Those saints whose appearance was not recorded during their lifetime are usually known through the expediency of a dream apparition to an artist. The saint's image, for the first time then rendered

in art, would be confirmed again and again as his "true image" by the faithful who, having already seen the saint's icon, would inevitably see him with that same face in their own dreams. Finally, and most important for my story, the icon must be accompanied by the saint's written name, usually in the form of an inscription flanking his head that almost invariably employs the Greek epithet *Ho Hagios*. . . . ("The Holy . . ."). That inscription connects the saint through his portrait and *vita* with the supplicant as he or she engages in the act of veneration.

But something *was* wrong, something trivial to most people but for me profoundly disturbing: Saint Peter had no inscription—he had no name. At the time I could not account for this, but when I did figure out why the saint's inscription was absent more than six months later, this missing piece to the icon supplied a missing piece to my disturbing scenario of how this extraordinary work of sacred art came to be in Amsterdam.

It was the second week in October 1981, and I was on my way back to Dumbarton Oaks from the International Byzantine Congress in Vienna. I had presented a paper there on keys, seals, and weights in Byzantium, and curated a small exhibition in the Hofburg Palace on the same topic. Both were based on Dominique de Menil's collection of small bronzes that I had encountered more than four years earlier in Marvin Ross' bedroom. I had been asked by Director Giles Constable to change my return flight from Vienna so that I could visit this warehouse in the Amsterdam airport and examine this icon for possible purchase.

It was my first face-to-face encounter with Saint Peter. I was overwhelmed by the panel's size and by the power of its image, which seemed to capture the intensity and grittiness of this fisherman turned Disciple. It was as if Henry Adams were personally guiding me into Chartres. I recall being drawn especially to that explosive intersection between the eyes, offset by Peter's bristling

eyebrows, where his deeply furrowed brow intersects with his bulbous, seemingly muscular nose. I felt as if I were in the presence of the sacred, and at the same time invading this saint's privacy and dignity as I came eye-to-eye with him lying prostrate and helpless there on that packing table.

I had been introduced to this magnificent work two months earlier by way of a book illustration. I was then Associate for Byzantine Art Studies, a job that allowed me to do pretty much anything I wanted to do under the broad umbrella of Byzantium. This included writing articles and presenting scholarly papers, teaching local college students, curating small exhibitions, and, with the Curator of DO's Byzantine Collection, Susan Boyd, buying art.

Giles had called Sue and me into his office in August and placed before us a big, glossy catalogue published in Amsterdam in 1980 with this Saint Peter icon on its cover. Neither of us had ever seen this publication or knew of this icon, which was very disconcerting. As historians of Byzantine art and museum professionals, we should have been aware of everything out there in the trade of any significance, and this icon was clearly very significant.

The catalogue had been sent to Giles by John Langdon, an aspiring young Byzantine historian from Los Angeles, who had recently taken part in a National Endowment for the Humanities summer program at Dumbarton Oaks. John's story was strange but turned out to be true. The catalogue had come to his attention by way of his friend Basil Jenkins, who was then Director of the Fowler Museum at UCLA. Jenkins in turn had gotten it from a Dutch businessman named Dingeman Stoop, whom he had met shortly before by way an acquaintance, Louis Stoap (same name, Americanized spelling), who was Dingeman's brother and a businessman in the San Gabriel Valley.

Dingeman Stoop, who amassed a fortune in Starlift Elevators and was then President of the FC Amsterdam Soccer Club, had lent

money to a Dutch art dealer named Michel van Rijn and held his inventory of Byzantine art as collateral. The publication, edited by van Rijn with an essay by my Princeton professor, Kurt Weitzman, was both a document of that collateral and a sales catalogue. Apparently Stoop had become impatient with van Rijn and was looking to sell his whole inventory as a single lot. But we were told he was willing to peel off its star piece, the Saint Peter icon, and sell it by itself for something on the order of $300,000.

It was obvious in an instant, even from that small illustration, that this was not only a magnificent icon, on a par with the very best in the greatest repository of Byzantine icons in the world, the Monastery of Saint Catherine at Mount Sinai, it would be by far the most impressive icon in the Western Hemisphere if only Dumbarton Oaks could snag it—which the three of us immediately and passionately wanted. After all, Dumbarton Oaks' collection of Byzantine art, assembled from the '30s through the '60s by founders Robert and Mildred Bliss with advice from the leading Byzantinists of the time, was piece for piece the finest of its kind in the world. What it lacked was a large, commanding icon like this one. The kind that comes out of churches.

As I stood over Saint Peter on that packing table in Schiphol Airport I realized I had the opportunity of a lifetime to be part of the purchase of a work of art unparalleled in any museum in the United States. This may seem odd, given that icons lie at the very heart of the spiritual identity of Byzantium, as the convergence of that great empire's defining belief and its highest artistic achievement. And thousands of imposing medieval icons have survived to modern times. But there is a very good reason why big icons like Saint Peter are so rarely found in museums outside the Orthodox world. These are church icons as opposed to private icons.

The latter are small and portable, and over the centuries may have travelled with their owners far from the place they were made. Portable icons in ivory, enamel, semi-precious stone, and precious

metal have been sought by collectors for centuries and now form the core of the great museum collections of Byzantine art in the United States, England, France, and Germany.

By contrast, big icons painted on heavy wooden panels, like Saint Peter, were and are as much part of the fabric of the churches for which they were created as are the frescoes or mosaics on the walls—which are also extremely rare in museum collections of the West. Saint Peter and icons of its type were made specifically for the icon screen or *iconostasis* that sets off the altar and sanctuary from the laity in the nave.

Because of its large size (nearly three feet tall), we know that Saint Peter was part of the eye-level row of icons that flank the Holy Door to the altar and form a visual prayer of intercession (or *Deësis*). Christ, the Virgin Mary, and John the Baptist are at the center, moving outward to Peter and Paul and perhaps other Apostles and ending with the saint to which the church is dedicated. If the church is still standing—and hundreds are—the icon screen with its icons will likely still be in place. And if over time these icons become very dirty or are damaged, they will simply be repaired or painted over with another, similar image. Such icons were not intended to move, and they rarely did move.

It was becoming increasingly obvious to me why there are so few large icons like Saint Peter in museum collections outside the Orthodox world. And I was becoming ever more worried by the puzzle of how this great icon got from a church somewhere in the former Byzantine Empire to Amsterdam. It was clear from its style that this icon was painted during the late Byzantine period, likely around 1300, and that it probably came from a region of the depleted empire still active in creating such panels, most likely the area around Thessaloniki in northern Greece. For us, Saint Peter's size, quality, and rarity were both its attraction, and its liability. Where was this icon before 1980? How did it cross borders? Why was it unknown to us?

Curators live by the cautionary dictum that they buy the work of art and not the story, which for extraordinary and puzzling works like this Saint Peter icon is, as often as not, concocted by the seller. Insofar as we could determine, Saint Peter had *no* story before 1979, when it was exhibited in Delft, and, as shown in the 1980 Amsterdam catalogue, was associated with the Dutch art dealer Michel van Rijn. In 1989 Michel van Rijn would be identified in Federal District Court in Indianapolis as the agent for the sale of the stolen Byzantine mosaics from the Church of *Panagia* Kanakaria in northern Cyprus. In 1981, though, I had to base my judgment of Michel van Rijn mostly on my own experience two years earlier with his Dutch collaborator in art dealing, Robert Roozemond. Roozemond had come to Dumbarton Oaks with his stylish wife, Hetty, offering to sell two cut-out pages from a rare Byzantine manuscript that had disappeared a half-century earlier from Constantinople.

The two eagerly told me about Kesteel Wijenburg, the museum they ran in Echteld with Michel van Rijn, and about their ingenious business plan. Somewhere and somehow, not mentioned, they would get third-tier icons and small Byzantine artifacts like those in Marvin Ross' bedroom safe and sell them to Dutch "collectors." They would then pay young scholars like me to write an article on this newly sold merchandise, and that article would be printed in glossy color and slipped into an ever-growing "book" held together in a loose-leaf binder.

Once these minor works were published by the likes of me, they were not so minor anymore, and the collectors would then get wonderfully inflated appraisals for their collections from friendly appraisers and then suddenly turn into "donors" to Kasteel de Wijenburg. This was so that they could get hefty tax deductions and so that Roozemond and van Rijn could sell the works a second time at much higher prices. And Robert proudly told me it was completely legal within the Dutch tax code.

As we contemplated the Saint Peter purchase, we only knew this much for sure: The seller was a Dutch elevator builder who had no knowledge of and seemingly no concern about the origin of the collateral he was selling. He thus offered a "provenance firewall" for the *real* owner, Michel van Rijn, of whom we had good reason to be suspicious. The icon had turned up in Delft in 1979, but ultimately, we had to assume, it came out of a church in northern Greece or perhaps in the Macedonian part of (then) Yugoslavia just across the Greek border to the north. Naturally, we suspected this had happened fairly recently, as otherwise this magnificent icon would have already been known to us. The happy news—given our eagerness to buy—was that this border ambiguity allowed us to assume that Saint Peter could have come from either one of two countries and thus might not be claimed by either.

In any event, Dumbarton Oaks did what was then the honorable thing to do: It made "private inquiries" to Greek and Yugoslav officials and to scholars knowledgeable about icons and later Byzantine art. These communications, that were in fact certified letters, indicated our intention to buy unless the recipient could come up with evidence as to where, exactly, the icon had come from. (In the meantime, the purchase cash was kept in an escrow account and would be returned to Dumbarton Oaks if bad news was forthcoming.) Not only did no one come up with such evidence within the time limit stipulated in the letters, but the most admired of all Greek Byzantinists, Manolis Chatzidakis, blessed the purchase. This made sense, given that he had written the catalogue entry on Saint Peter for van Rijn's 1980 publication.

So the purchase went forward, with funds raised through the sale of a Matisse and a Picasso that were part of the Bliss family collection. Saint Peter was quietly put on display shortly before Thanksgiving in 1982, and in late December it received a celebratory notice in *The New York Times* ("Dumbarton Oaks Acquires Rare Icon")

with the writer noting, though, that "most of the details of the trans-action have been withheld . . . and no public announcement has been made of its acquisition."

The details of the purchase, such as we knew them, would con-tinue to be withheld beyond the reference to a "Dutch business-man." But I had some really big plans, at least by the standards of Dumbarton Oaks, for Saint Peter's coming out party in April 1983. I envisioned a highly selective exhibition of icons modeled on the thematic shows I had already organized at DO, beginning in 1979 with *Security in Byzantium*. There would be an elegant wine and cheese opening for scholars, collectors, dealers, and various VIPs of the sort that inaugurated *Illuminated Greek Manuscripts* at Princeton in 1973.

Kurt Weitmann would write a short book on our Saint Peter icon and give the opening lecture. There was then a buzz in the air surrounding all things connecting icons and Byzantium, fueled by an active collecting community and by the amazing coincidence that the British Museum was just then also buying its first large Byz-antine icon, that by an even more amazing coincidence happened also to be a Saint Peter of the late Byzantine period.

Everyone who we hoped would show up for our April 27th open-ing did, from as far away as London and San Francisco. It was an unusually warm and humid evening, and it was clear to me that there were different camps of dealers and collectors gathered with their drinks there in the magnificent gardens of Dumbarton Oaks who would not likely intersect socially closer to home.

And everyone was trying to avoid contact with that truly odd Russian, Vladimir Teteriatnikov, who, by virtue of being the hus-band of the head of photographic resources at Dumbarton Oaks, came down from his home in New York City for the festivities. The reason Teteriatnikov, who trained as a conservator in Moscow and worked for at time at the Tretyakov Gallery, was to be shunned was

that two years earlier he had privately published a book wherein he challenged the authenticity of many of the icons from the collection of George Hann, which was sold through Christie's in New York in 1980. There was nothing worse for the burgeoning icon trade than the uncertainty created by a seeming authority calling out as fakes the icons just sold from a high-profile collection.

In any event, the opening all went according to plan, and unlike my earlier exhibitions, this one got plenty of national attention, including a half page in *The New York Times* on Sunday, May 22nd by the newspaper's leading art critic, John Russell. He characterized this display of just twelve icons as "One of the more distinguished exhibitions of the year. . . ." What could be better?

In a word, plenty. Plenty could have been better. In the eighteen months since my introduction to the Saint Peter icon in the Amsterdam airport, I had experienced two unexpected and unwelcomed moments of insight, one relating to Saint Peter and the other relating to three of the icons I had chosen to exhibit in his honor.

And now, as I think back on the group of dealers and collectors gathered on the lawn at Dumbarton Oaks that evening, I'm pretty sure that at least a few of them knew what I by then had come to realize, and probably much more. The only hint, though, that something might be amiss was an off-hand comment from someone that evening whom I trusted that the icon collector from San Francisco was "playing it fast and loose." And then there was my brief encounter in the mail room earlier that week with a senior Byzantinist I very much admired, Speros Vryonis, who happened also to be a tough Greek-American from Memphis. According to Speros, "people like van Rijn eat people like you, Vikan, for breakfast." I had never heard that expression before.

Had Giles Constable been willing to commit $10,000 for my Saint Peter epiphany exhibition, permitting loans of icons from Greece, I may have remained in the dark much longer, but he did

not, and I'm pretty certain I never asked. Since there were very few Byzantine icons of any size to borrow from American museum collections, I looked for loans from among the main icon collectors in London and the United States through their dealers, taking care to avoid direct contact with either van Rijn or Roozemond.

I found, or rather was found by, the two leading London icon dealers of the day: the spiritual Zen one, Dick Temple of the Temple Gallery, whom I had met years earlier at Princeton when he came to solicit KW's opinion about an icon, and the suave Greek deal maker, Yanni Petsopoulos of AXIA Islamic and Byzantine Art. This was all great fun, since with the sale of the two large Saint Peters, icon dealing was hot, and both the dealers and the collectors they cultivated (who might themselves turn into dealers) were eager to befriend me and help in any way they could with my welcoming party for Saint Peter, at no cost.

One disturbing insight came quietly in the curatorial offices at Dumbarton Oaks, probably in late 1982 or early 1983, as I researched the icons I had already chosen for the show in order to write the labels. There were three icons in our selection of twelve—one then belonging to a dealer and the other two to a private collector—that, through a combination of stylistics and technical qualities, I suddenly realized were unmistakably from Cyprus.

Moreover, the dealer-owned icon was part of a group of at least six that I was certain all came from the same *iconostasis* somewhere on that island. And as for the other two Cypriot icons, I was convinced that they had specific links to a well-known Byzantine church in the village of Asinou. Although I was then not yet fully aware that the invasion of northern Cyprus by Turkish forces in the summer of 1974 had unleashed a wave of looting of Orthodox churches, that possibility had begun to enter my thinking.

The other disturbing insight came earlier, in the spring of 1982, when Susan Boyd and I flew to Boston with the Saint Peter icon to

have it examined in the conservation laboratory of Harvard University. (Dumbarton Oaks did not have its own lab, but rather depended on its parent university for expertise.) Saint Peter was placed on an easel in bright daylight and, for the first time since the previous October in the Amsterdam airport, I examined him up close. I was struck even more this time by the absence of an inscription, but this now suddenly made sense to me, as I examined the cracks in the paint layer in the area of the saint's hair. There are many cracks, in rows, and they are wide and go through the paint layer. This happens with the aging of any paint surface and with the flexing of the wooden support panel over time, especially with changes in temperature and humidity. And given that Saint Peter is seven hundred years old, this is hardly surprising, and in fact does not detract from the overall aesthetic impact of the piece.

But what seemed to me very odd was something that I had noticed earlier but had not understood: Those wide rows of aging cracks in the area of the hair were all filled in with what appeared to be a red sealing-wax-like substance. It was now obvious to me that this fill could only be understood as the residue of a painted overlay of the entire panel as if it were the silt left in gutters after a flood. So as I envisioned Saint Peter covered over with this red "stuff" and then cleaned, the absence of the saint's name finally made sense to me. As the red material was removed, not only did a residue remain in the cracks, the saint's name was removed in the cleaning process. This happened not because the conservator who did the work wanted to remove it but because it was impossible to save it, given that the letters were written over the hard, slick surface of the icon's gilded background.

This all suddenly made perfect sense to me, given that the British Museum Saint Peter, which was discovered on the back side of a 17th-century icon beneath a layer of whitewash and varnish, was also missing its name. Yet, there are several lines of surviving

Greek letters on the scroll the saint holds, precisely because they were added over a paint surface as opposed to the slick surface of the gilding. (By then I knew that both Saint Peters were cleaned and "un-named" by the same London conservator.) At last it was obvious to me not only why the Dumbarton Oaks Saint Peter had no name, but even more important why it had no history, and I now knew how it made its way undetected from the Balkans to Amsterdam. Like the British Museum Saint Peter, it was covered over with paint and thus remained invisible during its travels.

My initial response to this realization was positive—that is, until it occurred to me that there was a basic difference between the two over-painted Saint Peters. The one that the British Museum was about to buy had been drastically cut down and the nose of the saint was all but destroyed, which means that it was not devotionally functional. So it made perfect sense that it would be painted over and that a new icon would be painted on the panel's back side. The Dumbarton Oaks Saint Peter, by contrast, was in very good shape except for some minor damage to the areas around the saint's right hand. And there was no later icon painted on its back side. That means that by all appearances it was devotionally functional before it was covered over.

This likelihood raised two uncomfortable questions: Was the DO Saint Peter painted over not for religious purposes (to make a new icon) but rather for commercial gain to disguise its identity so that it could travel across borders and be sold with no history? And if that were true, maybe it was seen or even photographed *before* that over painting? What little I then knew of the Dutch dealing duo, Michel van Rijn and Robert Roozemond, suggested to me that commerce and not religion might be at work. And I was right. In his 1994 autobiography, *Hot Art, Cold Cash*, Michel van Rijn admits that indeed, he had the DO Saint Peter painted over to mask its identity and origin so that he could smuggle it out of Greece. Then

in the mid-90s, two Greek scholars, in publications devoted to the icons of the northern Greek city of Veroia, both claimed that the DO Saint Peter had been stolen from the Church of Saint Prokopios in that city in the late '60s or early '70s. (As of this writing, the outcome of these claims is still pending. In the meantime, that "fast and loose" icon collector from San Francisco returned six of his icons to Cyprus, amicably, in 2007.)

In the conservation lab at Harvard in the spring of 1982, I recall more a sense of excitement at solving the name puzzle than a sense of anxiety borne of that solution, namely, that Saint Peter made its way to the art market *incognito*. After all, in this case there was no connection to Cyprus; neither Greece nor Yugoslavia were then offering any evidence that Saint Peter had come from one of its churches, and the beloved Manolis Chatzidakis said DO should make the purchase. I then had only a vague sense that Michel van Rijn was the notorious character that I eventually discovered him to be. Also, I drew special comfort from the fact that many of the players on both the dealing and the collecting sides were not only sympathetic to the Orthodox cause; they were themselves Greeks.

Certainly, there was plenty of "gray" to this Saint Peter transaction, but I never felt it shaded to black. I never felt I was doing anything morally wrong, much less illegal. Nor did anyone around me in those days speak in those terms. And in any event, a more pressing issue was about to be sprung on me—one that would dwarf my concerns about Saint Peter's disguise and ultimately envelop this icon and its story in a much broader conspiracy of art theft and smuggling that would eventually bring me to the witness box of a federal trial in Indianapolis.

Chapter Six

"Call After Midnight, Paris Time"

Fast forward five years, from that April 1983 exhibition opening at Dumbarton Oaks to August 9, 1988. I had just come back from lunch to my office (I was now chief curator at the Walters) to discover two telephone messages: one from Souren Melikian, a columnist for the *International Herald Tribune*, whom I had met two years earlier, and the other from Dominique de Menil, with whom I had not spoken in more than five years.

Dominique's message let me know that the topic was "the frescoes." Of course, I called her first. Dominique told me a stirring tale of how frescoes depicting Christ in the dome and the Virgin Mary in the apse had been plundered from a chapel near the village of Lysi in northern Cyprus after the Turkish invasion of 1974 and cut into thirty-eight sections for piecemeal sale. She went on to say how in she had worked out a deal with the help of Yanni Petsopoulos to purchase the fresco fragments and restore them for eventual return to Cyprus, and how the restored frescos were now in her new museum in Houston, ready for the world to see.

Dominique recounted this amazing narrative as if she didn't know what we both knew: that I was well aware of almost all of

this, and that it was through me, five years earlier, that her cura-
tor had made the connection to Petsopoulos and the frescoes in the
first place. The only new information was that the reassembled fres-
coes had finally been shipped to Houston, and the Menil Founda-
tion had gone public in a press release issued the previous Sunday.
Dominique concluded by saying that I should expect a call from
Melikian; he would be doing a story for the *Herald Tribune* and she
suggested that he talk to me.

I recall feeling a certain bemusement at the role Dominique de
Menil had chosen for me, since there had never been any acknowl-
edged connection at the Menil Foundation between me and those
looted frescoes. I was also amused at the timing and targeting of the
press release, on a dead Sunday in the dead month of August. I soon
learned that advanced copies had gone to Melikian and Thomas
Hoving of *Connoisseur*, both highly respected and both, I assumed,
honored to get this exciting news before anyone else. Each might
otherwise have dug for dirt, but instead, both bought fully into
the spin of the Houston press release claiming this purchase-resto-
ration-repatriation scheme was a noble act of salvation. Everything,
I thought, was set up to achieve the desired outcome. And I assumed
that Dominique knew that Souren Melikian and Yanni Petsopou-
los were friends.

Did I want to be drawn into the story publicly, as a supposedly
neutral authority? Of course. It was, after all, the *International Herald
Tribune*, and I love to be quoted in the papers. So dutifully, I called
Melikian back and played my role as a "well-known Byzantinist"
in his celebratory front-page article of August 10th entitled "The
Rescue of a Byzantine Masterpiece." The foundation, I said, "did
the right thing." Then I went on to the point out the obvious, that
"rescue and restoration is very important." Yanni Petsopoulos
emerges in the story as the wise and selfless godfather of this benev-
olent act of salvation, while Dominique de Menil hovers above it all

as an ethereal, saintly force for good. This was more than Dominique could have dreamed.

And it wasn't over. Thomas Hoving, whose essay would appear under the "Ethics" banner in *Connoisseur*'s November issue, predicted that the scholars assembled at the Byzantine conference that month for the frescoes' unveiling "will no doubt praise the Menil Foundation for its historic recovery of raped and stolen art"—a recovery whose "key ingredient is absolute honesty." This was and remains the official version of the Lysi frescoes story. And it was repeated far and wide (*NPR, The New York Times*) in glowing terms when the frescoes were finally repatriated to Cyprus in the spring of 2012.

I am one of the few who knows the rest of the story.

THE LYSI FRESCO SAGA BEGAN for me, and for Dominique de Menil, more than five years earlier on Thursday, April, 28, 1983, the day after the opening of my icon exhibition at Dumbarton Oaks. Yanni Petsopoulos came to my office on the second floor of the DO mansion. He knocked, entered, closed the door behind him, and asked if I would hold in total confidence what he was about to show and tell me. I said "of course," without thinking—something I learned never to do again. Yanni then produced three things for me to look at. One was a crude sketch of what I took to be a Byzantine church, perhaps of the 13th or 14th century, set on what appeared to be a rock ledge, with a series of saints beneath arches carved in low relief against the cleft in the hillside to the left. The church seemed plausibly Byzantine but those relief figures did not; they were Romanesque in style, not Byzantine. Yanni told me that this church had been discovered accidently by workmen bulldozing the dirt from a hillside to build a youth hostel in the area of Binbirkilise in southeastern Turkey.

The idea of a church being dug up in a hillside of dirt seemed to me even stranger than those carved figures. But before I could process this information and respond, Yanni showed me two black and white photographs of Byzantine frescoes. One photo showed the apse of a church with the Virgin Mary flanked by two Archangels and the other the dome of a church with a large and powerful bust-length portrait of Christ surrounded by many small angels. This, he told me, was what the inside of that church-in-the-dirt looked like. And he drew my attention to the many "cut lines" on the two fresco photographs—the idea being that these frescoes had been (or were about to be) cut up. Implausible all around, I thought, but I didn't sense that Yanni was there to convince me of the veracity of the church in the Turkish hillside story, but rather to get me to do something.

Those lines, Yanni said, indicated the intention of the present "owner" to sell the frescoes in many small pieces to collectors across the globe. At that point, I envisioned two things: a shadowy figure with a rotary saw, and an apartment somewhere in Geneva or London with a single Byzantine fresco of an angel on the wall. Yanni said his mission was to save the frescoes. The sale of the entire ensemble, he assured me, would not be difficult nor would there be legal issues, since no one in governmental authority in Turkey was aware of this find and no one could ever know the history of the church, since, in effect, there was no history. There would only be a hole in the ground in a remote place, which soon would be covered over with a youth hostel.

So, what did this have to do with me? The answer was simple: Yanni could get to the person who now possessed these frescoes, who, I had to assume, was a Turkish construction boss of some sort or a developer (*if* his story were true). He said that he was confident that for $600,000 he could "rescue" the frescoes (no mention of the church) and get them to a safe place to be reassembled, so that

scholars could study them and the public enjoy them. Whether he asked me about Dumbarton Oaks taking on such a rescue action or not, I do not now remember, but I do recall saying immediately that DO could not get near these frescoes, given that no matter what the circumstances of discovery, this was a real church with real frescoes in a real place, and no public institution could get involved as the beneficiary of its recent desecration. The story would inevitably come out.

Even then I had a strong suspicion that Cyprus and not Turkey was where these frescoes had been, or perhaps still were. (What I thought at the time, and what would prove to be true, was that the youth hostel did not exist. Instead, the frescoes had been plundered from northern Cyprus after the 1974 Turkish invasion.) It was obvious to me that Yanni's rescue plan was a combination of public spiritedness (after all, he is Greek and a passionate connoisseur of all things Byzantine) and a dealer's self interest, since he would stand to make a lot of money brokering the rescue. But what worked so neatly for Petsopoulos seemed to me a practical and ethical hornet's nest for any institutional buyer.

After I told him no, that Dumbarton Oaks couldn't get near these frescoes, hostel or no hostel, it became pretty clear that he had another buyer in mind in the first place, namely Dominique de Menil. He had already sold Dominique an important Russian icon, and he knew that I had worked for her in the past. Yanni was probably also aware that I was the go-between for her purchase four years earlier of about two hundred small Byzantine bronzes from George Zacos, the legendary Greek dealer from Istanbul, for more than $200,000. Would Dominique de Menil step in and save these orphaned frescoes? My answer was the same: The Menil Foundation was soon to become a public museum with all the ethical and legal constraints that entails, and so it could never be part of a transaction to buy a Byzantine church interior, no matter how lofty the motive.

The conversation concluded, secrecy was reaffirmed, and Yanni left my office. End of story I thought.

TWO MONTHS LATER, I AND my family—Elana, Nicole, age 7, and Sonia, almost 3 years old—had just arrived at the Bemidji Regional Airport on Mesaba (Ojibwa for "Soaring Eagle") Airlines by way of a connection at the Minneapolis-St. Paul International Airport. It was a beautiful, clear evening in the fourth week in June when way up there in northern Minnesota, sunlight lingers until well after 10:00 p.m. All we could see from the windows of the fifteen-seat Beechcraft turboprop as it landed were pine trees. We had just arrived in that tiny bit of America that is neither east nor west of the Mississippi, but rather north of the Mississippi. Its headwaters, about twenty miles south and a bit west of Bemidji, are so shallow and narrow that tourists can skip across them on a few rocks.

We usually rented a car and drove the five hours from the Twin Cities to Fosston, my hometown. The urgency was a Vikan family reunion that was bringing the five Vikan children and their children together, seventeen of us in all, on the occasion of Fosston's centennial celebration. This is why my father, along with most of the men in town, had grown a beard, as the town's founders wore beards.

My father picked us up at the Bemidji airport. Almost immediately he presented me with a pink telephone message he had received at *The Towns* office that afternoon. I sensed he was proud of that message as a sign that his son was now an important person, since the call had come from someone in Paris. The Paris caller turned out to be Walter Hopps, whom Dominique de Menil had recently appointed to be the director of her planned museum in Houston. I had never met Walter, so I wondered how he got my father's phone number and, more than that, why he was in such a hurry to get in

touch from Paris. But what really puzzled me was Walter's message: "Call after midnight, Paris time." I didn't think that was good.

So I called Walter Hopps in Paris the next day, just after 5:00 p.m. Minnesota time, and sensing that something big might be afoot, I had pen and paper at hand, as I almost never did. Walter was waiting for my call, and it was immediately obvious that he was very angry. (Only later did I discover that anger was one of Walter's main communication tools.) He was speaking from Dominique de Menil's Paris apartment, and it was clear that this after-midnight appointment was chosen so that Walter would not be overheard. It seems he and Dominique had very recently been to Munich with Yanni Petsopoulos to see someone whom he identified only as a "Turk," who was selling those same frescoes that Yanni had shown me in secrecy in my Dumbarton Oaks office two months earlier. The frescos were cut up and dirty, but otherwise in good shape, Walter said.

The more Walter spoke, the angrier he got. He knew those cut-up Byzantine frescoes were trouble, but there was nothing he could do, because Dominique was "in love." I assumed that what just happened in Munich was a match for what happened four years earlier when Dominique and I visited George Zacos at his apartment in Basel, when she bought, it seemed to me on impulse, more than two hundred Byzantine bronzes that George had laid out on his living room carpet. And for Christmas presents to give to her children, she bought a half-dozen Byzantine ceramic bowls that were stacked in his basement storeroom.

Dominique de Menil was decisive and, yes, she was susceptible to art infatuation on short notice. The question of the provenance of the bronzes and bowls, which George was happy to share (the Marmara shore of Istanbul for the former and a shipwreck in the Aegean for the latter), meant nothing to Dominique, who seemed to be above such legal or ethical constraints. Now something similar

had happened, but with a much bigger treasure. Yanni had found his buyer.

So yes, I could imagine that Walter Hopps had a problem; there was, after all, a big difference between anonymous Byzantine bronzes and bowls at around $1,000 each and the $600,000 frescoed interior of a Byzantine church that would inevitably show up, denuded. Moreover, although Walter gave me a rehash of that odd story of the sands of Binbirkilise, I suspected he shared my assumption that the church would show up not in southeastern Turkey but in occupied Cyprus. But why was Walter Hoops angry at me? Because, in his opinion, this was all *my* fault. Walter's truncated accusatory narrative included something about the Menil Foundation's curator seeking out Yanni Petsopoulos and, through him, these cut-up frescoes *on my instruction*. And then Dominique, introduced to the works and the Petsopoulos mission to save them, was smitten.

Why had Walter concluded that I had played the role of cupid? I asked him, but it was clear his mind was made up. Moreover, he felt that since I had gotten him into this mess, it was my job to get him out. Despite being falsely accused, I gave Walter the best advice I could. I told him to assume the frescoes came from Cyprus. I told him that the offer on the table in April was $600,000; his silence at that point suggested to me that the price Dominique was quoted in Munich was much higher. Did they have legal counsel? The answer was yes; Walter had retained Herbert Brownell, Jr., legal advisor to the Met and former Attorney General in the Eisenhower Administration. He referenced an export license that had been shown to him in Munich that supposedly was issued by a Turkish official, and we spoke briefly about who in Cyprus, should that be the location of the plundered church, would have the authority to issue such a license.

Toward the end of the conversation, Walter mentioned a Turk named "Fuad" ("Big Fuad," I believe he said) with an umlauted last name. I took Fuad to be a second Turk present at the Munich

meeting, distinct from the seller. According to my notes, the year 1974 was mentioned within the context of something else Walter had seen that day in the Turk's apartment, namely a "Cypriot mosaic head" whose image Walter said had been published by Dumbarton Oaks—information that I assumed Petsopoulos supplied.

In fact, at the time I had no knowledge whatsoever of any Cypriot mosaic head (although in later years I would know it very well). Why did Walter tell me all of this? Did he think I would recognize Fuad's last name or recall that mosaic head? Or was he simply burdening me with the liability of knowledge he himself wished he did not have? Whatever his motive, the combination of a looted mosaic that might further connect me to players in this transaction, and the involvement of someone named Big Fuad, suddenly made me very nervous.

I made it clear that neither my name nor that of Harvard should be associated in any way with what I assumed was an all-but-done deal to buy the frescoes and ship them to Houston. I told Walter that he needed the advice of a respected museum director and I suggested Sherman Lee at the Cleveland Museum of Art. But no matter what Lee might say, he should do what Dumbarton Oaks had done with the magnificent Saint Peter icon we bought in 1982: Put the purchase funds in an escrow account and send registered letters with photographs to the embassies of all potential countries of origin. No bad news, and the funds are released to the Turk; bad news and they revert to Dominique de Menil. I do not recall now if we came to any resolution at the end of the call—or whether I thought Walter Hopps had come to see me as an ally and not as the villain. I remember very clearly, though, that I was rattled.

Nevertheless, when I hung up the phone and looked out again into the clear early summer air of Minnesota, I felt a sense of relief that all this was taking place half a world away and really had nothing to do with me. And as things unfolded that summer back in Dumbarton Oaks, I had good reason to believe that was true. It was

soon clear that Walter Hopps had decided to find out for himself where the Munich frescoes had originated. I knew that because a few weeks after the call to Paris, I saw his medieval curator, Bertrand Davezac, fishing around in the Dumbarton Oaks photo archive.

And I later heard from the head of the archive that the Menil Foundation had hired a graduate student from Georgetown University to do some research, which I assumed was their continuing effort to track down the violated church. This made perfect sense, given DO's long history of documenting the Byzantine monuments of Cyprus. So I figured that Walter was taking charge, he would figure things out, and I was effectively out of this mess. This gave me some comfort.

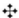

MY SENSE OF COMFORT LASTED FOUR MONTHS, until Monday, November 7th, which was a very bad day for me. I recall seeing a beautiful Bentley with the vanity plate "Stanley" parked just opposite the entrance to Dumbarton Oaks as I walked in to work that morning. It signaled that Dumbarton Oaks' lawyer, Bill Stanley, was on site. A short time later, as I was leading a women's group through the Byzantine galleries, the front desk security officer came to tell me that my boss, Giles Constable, wanted to see me in his office, immediately. The tour ended abruptly and, in a moment, I was sitting in Giles' rococo office under the somber gaze of William Stanley of Covington & Burling. The feeling in the room was cold.

Bill Stanley's narrative fit the mood. Dumbarton Oaks had been approached by the Embassy of Cyprus for some legal advice, which Giles was happy to extend through Covington & Burling, given DO's long and close association with Cyprus through various excavation and documentation projects. The embassy had received a registered letter, in August, from Herbert Brownell, Jr., of the New York firm of Lord, Day & Lord. It included photographs of

Byzantine frescoes that Brownell's unnamed client intended to purchase, subject to whatever evidence Cyprus could supply that the frescoes had been stolen from a church on the island.

I immediately understood this to mean two things: first, that the Menil Foundation sleuths, Bertrand Davezac and the Georgetown graduate student, had failed to find those Munich frescoes in the Dumbarton Oaks photo archive; and second, that Walter Hopps had followed my advice and, by way of Herbert Brownell, had sent registered letters with photographs of the frescoes to all potential countries of origin. (I found out later these included Bulgaria, Cyprus, Greece, Israel, Lebanon, Romania, Syria, Turkey, and Yugoslavia.) Cyprus responded with the claim that the frescoes had been stolen after 1974 from the Church of Saint Euphemianos just outside the village of Lysi, in the occupied northern sector of the country. The Embassy of Cyprus contacted Dumbarton Oaks for help, DO contacted Stanley, and Stanley and the Ambassador of Cyprus to the United States had met with Brownell.

I gathered pretty quickly from Bill Stanley's story that conversations were underway that might lead to some long-term loan agreement with eventual repatriation, and that Brownell had revealed his client to be the Menil Foundation. But they were now at an impasse over the embassy's demand that the Menil Foundation divulge the identity of the seller and the location of the frescoes, which Dominique refused to do. So then, as I understood it, Herbert Brownell let it be known to Bill Stanley that there was someone at Dumbarton Oaks who had special knowledge of the circumstances of those frescoes, and that someone was Gary Vikan. Giles, and now Bill Stanley, knew that I had worked for Dominique de Menil.

I was becoming increasingly anxious, especially when that tony lawyer declared that my Menil Foundation connection now "compromised" Dumbarton Oaks and Harvard, because it gave the appearance that they had somehow colluded in the deal. Bill Stanley

requested that we meet later that day at the offices of Covington & Burling on Pennsylvania Avenue near the White House, so that I could make a statement revealing, I assumed, what I had learned in confidence from Yanni Petsopoulos the previous April.

That afternoon, in a windowless Covington & Burling conference room, Bill Stanley, Giles Constable, and I were joined at an enormous table by a young lawyer with short blond hair, who was there with a legal pad to record what I had to say. No one seemed at all interested in where the frescoes were now. Perhaps they assumed I didn't know. And I suspected that Walter Hoops had kept our late-night phone call to himself, so I felt no need to go into anything about the Munich Turk, Big Fuad, and the mosaic head. I made it clear that I had been approached in confidence about these frescoes and for that reason had not said anything to Giles Constable about them; nor would I reveal the name of the person who approached me, whom I never understood to be the owner. The young blond guy said something about lawyer-client confidentiality, but that was meaningless to me, given that any action that might be taken by the Embassy of Cyprus on the basis of information I supplied would certainly come back to me. I had made a promise, and I intended to keep that promise—sort of.

I was set on protecting the actual name, Yanni Petsopoulos, but I had no compunctions about sharing what he had told me in my office in April. If they could come up with four from two plus two, that would be their ingenuity at work and not Vikan breaking his promise. So I explained that I was approached during the opening festivities surrounding our exhibition honoring the Saint Peter purchase by "a Greek dealer in Byzantine art working out of London." Now, while this almost certainly meant nothing to either Bill Stanley or Giles Constable, to anyone with any familiarity with the antiquities trade, only one person would qualify, namely, Yanni Petsopoulos. I told them about the sketch and photographs that this unnamed

person had shown me, about the story of Binbirkilise and how I
didn't believe it, and mentioned in passing that the frescoes were
said to be in Germany. I wondered as I spoke whether I learned
that from Yanni or from Walter. But no one seemed to care. All they
cared about was that unnamed name.

I had the feeling that I could be stuck there indefinitely until I
came up with a compromise: If *they* managed to discover the right
name themselves on the basis of what I had just told them, then I
would confirm that indeed that was the right name. As it turned out,
this little game took exactly two days. The embassy's first try was Con-
stantine Leventis, which was not a bad guess. Leventis was the Per-
manent Delegate to UNESCO from Cyprus and an active player in
the propaganda and lobbying campaign surrounding the plunder of
Christian sites in the Turkish sector of the island. And, as I would later
learn, in buying back looted Cypriot antiquities. I was told the Leven-
tis family made money selling Coca Cola to the Nigerians. Anyhow,
on day two the embassy came up with the winner, Yanni Petsopoulos.

After the law office rendezvous came the absolute low point of
the day, which was my audience with the Ambassador of Cyprus
in his embassy office on R Street. Why this was necessary I have
no idea, but feelings were running very high in the embassy. What
had been cold until now had suddenly turned hot, to the point that
the ambassador was shouting—not necessarily at me, but certainly
in my direction. The room was small and dark, and there was chil-
dren's art high up on the walls, all of which was devoted to showing
miserable Cypriot families being abused by the occupying Turkish
troops. The ambassador was seated behind his desk with his press
officer, Marios Evriviades, at his right, and I was on the other side
of the desk, with Giles and Bill Stanley to my right.

I was asked to repeat what I had said just a short time earlier in
the conference room of Covington & Burling. I do not recall that
the ambassador had any specific reaction to anything I said, but I

do remember vividly his rant against "Mrs. de Menil," which Giles, through his gestures and occasional grunts of affirmation, clearly endorsed. The words "severe" and "severely" punctuated the rant, with the former applied to what Mrs. de Menil had done and the latter to how she should be treated. The only specific accusation I recall, though, was that Mrs. de Menil was not only in cahoots with the Turkish looters, but she intended to keep the frescoes in Houston for at least fifteen years, while the ambassador thought that five years was more than enough. Here I piped up with two unsolicited comments: first, that Dominique de Menil was a profoundly spiritual woman and that she wanted to bring the glory and spirituality of Byzantine Orthodoxy to America; and second, that restoring these frescoes was going to take a long time and lots of money, and that would be an irrationally large investment to make if they would only be seen in America for five years. Eventually we left, with nothing resolved other than the guessing game.

SIX WEEKS LATER, ON CHRISTMAS Day, 1983, I decided to leave Dumbarton Oaks to become the chief curator at the Walters Art Gallery in Baltimore.* My Princeton graduate school friend and fellow medievalist, Bob Bergman, had been appointed Director of the Walters in 1981, and he was eager that I join him as chief curator. I was not at all keen on moving to Baltimore, but my relationship with Dumbarton Oaks, and specifically Giles Constable, had taken a nose dive, and that was not only because I had embarrassed Giles and his friend Bill Stanley in front of the Ambassador of Cyprus.

Giles had hatched a scheme to bring Wendell Phillips' large Sabean art collection to Dumbarton Oaks. He presented the idea to me that fall as a *fait accompli*, along with a complete redesign of the

* In 2000 we changed the name of the Walters from "Gallery" to "Museum," in order to more accurately reflect the wide range of its collections.

Dumbarton Oaks medieval galleries. Mostly, I was angry that Giles hadn't consulted me, but I was also irritated by the fact that Sabean (ancient south Arabian) art has virtually nothing to do with what Mr. and Mrs. Bliss had collected or with what scholars at Dumbarton Oaks studied. So I did what I thought was right: I wrote a long and detailed letter laying out my complaints to Derek Bok, the President of Harvard, with a copy to Dean Henry Rosovsky. (I got polite responses from both.) I have no idea whether either cared what Gary Vikan had to say, but the Wendell Phillips Collection never came to Dumbarton Oaks. This was good, but between my protest letter and my apparent role as Dominique de Menil's mole at DO, it was clear that my time with Harvard had come to an end.

What did I think I was getting myself into? I can't say I was optimistic. After ten years of working and socializing among the cultural and academic elite in Washington, DC, the prospect of moving to Baltimore was not at all appealing. Sure, I knew that the Walters had a spectacular collection—that it was an Art 101 kind of museum with nearly one of everything from ancient Egypt to Fabergé and that it was especially strong in my area, the Middle Ages. I also knew that it was the collecting legacy of a father and son team, William T. and Henry Walters, who made their fortune in the Atlantic Coast Line Railroad. I was aware that, like Dumbarton Oaks, the Isabella Stewart Gardner Museum in Boston, and the Frick Collection in New York, the Walters had a strong personal flavor, but unlike the others, it was encyclopedic in scope. Truly, "a little Met."

I also knew that unlike DO, the Walters is city-owned, relatively poor, and that it has a public mission. The Walters has always been beloved by collectors and scholars worldwide, and, most important, it was beloved by Kurt Weitzmann. KW assured me, as if this information had been delivered to him on Mount Sinai, that while the Met and the Morgan Library are wonderful places with great art, neither was a match for the combination of collections, curatorial

scholarship, and conservation research that historically defined the Walters. I never questioned KW's opinion, which probably explains why I remained at the Walters for twenty-eight years.

But what I knew and believed about the Walters in 1983 as I contemplated my move did not square with the museum I first encountered in March 1972. What prompted that visit was research for *Illuminated Greek Manuscripts*; thanks to KW's hype, I was so excited the night before that I couldn't sleep. So imagine my puzzlement: The Walters I found that day was a dump, and an empty dump at that. The galleries were dark and gloomy and seemed to be abnormally warm and damp. The parquet floors in the Old Master paintings galleries were raw and stained, with puddles here and there, the result of dripping condensation, I later learned, from the uninsulated roof. But it seemed to me at the time that maybe the Walters' night security was a pair of untrained German Shepherds. And the ambient lighting was greenish, because green corrugated fiberglass was then used to keep the harsh sunlight out.

While I stayed for an entire day, I can remember encountering only two people. One was the legendary Curator of Manuscripts, Ms. Dorothy Miner, then in her last year of life. Her domain was the ornate, warm, and woody old "Library," with its mezzanine of shelves that was accessed by a sliding ladder and served by a basket on a pulley (so as to safely lower books). The Library, with its priceless collection of illuminated manuscripts and rare books, was secured behind what seemed to me a golden chain, but was in fact, nothing more than a brass chain hung across its open door so that no visitors would wander in.

Ms. Miner, who wore a little fur hat, greeted me and a fellow KW student with great enthusiasm; she seemed to have all the time in the world for us. Ms. Miner was in a teaching mood, which I gathered was normal. We learned, among other things, why it was that so many Walters manuscripts had to be rebound. It seems that

Henry Walters' Paris dealer, Leon Gruel, knew that Henry was a man in a hurry. So Gruel would reorder the pages in his books, putting all the pictures at the front.

Those few hours in the library were magical. And as we left Ms. Miner's lair, we encountered the other person whom I recall sharing the museum with us that day. It was the venerable Mrs. Poe, a frail, elderly woman who sat alone behind a small, glass display case in the sculpture court. This was the Walters "store" at the time, and besides the beloved Walters Christmas cards, she offered a short list of old Walters publications. I bought an exhibition catalogue from 1947, I think for just $4.75. Mrs. Poe, I was told, had been with the Walters since it opened in 1934.

What made the Walters of 1983 different from the Walters of my first visit in 1972 was Bob Bergman, who was beginning to breathe new life into the museum and had boundless ambition for what he and I could do together. Only when I arrived and settled in, though, did I discover that the curatorial staff was in total disarray, the exhibition program all but non-existent, and the installations outdated and impenetrable, except to scholars. There was lots of work to do and not much money, but there was endless blue sky, and I was eager to get going. Plus, for the first time I had a staff—a good staff, but not yet a great staff. Things were different. My exhibition budgets at Dumbarton Oaks were typically around $5,000, and all I had to do was ask. By contrast, my first major Walters show cost $250,000, and I raised the money myself, which I much preferred. As it turned out, the change suited me.

DUMBARTON OAKS OR THE WALTERS, it made no difference: I could not shed those goddamn Lysi frescoes. It was near the end of March, 1984, and I was eagerly awaiting the feature story on my Walters appointment in *The Baltimore Sun*. In that same week,

though, two more important things happened. First, the beloved Colts abandoned Baltimore by surprise in the dark of night to move to Indianapolis, thus co-opting all local news coverage for days. And second, I was visited at Dumbarton Oaks by a mystery woman who had a letter for me. The courier was a very attractive blonde who identified herself as the wife of Yanni Petsopoulos. She held out a sealed envelope with my name and address on it, and the words "By Hand" underlined twice. Great, a letter from that "Greek dealer in Byzantine art working out London" whose secret identity I had divulged to Bill Stanley and the Cypriot ambassador, among others, just weeks earlier. This was a letter so secret and, I assumed, so laden with ugly and incriminating invectives against me that it could not be trusted to the Royal Mail.

Yanni's handwritten message, under his AXIA letterhead, was both to the point and elegantly obscure—in fact, so obscure that should this letter have fallen into unfriendly hands its meaning would likely not be understood. What a relief. This was not a diatribe but rather a good old-fashioned thank you note, with words at once vague and poetic:

> *Life is a series of accidents, some of which bring about remarkable results. Our meeting and discussion last spring was one such accident which brought about the most elegant and happy outcome, all around, to a very thorny problem.*

The "thorny problem" was of course the endangered frescoes, and the "happy outcome," I assumed, was some consummated version of a long-term loan and repatriation deal. As for "all around," I took that to mean that all parties benefitted from the deal, including Yanni and the Munich Turk, and in their case it involved money. And then suddenly, the remaining piece fell into place. I knew what that "accident" was. It was a *she*, and her name is Mary Jane Victor, Curator of Collections at the Menil Foundation. And I knew why Walter

Hoops was so angry at me over the phone that night in June, 1983. But I kept this to myself until the next time I saw Walter, which was almost five years later.

"I'LL RIP HER TONGUE OUT!" That was Walter talking—actually shouting—in reaction to what I had just told him during our first conversation since my midnight phone call to Paris in 1983. I was in Houston at the inaugural social gathering of the Byzantine Studies Conference, which had come to town to celebrate and explore the collection of Byzantine art that Dominique de Menil had recently put together. But mostly they came to see for the first time the restored frescoes, looted from the Church of Saint Euphemianos near Lysi.

Yanni Petsopoulos and the London icon crowd were in attendance, along with virtually all American Byzantinists. It was November 11, 1988, three months after the press release and the celebratory article on the fresco rescue by Souren Melikian. The group and the festive mood reminded me of the opening of my icon show at Dumbarton Oaks in 1983. But in the intervening years, I had lost all naivety in matters relating to the movement of Byzantine icons and frescoes across borders. Among those at the cocktail party was Larry Morocco, the conservator who headed the team that restored the frescoes over a period of almost four years in a specially built London studio. Delivered to Houston the previous spring, the thirty-eight fresco fragments that had been stored in crates in Munich were now, thanks to Morocco, assembled into an intact apse and an intact dome. Both were leaning against the wall in the gallery adjacent to Walter and me as we spoke.

What had set Walter Hopps off was my little narrative about the Lysi frescoes "accident." I told him that shortly after my secret April 1983 meeting with Yanni Petsopoulos, I received a catch-up-on-news

phone call from Mary Jane Victor. In the course of the conversation I mentioned a magnificent 14th-century icon of John the Baptist belonging to Yanni that I had seen in the New York penthouse of a major, though very discrete, collector of Byzantine art. Other icons in that penthouse were lent to the Dumbarton Oaks exhibition, but for some reason, Yanni would not lend this John the Baptist, which was the best of the lot. I told Mary Jane to tell Bertrand Davezac, Dominique's curator, to ask Yanni about this wonderful icon the next time he saw him, thinking that he just might be willing to sell it.

As it turned out, Bertrand stopped by to see Yanni in London a few weeks later, in early June, on his way to Paris to rendezvous with Walter and Dominique. His visit was motivated by what Mary Jane had passed on to him from me. Bertrand offered his recollections of that London encounter in a talk he delivered at the Menil Collection in November 1990. He spoke on that occasion about a "rumor" that he heard from Mary Jane involving a Byzantine work of art of "great significance" that had just emerged on the art market, and the person who knew about it was Yanni Petsopoulos.

Bertrand did not mention me as the origin of that information, but I'm certain Mary Jane named her source, which means that this hot tip came to Bertrand from me, with my endorsement. Did Bertrand muddle the details when he met with Yanni in London and forget that the important artwork in question was an icon? Or, more likely, did Mary Jane speak to Bertrand only in general terms, not mentioning the John the Baptist icon specifically? According to Bertrand, when he "inquired of Mr. Petsopoulos" about the mysterious masterpiece, Yanni's reacted this way:

> He looked at me inquisitively, unsure of what I was asking, and then suddenly realizing what it might be that I had heard of, searched for two photographs that he passed on to me.

The photographs presented by Yanni Petsopoulos to Bertrand Davezac that June day were not of the John the Baptist icon, but rather of the frescoes in Munich. Whether the "accident" was a mutual misunderstanding shared by Yanni and Bertrand, or whether Bertrand's general (confused?) inquiry allowed Yanni to substitute pictures of the frescoes when he must have guessed that it was the John the Baptist icon that I had endorsed, I do not know for sure. I suspect, though, that the latter was true, for why else would Yanni have characterized the chain of events as an "accident"? In any case, I am absolutely certain that Bertrand, though he chose not to mention it in his 1990 speech, knew that this tip about Yanni Petsopoulos having access to a masterpiece had come from Gary Vikan. And, of course, he had shared that information with his boss, Walter Hopps, who from that moment until our cocktail party conversation more than five years later was pissed off at me. And then, suddenly, his rage was redirected toward Mary Jane Victor, whom I then imagined I could see over his right shoulder, in the next room.

So that was the accident, or rather the misunderstanding, that led to the fateful meeting in Munich a few weeks later. Dominique must have been intrigued from the start, I'm certain both with the prospect of saving these frescoes from being dispersed and with bringing the art of Byzantine Orthodoxy to America. Walter knew that they represented trouble for his museum-in-the-making and for him as its director, but it was too late; Dominique had fallen in love. A thorny problem had been created by accident; Vikan had inadvertently engineered it, and so he was to blame. But in the end, this accident set off a chain of unanticipated events over which none among us was in full control—and that led to a most elegant and happy outcome.

Chapter Seven

Working the Numinous

With that hand-delivered note from Yanni Petsopoulos in March 1984, I figured that the Lysi frescoes problem had been solved or, at least, that I was out of the picture for good. The Lysi episode made me uncomfortable even to recall, so I forced it out of my head. But I always suspected that there was lingering, unpleasant chatter at Dumbarton Oaks, and among Byzantinists generally, that I had been involved with the Menil Foundation in something sinister and perhaps illegal.

In January 1985, I began my new life at the Walters Art Gallery as Assistant Director for Curatorial Affairs and Curator of Medieval Art, a position I held until I became the museum's director in the spring of 1994. For me, being a curator meant scholarly exhibitions with hefty catalogues. That is what I wanted to do, and I hired curators who wanted to do the same thing. I guess I had inherited that scholarly bias from Princeton and Kurt Weitzmann. But my year at the National Gallery in 1973–1974 had introduced me to the blockbuster exhibition showmanship of Carter Brown and his brilliant installation designer, Gil Ravenel. Each day for the last three months of my fellowship I had walked through *African Art and Motion* on the way to my green enamel cubicle in the mezzanine above the

Widener Room. I marveled at the way Ravenel brought individual works in the show to life with piped-in tribal music and videos showing dance rituals involving works like those on display. The powerful sense of place and intense visitor engagement he had created amazed me. The galleries were packed. And yes, the catalogue was hefty.

That was the kind of exhibition I wanted to do, but at Dumbarton Oaks it was impossible, mainly because my "gallery" consisted of three small wall cases in a hallway bathed in daylight. Videos, piped-in music, evocative wall colors, dramatic lighting, and stage sets—all those ingredients that defined the National Gallery blockbuster—were out of the question. The result was that my first exhibitions at DO were comically dense and insanely didactic. In those tiny wall cases I tried to tell enormously complex stories of Byzantine art and culture using little bitty objects that were mostly inherently ugly and all but impossible for normal people to see clearly, much less understand.

The scale and setting were very different in my first exhibition at the Walters, *Silver Treasure from Early Byzantium*, that opened in the spring of 1986. I borrowed from Gil Ravenel by building a miniature church in the gallery with an altar, columns, and arches, and I also created a video, shot on-site in Hagia Sophia in Istanbul, to introduce our visitors to Byzantium and its liturgical silver. The video's background music (Byzantine chant) spilled over into the galleries and created a wonderful effect. My little stage set was intended to evoke the church for which the silver treasure that was the subject of the show would have been created in the 6th century. Visitors seemed to like it, and it was celebrated by John Russell in an enthusiastic review in the *Times*. This was mostly an intellectual exercise, though, and I had no great hope that our plywood and Styrofoam church would achieve the magical aura of the sacred that Chartres had for Henry Adams and for me—much less, the intensity of audience engagement in *African Art and Motion*.

I did have some hope, though, for the power potential of the star of the show, the famous Antioch Chalice from the Met. A scholarly consultant had concluded that it was neither from Antioch nor a chalice; rather, it was very likely a lamp. While accepting this as true, I was also aware that since the '20s the Antioch Chalice has been believed by millions to be the outer casing of the Holy Grail, the cup from which Christ and his Disciples drank on the night of the Last Supper. It was also thought by some that the twelve little seated figures dispersed among its openwork vine decoration are accurate portraits of Christ and the Apostles. So I assumed there was a predisposition on the part of at least a segment of our potential audience to cling to this fantastic theory, and in doing so to inform a 6th-century lamp from northern Syria with the numinous potency of Jerusalem and Jesus.

Our description of the object made clear what I thought the object really was and when and where I believed it to have been made. But the text also told the tale of the Holy Grail. In addition, I placed this one work all by itself in the first large gallery, with sepia photo murals on the walls evoking the exotic feel of the Holy Land and ancient times, and took advantage of the spill-over of the Byzantine chant from the nearby video theater. I put the Antioch Chalice in a case that was taller than all the others in the show, which meant our visitors had to look up to see it. By doing all of this, I allowed for an ambiguity that let a sense of the divine creep in and, for some, flourish. I know it worked, because I recall the staff in silent awe as we installed the piece and how reluctant our art handlers were to touch it.

But my goal was to present the Byzantine icon, Byzantium's "theology in color." I felt its power potential in that small show I did at DO in 1983; I was certain that if I could somehow bring dozens of icons together and present them as Gil Ravenel would, I could create for our visitors a sense of being in the presence of the divine—a sense of the numinous.

My opportunity came with a call from Carter Brown of the National Gallery in September 1986. It seems that Melina Mercouri, who was then Greek Minister of Culture, was eager to send exhibitions abroad celebrating Hellenic culture. And she had offered two to Carter: one devoted to Byzantine icons and frescoes and the other to the human form in classical Greece. Carter chose the latter, and he was kind enough to think of me for the former. And as it turned out, the show on icons and frescoes would soon be in Florence at the Palazzo Strozzi, so I could go see it. There was an uneven mix of icons by quality and date in the Greek show, and some interesting frescoes, including parts of the interior of a real church, which could be reassembled to give the effect of a Byzantine church interior.

I concluded that this could be a wonderful exhibition for the Walters. Especially once I dressed it up by adding the DO Saint Peter and the other icons I had shown five years earlier, which were better than most of the panels that Greece had to offer. I partnered with a Washington, DC, exhibition circulating agency, wrote a successful National Endowment for the Humanities grant, and organized a national tour from Miami to San Francisco. With *Holy Image, Holy Space: Icons and Frescoes from Greece,* I was going to introduce the history, meaning, and power of the Byzantine icon to America. Of course, this meant a deep dive into the theology and ritual of the icon, with special emphasis on its role in the Byzantine church. My tools were primary sources of the Byzantine period and a seventeen-minute video I created called *The Icon,* which transported museum visitors back in time, into the Byzantine churches at Daphni and Hosios Loukas.

But beyond this didactic aim, and pretty much independent of it, I was going to load the show up with the numinous. I had come to the conclusion that a Byzantine icon, unlike a Byzantine silver chalice, could not be realized for what it was *without* the numinous.

To put it back in its church by reconstructing an icon screen comparable to the *Silver Treasure* church was fine, and I did that. However, the real story of the Byzantine icon is not how and where it is situated in a Byzantine church, but rather how it is understood as a vehicle for gaining access to the holy by the supplicants for whom it was created. It was, and is, an agent for engaging the divine—a door or window to heaven.

The critical ingredients for creating a sense of the divine in the galleries for *Holy Image, Holy Space* were wall color (a deep blue), ambient darkness, dramatic lighting, Byzantine chant (which again spilled over into the galleries from the video theater), and the positioning of the best of the individual icons in such a way that they would dominate and control the visitors' field of vision and thus command their emotions. (I was lucky to be working with a gifted contract designer who had trained at the National Gallery with Ravenel.)

What set the tone for the whole exhibition was my choice and placement of the very first work the visitors would encounter—an enormous, five-feet-tall icon titled *Christ the Wisdom of God* of the later 14th century. It is a big, powerful, and commanding version of the familiar image of Christ that traditionally appears in the central dome of Orthodox churches. It shows a bust-length Christ with an open Gospel book ("God's Wisdom") in one hand and the other hand raised in blessing. I wanted this icon to bring to life, to make real, for each visitor a compelling text from around the year 1200 that describes how a single icon of Christ, much like this one, could inspire very powerful but different emotions, depending on the psychological state of the viewer:

> *His eyes are joyful and welcoming to those who are not reproached by their conscience . . . but to those who are condemned by their own judgment, they are wrathful and hostile.*

To make certain that this icon would do its numinous work, I put it alone at the end of the long, dark entrance hall to the show. It was right in the middle of hall, positioned in such a way that it seemed there was no way to get around it and into the exhibition proper. Each visitor was forced to come straight at this great icon and stare back into Christ's enormous eyes. Only once arriving directly in front of it could they skirt it, at the last moment, and enter the first gallery.

My aim was to make clear that in this space, in this exhibition, Christ is in charge. And what's more, he knows what you're thinking. Michael Brenson, who characterized *Holy Image, Holy Space* as "a good and perhaps a great show" in his *Times* review, got it. His first four paragraphs, which flanked the large reproduction of the *Christ the Wisdom of God* icon, were devoted to how that icon worked in the show. He assumed that the congregation of the church for which it was created around 1400 "must have had absolute faith that this image in the front of the apse was a door or window to Christ." And he went on to complete the thought with precisely the affective, emotive outcome I was after: "Six hundred years later, on another continent, in a museum, the icon still seems like a medium, a passageway to another realm." Just what I had hoped for.

But what the reviewer criticized—what made this a good but not a great show in his view—was the tension between my academic labels and my theatrical installation. I felt (and feel) that the art history of a work must be told, and told accurately. So for Michel Brenson, and I'm certain for many visitors to *Holy Image, Holy Space,* there was a constant back and forth between a sense of transcendental rapture and lessons to instruct the viewer about the iconography and history of icons. I never could resolve that.

I PRESENTED THREE ICON EXHIBITIONS between 1988 and 1993, from Greece, Russia, and Ethiopia. Each was the first of its kind in America and, in all, they toured to eighteen cities from coast to coast and were seen by about half a million people. And in each, my aim was to create a sense of the divine for our visitors. The Met's great *Glory of Byzantium* exhibition of 1998 was far bigger than my three shows combined, and was seen by about half a million people in its single venue. It was a magnificent exhibition.

But I like to think that our efforts were complementary and that I somehow paved the way. In the end, over a ten-year period, the United States became well acquainted with the icon. This was long overdue for reasons I think have something to do with the spiritual power of icons and America's discomfort, both in academic circles and in daily life, with embracing an art form over which we simply cannot maintain critical disinterest. Despite its stylistic austerity, the icon is a hot medium and, to get it, you have to get hot with it. You have to take the icon on its own terms. So, bravo for us.

Celebratory reviews in *The New York Times* and lots of visitors are good signs. And all three of my icon shows got both. But Jeff Koons with his balloon dogs and David Hockney with his watercolors of Cornwall get that. And neither is in the business of working the numinous. How can you tell if you've captured the holy—the sense of profound affect that the object, the icon, can impart, but only when the viewer completes it?

I remember well a scrawny guy I took to be maybe 35, who had the thickest glasses I had ever seen. Truly like the bottoms of Coke bottles. And pretty soon, I was seeing this person in *Holy Image, Holy Space* every Wednesday, which was our free day. He had one of those collapsible chairs with three legs and a very small canvas seat that he brought with him. He behaved like a monk, but he was

dressed in street clothes. I never spoke to him. He parked himself in the same spot each time, in front of a two-sided icon showing an anxious-looking Virgin Mary with Christ Child on one side and the dead Christ, chest up, on the other. For me, and I guess for him, it is the greatest icon ever created. Powerful, beautiful, puzzling in its meaning, and, like all icons, anonymous. It is from Kastoria, in northern Greece, and dates around 1200. See this icon and you shall never forget it.

The show traveled to Miami and I went to give the opening lecture in an anonymous darkened hall downtown that was packed. As my eyes adjusted to the low light, I saw someone I sort of knew at the far right of the first row: Mr. Bottle-Glasses. I realized then that there is such a thing as an icon groupie.

Another person I know from the show is Frederica Mathewes-Green. Actually I learned about her because of it and met her later. Nowadays, she leads an Orthodox parish just south of Baltimore with her husband. Frederica started her life as a Catholic and later, through marriage, became an Episcopalian. And then she went to *Holy Image, Holy Space*. I still occasionally see her, and she tells me the same story each time.

It's the story of the impact on her of that very same Kastoria two-sided icon that Mr. Bottle-Glasses parked himself in front of each week. She, too, was profoundly moved. But in her case it took the form of precipitating her conversion to Orthodoxy, which she wrote about in a book called *Facing East: A Pilgrim's Journey into the Mysteries of Orthodoxy*. Those two people give anecdotal evidence that the divine was in the air for that show.

Holy Image, Holy Space opened on Sunday, August 21, 1988, and I knew immediately that I had found the numinous. First, there were the kisses on the Plexiglas of the cases. There were many kisses, and they had to be cleaned off constantly. But what really showed the power of this show was the report I got from the security staff on the

first day that by mid-afternoon our visitors were kissing the painted hand of Saint Francis. Now, to be clear, we ended the show with a few panels reputed to have been painted by Domenikos Theotoko- poulos, El Greco, while he was a young icon painter on the island of Crete. They were not great works, and not with all certainty by him, but they were very interesting and provocative. However, Henry Walters had bought a magnificent El Greco of his own, a canvas showing *The Stigmata of Saint Francis*. It is one of the stars of the museum's Renaissance gallery.

I decided to bring this painting down and include it in the show to remind our visitors what this Cretan icon painter turned out to be in later life. It was the only work in the exhibition not covered by Plexiglas. And to my knowledge, in the half century that the Wal- ters had been open to the public before *Holy Image, Holy Space*, no one had ever kissed this painting. But that day, it seems a lot of peo- ple were kissing this painting, which made no sense, given that Saint Francis is among the most nearly Catholic of Catholic saints and has no relationship whatsoever to Byzantium or Orthodoxy. But such is the power of the numinous. And I had nailed it.

There was poetry in the outcome of my quest to capture and work the numinous in the fact that *Gates of Mystery: The Art of Holy Russia*, which remains the finest Russian icon show ever to come to the US, found its home at the Princeton University Art Museum exactly twenty years after my 1973 Princeton exhibition of *Illu- minated Greek Manuscripts from American Collections*. (*Gates of Mystery* began its national tour in Baltimore in August 1992.) While this 1993 show was very large and prominently displayed upstairs, my earlier show was very small and hidden away downstairs. Almost no one came to that manuscript exhibition; this icon show, by con- trast, was the highest attended up to that point in the history of the museum. There was no review in 1973, but a "must-see exhibition," said Michael Kimmelman in *The New York Times* in 1993, under the

banner headline: "Opening the Gates of a Russian Mystery." Much of the difference in impact had to do with the difference between illuminated manuscripts, which are small, often badly damaged, and may not even have figural decoration—and icons, which typically are big, powerful, compelling, and focus on sacred faces.

But there is more nuance to what separated the dud from the blockbuster. In *Illuminated Greek Manuscripts* I was conveying information that was mostly the label's answer to the question: "When was this manuscript made?" I didn't even have much to say about the "where," other than that if the manuscript was beautiful, it must be Constantinople, and if it was ugly, it must be "provincial"—whatever that was supposed to mean. I almost never asked or attempted to answer questions about context of use, ritual, or belief. Instead, I offered information about *the thing*, the book, which was on the whole pretty accurate. But no one seemed to want that information. By contrast, in *Gates of Mystery* I was offering an *experience* of the thing, which put the emphasis on the visitor and on the impact of the icon encounter.

It was the kind of art that was on display and the experiential focus on the visitor that had changed. But as important as these was how the display was orchestrated. For *Gates of Mystery*, the numinous installation involved deep green walls, dramatic lighting, piped-in Russian chant, and as the star individual work we presented the great *plashchanitsa* ("burial shroud") of Jesus from Moscow, dated to the year 1592. At nine by six feet, it is an enormous damask, embroidered with silk, silver, and gilt threads, showing the dead Christ lying on the Slab of the Anointment with Saint John cradling his feet and a diminutive Virgin Mary cradling her dead son's enormous head. Angels with altar fans and mourning women are behind. And all the figures, in neutral tones, are set against a powerful Russian-red field.

We put the *plashchanitsa* in context, both for how physically it would have been encountered in a Russian church and for how, emotionally, it would have been received by its congregation. For the faithful, this is not simply a representation of the dead Christ; it *is* the dead Christ. And that collapse of art and the sacred, image and divine reality, is what I was trying to achieve for the visitors to the exhibition. Again, a reconstructed context (the sanctuary) and dramatic presentation enhanced with color, light, and sacred music were my tools. Michael Kimmelman, in the caption beneath the large reproduction of this work in his review, spoke of "a strangeness and melancholic silence." This, for me and for the exhibition's visitors, was the numinous. I had brought the icon into art museums on its own, numinous terms, and it was embraced by my audiences. It was embraced as well by the academic community, which now made icons a topic of critical research and scholarly conversation as never before.

When Byzantine icons are presented in traditionally antiseptic museum settings they lack that spiritual potency, at least for most people. I can say this from having watched visitors to *Heaven and Earth: Art of Byzantium from Greek Collections* in the National Gallery of Art in the spring and summer of 2014. The great icon of *Christ the Wisdom of God* and the magnificent two-sided icon with the dead Christ from Kastoria, the two stars of *Holy Image, Holy Space*, had paid a return visit to the United States after a quarter century. But this 2014 National Gallery installation was completely different from their showing at the Walters in 1988. Dry and lifeless, it was essentially a match for the installation of the Ashcan School paintings in the gallery opposite the exhibition's entrance. There was no drama, no spiritual rapture—and no kisses on the Plexiglas.

Chapter Eight

"I Loved to Fondle It"

Tuesday, August 16, 1988, was a day of high drama at the Walters. The following Saturday would be the festive members preview for my exhibition, *Holy Image, Holy Space: Icons and Frescoes from Greece.* Icons are extremely fragile, so their display cases must be specially constructed with silica gel hidden inside to mitigate fluctuations in relative humidity in order that the panel will not warp and the paint pop off. The cases have to be perfect. Forget that the Greek Air Force plane carrying those fragile icons out of Greece for the first time had arrived at Baltimore-Washington International Airport in the dead of the night after a day when the temperature reached 104 degrees and sat for hours on the tarmac without air conditioning.

Forget that the Greek conservators who accompanied those icons to America would smoke cigarettes as they worked over the icons and set their cups of coffee down on the paint surfaces—right on the faces of saints. Forget all of that brutal treatment; our display cases had to be perfect. Obviously this wasn't easy, which was why we were far behind with our installation schedule leading up to the members preview, just four days away. We were in over our heads, trying to do an exhibition that would be normal for the National

Gallery or the Philadelphia Museum of Art, but for the little Walters Art Gallery, it was on a scale that was new and daunting. Nerves were on edge and our installation crew of four were all straight-out angry, I assumed at me, since I was the one who inflicted *Holy Image, Holy Space* on them. So when they suddenly disappeared from the temporary exhibition space at about 4:00 p.m. that Tuesday, I concluded that they had just walked off the job.

But out of the corner of my eye I saw one of them disappear up the little winding stairway that led up from the armor gallery, about thirty feet from the entrance to the temporary exhibition space. I followed him and found that he was trailing the other three. The group was silent and serious, which convinced me I was right—they were really pissed off. I followed them up to the sculpture court of the palazzo, then up to the third floor medieval galleries, past the 19th-century and Asian galleries on the fourth floor, to the curatorial offices and library on the fifth floor. And finally, into to a conference room on that floor that we rarely used. Our director, Bob Bergman, was already there with the chief of security. They were sitting in silence at a long table with our chief registrar and our Curator of Asian Art, Hiram "Woody" Woodward, Jr.

All were ashen and the registrar looked as though she was about to cry. Someone had died, I thought. But this was not the tragedy that dismayed them. Apparently there had been a theft. A very big theft. At least three dozen pieces of Asian art could not be found, and among them, the famous *Peach Bloom Vase*, an astonishingly beautiful, slender copper-glaze Qing Dynasty porcelain vessel—famous and an iconic Walters' piece, ever since it was purchased by William T. Walters in 1886 for the spectacular sum of $18,000. (That would be about $450,000 today.) The auction catalogue noted that this vase had a "world-wide reputation of being the finest specimen of its class in existence."

There are only four places that a work of art can be in the Walters or, for that matter, in any museum at any given moment: on display in the public galleries, in storage, in the conservation lab, or in the photo studio. Things do move around, and in the days before computers, the paperwork was clumsy, so it was not unusual that a little bit of searching was necessary before a specific object could be tracked down.

It seems that Woody Woodward had arrived back at work after a three-week vacation in Maine and was giving a tour of the Asian galleries to a conservator from the Met. He went to the large display case where the *Peach Bloom Vase* had been shown for years, but there was no vase. Nor, strangely, was there any hint that anything was missing from the case. Everything seemed perfect, and all the little paper labels were in place, but no *Peach Bloom Vase*. The case seemed "lean"—with fewer works of art in it than normal, yet they were all perfectly and elegantly arranged.

A quick trip to the conservation lab revealed that the *Peach Bloom Vase* was not there. Then a run down to the newly renovated storage space at the street level of the palazzo: no trace of the *Peach Bloom Vase*. By this time it was late morning. The chief registrar was called, the Asian galleries were searched, the card file with those objects on public display was checked, and then checked again. By the later afternoon the AWOL *Peach Bloom Vase* was now in the company of three dozen other missing works of art, all Asian and all from the same fourth-floor galleries. Bob Bergman and the chief of security were now part of the frantic search, and soon Bob called in the installation team, whom, he once told me, he trusted most among all the Walters staff. And there I was, trailing after them.

The heist was very sophisticated, for sure. And I'm certain that I was not the only one who thought of *The Pink Panther* and someone playing the part of the white-gloved Phantom, David Niven.

We could imagine the clever thief coming across the Peabody Mews alley behind the Walters from the roof of the Engineering Society building just opposite on a taut steel wire secured with a huge hook. He would have entered the museum through one of its fifth-floor windows (how did he get the window open from the outside?) or maybe by way of the fourth-floor skylights (was a pane missing?). This must be the work of a real professional, and certainly someone working for a rich, discreet, and discerning client far away, which in those days meant Japan. Was this the end of the *Peach Bloom Vase* for the Walters and for Baltimore? Had it already gone underground? How long had it been gone? Our best guess was that it was still in its case on July 22nd, when Woody went off to Maine. But how much longer? We had no idea.

Clearly, this was a job for the FBI. And it turned out that they would have a lot of other art to track down. Within the next 48 hours the tally had reached more than 130 works, including some jewelry from the ancient galleries on the second floor, a pair of dueling pistols, a fancy dagger, and a few early American rifles from the armor gallery. How did the thief get them out of the museum? How long did it take?

But at that moment, waiting for the FBI, we all wondered what was to be done. We were pumped up with adrenaline and we were all profoundly fearful, and we just needed to do something positive. So, we said, let's have a look at the scene of the crime, the Asian galleries, one floor below the conference room. We went down the fire stairs in silence.

What followed was both astounding and comical, for being absurd—absurd at our expense. The display case that was missing the *Peach Bloom Vase* was designed and built in the early '70s by a local Baltimore fabricator with a national museum clientele named Helmut Guenschel. Made to be abutted against a wall, this particular Guenschel case was low and rectangular, with a large

glass front panel and glass side panels, shiny brass fittings, and a rich walnut-veneer base. It was much more sophisticated and vastly more expensive than the simple plywood and Plexiglas cases we made in-house. A set of such cases had been commissioned for the installation of the brutalist-style wing added to the Walters in 1974. These Guenschel cases had little locks built into the brass fittings that secured the large glass front panel in place, and the only way that a glass panel could come off was if two strong people, working together and using big rubber suction cups affixed to the glass itself, unlocked the two locks and slowly drew the sheet of glass forward and then lowered it to the floor.

The comically absurd part of this unfolding drama was what we now discovered, and should have known, about the case's design: from above, it had virtually no security. There was a hinged ¼-inch plywood top held down with wing nuts, and below that, the guts of the case: a plywood platform with a rack of florescent lights and below that a plastic waffle grid to diffuse the light. The panel with the lights could be easily lifted, and the waffle grid was secured only with screws. So what did we see? It didn't appear as though the waffle grid had been unscrewed and lifted, but there was a 8 × 10-inch section of that grid that had been cut out, obviously to give access to the art below, and then glued to a piece of Plexiglas so that it could be set back in place, undetected. And that was UV Plexiglas, I noticed. Odd.

Very, very clever, we all thought. And how agile this thief was. With just that little rectangular hole in the waffle grid he was able to reach down, somehow, to snatch the *Peach Bloom Vase* and its label, and then rearrange all the other Chinese works to fill the void, and their labels, too, so that the installed case looked perfect. Wow! And since no one's arm could possibly be long enough to reach all the way down from that opening to the bottom of the case, there must have been some sort of mechanical pincer or tweezers brought into

play. And the thief must have the hand-eye coordination of a brain surgeon to be able to pick up, move, and rearrange the little labels, which were, in those days, smaller than a credit card and typed on thin stationary stock. It was hard enough to pick up those flimsy little things with your fingers.

This was definitely the work of a real pro. And now the *Peach Bloom Vase* was gone, off to or already in Japan. We were all thinking, but not saying, that we must be the dumbest bunch of museum staff in the world. What will the newspapers say? And what will the *Holy Image, Holy Space* Greeks back in Athens say? (We had been dealing directly with the Minister of Culture, Melina Mercouri, and with her look-alike but bearded brother, Spyros.) We knew we had to tell them, and we did. I don't recall that they had much to say. I took this to be an indication of what Greek museums were like at the time.

Because we were told by the registrar that some Chinese snuff bottles were missing, we made our way, a dozen of us, all in a daze, over to that area of the Asian galleries where we displayed our Chinese snuff bottles. They were in a tall, narrow, 19th-century glass and brass case that was elegant and beautiful, but very inefficient. The case had adjustable glass shelves, all ¼-inch thick, and there were about a half-dozen such shelves. Snuff bottles have small bases, so they must be held down with bits of wax. So each level of the case had to be installed separately, back to front, since only the front panel of glass could be swung open. And it was very tricky and tedious work, because you could easily knock over a snuff bottle or even a whole shelf of snuff bottles.

Like the much larger Guenschel case that had been the home to the *Peach Bloom Vase*, this smaller and older case looked perfect. We pondered this together, silently, focusing our collective intelligence on something we know nothing about: art theft. There were no graduate seminars on this topic at Princeton, where Bob and I

had met two decades earlier. As we were all just standing there look-
ing at these twenty or so snuff bottles, I noticed what seemed to be
a pile of sawdust at my feet. It was an odd little pile, and it seemed
to be shiny. So I licked my finger and daubed some up, and ouch:
fine metal shavings.

The door on that snuff bottle case had a little square bronze
handle next to the lock; it was beautifully made. I reached over and
pulled on that bronze handle and the door opened. Yikes! The ¼ ×
¼-inch brass bolt that had secured the front glass panel of the case
had been sawn through. That simple. So there was someone with
time, who was gifted with mechanical things, and who was very
smart. And someone who had access. Just maybe, I began to think,
that someone had even considered the vacation schedule of Woody
Woodward, and how no one else but Woody might miss the *Peach
Bloom Vase* and the rest of the pieces. An inside job, perhaps. Some-
one we knew. This was a novel and very disturbing epiphany that I
suspect others in our anxious little group experienced at some point
that Tuesday afternoon, but none among us mentioned it since, after
all, that someone could be one of *us*.

The next several days were a cascading public relations disas-
ter for the Walters. The tone was set at Thursday's press conference
announcing the news, where Bob Bergman was at once defensive
and combative and pretty much bereft of good answers to any num-
ber of questions. How many works of art were stolen? We *think* 81
works were stolen, but the inventory is on-going. (The real number
turned out to be 145.) What is the approximate value of the works
stolen, we asked, and we understood from Larry Leeson, spokesman
for the Baltimore City Police, that it "could reach $1 million." To
which Director Bergman responded "that's not our guess." Guess?
(It was at least $1 million, and Bob was guessing $500,000.)

When were the works taken? Sometime between July 22nd
and August 13th, the dates that our Curator of Asian Art was on

vacation. But how is it possible for the famous *Peach Bloom Vase* to be gone from its display case in a public gallery that is supposedly monitored daily by your security guards and, presumably, by other museum personnel, for as long as three weeks and no one noticed that it was gone? This time the answer came back from the Walters head of PR, Howard White. The cases, he said, were "rearranged" to make the theft less noticeable. So what is that supposed to mean, that it was an inside job by someone with museum skills who was monitoring the vacation plans of the Asian curator?

Bob Bergman's answer to the inside job question pretty much summed things up. He said, simply: "I have no idea." Bob's claim was that any explanation (and there was none) from the director would "compromise" the investigation. This did not go over at all well with the *Baltimore Sun* arts reporter, John Dorsey, and in fact was not the truth. The truth was, none of us had any idea what was going on. So we got what we deserved. A cartoon in the *Sun* captured our profound ineptitude in the most painful way. It showed the Walters director putting the key to the museum's huge bronze doors under the front doormat.

But we had other, bigger problems inside the museum's walls. The FBI had swept in and was conducting interviews and giving lie detector tests to staff members, seemingly at random. At the same time, I think we had all come to the conclusion—as had John Dorsey—that it *was* an inside job. And I think I was not the only one who had a single obvious candidate, namely, the head of night security, Greg Bartgis. Not only did Greg have private and leisurely access all night long to the whole museum, he was gifted with his hands. (He had started at the Walters eighteen months earlier as a contract employee who retrofitted cases in the woodshop.) And Greg was straight-out weird, and you knew that in an instant.

He had an odd outfit that was his uniform, insofar as he wore it every day that summer, no matter what the weather. (Of course,

he also had a guard's uniform that he had to wear on the job.) He wore big, heavy workers' boots, cut-off jeans, and a greenish T-shirt (or sometimes, no shirt at all). At age 30, Greg was living with his parents in Govans, a neighborhood near the north edge of Baltimore, about four miles from the museum. And he was a compulsive walker, so you would see Greg—everyone would see Greg—in that uniform of his walking along York Road to and from the Walters, and well beyond, I was told, since he walked as much as twenty-five miles a day. He was a camera nut, so swinging from his neck on any given day on any given walk might be two or more cameras. And Greg always carried a backpack with who knows what in it.

Greg was also odd socially. He was the kind of person that I recall from college who knew a vast amount of what seemed to be worthless information. Like the total number of kilometers of such and such gauge of railroad track in Russia before the Bolshevik Revolution. Greg knew that kind of stuff, seemingly volumes of it, and he would make it a point to corner you someplace around the museum and inflict yet another Bartgis monologue on you, totally oblivious to the fact that he was getting no verbal reaction or even gestures of acknowledgment. But Greg was clearly smart, and such people were hard to find and keep on our night security staff. So over a remarkably short period, just nine months, he was promoted to head of night security, a position in which he was pretty much all by himself with no one to talk at. (There was a second guard on duty that summer with Greg, who was totally the opposite of him, not so bright and all but mute. He was fired a few years later for falling asleep on the job.)

From the beginning of this painful misadventure, I kept two images simultaneously in my mind. One was of someone like the white-glove Phantom, the suave David Niven, and other was of the weird Greg Bartgis. And the clincher for my Bartgis theory was that piece of Plexiglas that was glued to the rectangle of light-diffusing waffle grid that the thief had cut out of the Guenschel case we

examined together that first afternoon. That was not ordinary Plexiglas, it was ultraviolet-reducing Plexiglas, the kind that museums use to keep framed works on paper from fading through exposure to daylight. I was certain that piece of Plexiglas came out of our woodshop, and I knew that Greg had access to our woodshop because he would still help out there from time to time.

But if we were right and if it was an inside job, and if it was Greg Bartigs, as I'm certain many of us came to believe, why had he not been arrested? And more to the point, why was he still on duty every night, alone, in those same Asian art galleries? And why were we being given the lie detector tests? So yes, let's say it was an inside job, but maybe not Bartgis. Or maybe Bartgis working with someone else. But then, with whom? It was Friday, three days after we had discovered the theft. The tally of the loss was now up to 130 works, and still rising. We were being beaten up in the press and laughed at. Our minds were racing, we were paranoid, and conspiracy theories were being conjured up and shared—which was a very bad idea. To be above suspicion you needed to be dumb or rich. Otherwise it was open season for us all, on us all.

One leading candidate for the inside thief who was not Greg Bartgis was a sweetheart of a man named Ted Theodore. Ted was a contract employee that summer helping us get ready for *Holy Image, Holy Space*. And he was perfect for the job. Not only was Ted a skilled conservator, with lots of experience restoring icons, he was Greek-American, which meant that he could reign in, in their own language, those cigarette-smoking Greek conservators. So why was Ted a leading suspect in some of our feverish minds? For three reasons: one, he carried a backpack (which was then unusual); two, he wore the same clothes two days in a row and hadn't shaved (which suggested he stayed overnight in the museum); and three, Ted had been working on contract at the Walters in 1974 when the Asian galleries were being installed. (I wore the same clothes for two days

and didn't shave and asked if anyone noticed anything interesting about me; nobody did.)

Ted took his polygraph test on Friday morning, and I can still see him as he walked into the exhibition space afterwards (was he told he failed?). Ted was shaking, dripping sweat as if he had just gotten out of the shower with all his clothes on, and he had suddenly acquired a stutter he didn't have before. Did I—did anyone—give Ted a hug? I don't know if I even shook his hand, though I never bought into the theory that he was the thief. That was the strange and frightening mood at the time. It filled the entire museum and we were all in its grip.

As for me? A person whom I took to be an FBI agent poked his head into my office, probably that Thursday, and said he would be back. But he never came back. This puzzled me, given that the Asian curator, the chief registrar, the installation crew, and Ted Theodore all worked for me, as initially did Greg. And I was one of only a handful of staff that had access to the key vault, which is where all the keys to all the exhibition cases were kept. I was disappointed. But then, I had rented a house for a week in Rehoboth on the Delaware shore for the Vikan family, and after the opening of *Holy Image, Holy Space* that Saturday I was gone and was following the case in *The Baltimore Sun*.

Strangely, no one called me to give me the news when the case was broken on Tuesday, August 23rd, a week after the theft was discovered. I read all about it in Thursday's paper, which I got out of one of those yellow boxes on the boardwalk. The headline read: "Walters guard held in theft of 145 objects." And the subhead continued: "$100,000 bail set for night shift chief; 84 books also taken." So it was Greg Bartgis after all. We were all sort of right from the beginning. And it seems that the FBI was on to him from the beginning, too.

This is how it spun out after I took off for the beach. Tuesday was the all-staff picnic, and Bartgis played volleyball that day opposite

Bergman. Then he was called in by the FBI for his third interview, and this time, they "went downtown." A few hours later Greg confessed. It was the evening of Tuesday, August 23rd. Now, said the FBI, it is time to visit your house in Govans. The local TV stations picked up the Baltimore police radio squawking, and they were on their way. And in the meantime they got in touch with Director Bergman, who in turn got hold of two of his four trusted installation guys. So they converged on Rosebank Avenue in Govans with enormous klieg lights illuminating this tiny, dark block. There were cop cars and TV crews all around. And at that moment (as he recalls it), Ted Theodore, who happened to live on that very street just opposite Greg's mother, turned the corner toward home; that was the nature of this bizarre ordeal for him.

The group converged with 145 Walters works of art in the basement of Greg Bartgis's mother's house on Rosebank. Nearly everything was there and intact in newspaper wrapping. Almost all the works were Asian. But there were nine ancient gold pieces, rings and such, that Greg had melted into an ugly blob. Why? Because he needed cash to get out of the country, a country he had never left before and from which he had no passport. And those dueling pistols and the rifles? In case the escape idea didn't work, he was going to kill himself. Forget the fact that these museum weapons didn't have any bullets.

The news conference was the next day, Wednesday, with the regional manager of our insurer, Lloyds of London, at the podium (he had offered a reward of $100,000 for what he estimated to be a $1 million claim). The insurance loss was $100,000 for that melted blob of gold and the museum's loss, the deductible, was $25,000. Greg was looking at fifteen years for a single felony count, and his bail was set at $100,000, which after two weeks his mother covered with the title to her Govans house. Greg's judge was John Prevas, a Greek-American of old Baltimore lineage and generally a tough guy in court.

No one doubted the story that came from both Greg and his mother—that he had been brutally abused by his father. And as Judge Prevas believed, Greg would die in jail by his own hand. So the deal, which to many of us at the time seemed like cheating, was time served (just two weeks) plus seven weeks of house arrest in a half-way house, plus community service with a local nonprofit. It involved door-knocking around town all day, perfect for a walker. Greg had to pay off that $25,000 deductible to the Walters. What was supposed to happen in five years took fifteen years. But it did happen. In the meantime, Greg Bartgis was "banned" from the Walters, whatever that means. And so when he suggested to the museum's ex-Marine head of operations that he come back on staff in order to efficiently pay off his debt, he was sent on his way.

END OF STORY? SORT OF. We beefed up security on the Guenschel cases, for a while took pictures of the case installations, and, most important, we eventually installed video cameras in nearly every gallery. That not only put an end to thievery, which was very rare, but also to staff-driven vandalism, which up until that time was surprisingly common. Then in July 2014, after twenty-six years, I looked up Greg Bartgis on the Internet. It turns out he lives half a mile from me, and his email address indicates his talents and profession: "gregthemachinist." Among other things, Greg helps fancy eye surgeons at Johns Hopkins design precise cameras to photograph the retinas of frogs. So I got in touch, and we shared a glass of wine on a beautiful sunny July afternoon in Charles Village. Greg was then 57 and looked older, but I recognized him immediately. He has no front teeth from an accident some time ago and long, scraggly, brownish-gray hair bound in a tangled ponytail, and he wore a slightly tamed version of his 1988 uniform. But he was still the Greg I knew: a

smart guy, an articulate guy, a compulsive guy, and a guy still totally enraptured with Asian art.

I learned that Greg Bartgis, with no professional help and no ameliorative medications, understands himself to be not only afflicted with OCD (Obsessive-Compulsive Disorder) but also with Bipolar II Disorder. And I think he's probably right. The events of the summer of 1988 at the Walters are unique in Greg's life—no stealing of any sort before or since. The problem, as Greg recounts it, was being alone all night and not being able to sleep during the day. He got on a bad mood swing. And yes, he did love Asian art and yes, he did pay attention to Woody Woodward's vacation schedule.

His first theft was unplanned and occurred in late July shortly after Woody left on vacation. It comprised four Chinese jades taken from a Guenschel case. And he was all but caught by the guard with whom he worked the night shift. Greg had the jades on a tray and was carrying them down from the fourth floor toward the wood shop on the first floor to wrap them when he met his coworker coming up the stairs. "Woody asked me to take them to photography," is what Greg said, and it worked. The other security guard seemed not to consider this an odd task at 2:00 a.m.

And so it continued, for more than two weeks. He started by cutting bolts, but realizing that one of those now boltless glass fronts just might fall off one day, Greg got into waffle grid cutting. Amazingly, he did reach all the way down to snatch the *Peach Bloom Vase*. That, he said, was among the last cases he violated. Greg carried all the loot out himself, mostly in his backpack. As for the rifle, the one with which he might shoot himself, he built a long travel box out of scrap wood, with a void in the middle, and put the rifle in there. He took it out past Walters security and walked four miles home with it over his shoulder.

Greg says he was almost caught a second time, by the guard who manned the security desk at the loading dock where the staff

left, and their bags and purses were (in theory at least) probed. It seems that on that particular morning Greg had really packed his backpack to the top with Chinese porcelains wrapped in newspaper. And suddenly there was this security-desk guard poking around in his wrapped-up booty. But then the guard said fine, be on your way. After all, Greg was head of night security. Greg claimed he had stopped stealing a week or so before Woody came back, and he said he understood his own sickness at the time. He wasn't sleeping, he wasn't talking to anyone, and he got really excited when he stole Asian things. A real high.

Greg knew he was going to be caught, and he wanted to get caught. The sheer volume of the works he was taking and the notoriety of the *Peach Bloom Vase* guaranteed that. And when he was caught, he would get those ammo-less pistols and blow his brains out. But if he was not caught, which on some level he thought might be the outcome, he would use that glob of gold to get out of the country and build a Chinese-style hut somewhere in South America. (I saw his rendering of that hut, with a deep porch and a wide bench for relaxing, which was straight out of a Chinese ink painting.) Greg would then enjoy the *Peach Bloom Vase* in perpetuity, all by himself.

But Woody came back and the FBI showed up. And then the raid occurred with his mom thinking her son was being framed. "So, Greg, why did you do it?" I asked. The answer was simple, crisp, and as fresh, twenty-six years after the fact, as if it had just popped into his head. He said he would go down into his parent's basement where he stored the loot (the guns were in the rafters), unwrap a piece, and then he would hold it because he "just loved to fondle it." I thought of Dominique de Menil, who "fell in love" with the looted Lysi frescoes. And I recalled a passage in Dan Hofstadter's book, *Goldberg's Angel*, where Michel van Rijn describes his reaction upon receiving the Dumbarton Oaks Saint Peter icon from a Greek thief:

I asked him if I was able to sleep with it in my room for a night—one must sleep with the things one loves, no?

I'm pretty certain that each of the acquirers-of-things-stolen shares that same infatuation, the same compulsion. And perhaps I shared Michel van Rijn's infatuation with Saint Peter, and maybe that's why when I was in the conservation lab at Harvard and figured out that Peter had been painted over and that the place he was stolen from was untraceable, I was happy. I felt he now seemed to belong to me. But why is it that some of us get caught and some do not? Maybe it's because some among us get to set the rules we play by—and the others do not.

Chapter Nine

"All the Red Flags Are Up"

T he next chapter in my saga of things sacred and stolen began in the third week in April 1989 when I received a hand-delivered envelope at the Walters with a story clipped from the March 31st edition of *The Indianapolis Star.* Cyprus was now taking legal action in Indianapolis to force the return of four Byzantine mosaics looted from Kanakaria, which had been confiscated by the court and were secured in the basement vault of a local bank. There was to be a trial. In a second article on April 9th, Walter Hopps, now Director of the Menil Collection and a perceived expert in repatriation because of his role with the Lysi frescoes, expressed high-minded notions about stolen art that must be returned. This piety seemed odd to me, given the nature of our midnight telephone conversation of June 1983 when he went into some detail about the Kanakaria Apostle mosaic he had just seen in the Munich apartment of a Turk and then, insofar as I knew, did nothing. But then, of course, neither did I.

Accompanying the newspaper clippings was a letter from Thomas Starnes of Manatt, Phelps, Rothenberg, & Phillips, a law firm on New Hampshire Avenue in Washington, DC. The letter asked whether I would consider being an expert witness for Cyprus at the upcoming trial and urged me to give him a call, which I did,

though I had no idea what an expert witness was. My phone conversation with Starnes left me with the impression that neither he nor any other lawyer in his firm had any idea what was going on. I gathered that they were retained by the Embassy of Cyprus to handle routine legal matters that any embassy would encounter from week-to-week. And now there was this big trial coming up centered on looted Byzantine mosaics, and they were scrambling to catch up on Byzantine history, Byzantine mosaics, the theology of icons, and cultural property law.

This is what I learned. The plaintiff was the Autocephalous Greek-Orthodox Church of Cyprus and the Republic of Cyprus. It was a civil action to be heard before Judge James Noland in the United States District Court for the Southern District of Indiana. The complaint was filed in March to force a local art dealer named Peg Goldberg of Goldberg & Feldman Fine Arts, Inc. to return to Cyprus four mosaic fragments from the Church of *Panagia* ("All Holy") Kanakaria in the little town of Lythrankomi in the occupied northern sector of the island. These included two Apostles in roundels, the upper part of an Archangel, and the head and upper torso of a youthful Christ.

I knew that these four fragments were part of the larger group of looted mosaics that also included the Apostle's head that Walter Hopps and Dominique de Menil had seen in June 1983 in the Munich apartment of the "Turk." This was the one Walter dutifully told me about in our late-night conversation, noting that a photograph of it *in situ* had been published by Dumbarton Oaks. All of this is to say that the saga that began in August 1981 with the Dumbarton Oaks Saint Peter icon appearing on the cover of Michel van Rijn's catalogue, and that then transitioned in April 1983 to the situation of the Lysi frescoes during my confidential meeting with Yanni Petsopoulos, had now moved into its third climactic chapter: the Kanakaria mosaics. And I was still at the center of the action.

My job, as I initially understood it, was to show up in Indianapolis for what Starnes said would be just one day, and tell the presiding judge what Byzantium was, what church mosaics were, and how really important these mosaic fragments happen to be, given how few of such things have survived. It sounded interesting. And I thought that this would put a gloss of high-mindedness on my mostly troubling history with the Dumbarton Oaks Saint Peter icon and the Lysi frescoes. Sure, DO had gotten a green light for the icon from Manolis Chatzidakis and yes, Dominique de Menil's "savior-scenario" news release on the Lysi frescoes the previous August had been all but universally hailed for its courage and honesty—but neither felt right. So here, by happy accident, was a case where we seemed to have an obvious culprit in Peg Goldberg, and a good chance in court to force the return of stolen art to its rightful owner. That is, those poor Cypriot Greeks whose forlorn faces I could still see in my mind's eye in the children's art high on the walls of the office of the Ambassador of Cyprus. So sure, Mr. Starnes, I'll do it, but first I need to make one phone call.

That evening I called Walter Hopps at his home in Houston. Given his accusatory tone during our June 1983 phone call and his spitting-mad "I'll rip her tongue out" dictum during our cocktail party conversation in his museum the previous November, I thought I should check in and take his temperature on this expert witness idea. But mainly my concern centered on that midnight phone call that I assumed no one other than Walter and I knew about. Should details of that conversation (the mosaic head) come out under oath, it could leave us all—Vikan and Hopps, Dominique, the Menil Foundation, and Cyprus—immensely compromised. Should I be worried, I asked him? Walter said I should go ahead, things would be okay, and that it was the right thing to do. This was certainly good to hear. I felt Walter and I were finally on the same team.

By the best of luck, I sat next to a lawyer friend at a Walters dinner a day or two later, and was given the chance to find out what

being an expert witness was all about. In fact, I was really a witness to nothing, which made me different from someone called to court to testify about a traffic accident that he may have seen. Rather, I was an expert, and all I needed to do was to say things revealing of my expertise that would help frame the issue for its general importance and knit together the real testimony of others. All of this would be to help the judge form his opinion. This should be pretty easy, I thought, and this lawyer friend told me I would get paid. Get paid! How much would be normal, I asked, and she said perhaps $100 or $150 per hour, and that would include time on the phone. I figured that since I was a beginner at this, $100 would do just fine, and I told Mr. Starnes so.

My official letter of appointment arrived at my house via FedEx on April 21st. With it came a stack of background papers as well as two surprises. The first was that I was to testify not only to the historical and religious importance of the Kanakaria mosaics, but was to offer my expert opinion on the question of due diligence. Specifically, was Cyprus sufficiently diligent in getting the message out that the Kanakaria mosaics had been stolen? And then in actively seeking their return? I thought I could testify affirmatively to that since I recalled conversations at Dumbarton Oaks in the early '80s about this theft driven by various antiquities officials from Cyprus.

And if asked whether Peg Goldberg had been sufficiently diligent in seeking to discover whether these mosaics had been stolen, this would be even easier since I had walked the due diligence walk twice in recent years, once with the Dumbarton Oaks Saint Peter icon and the other time over the phone with Walter about the Lysi frescoes. I knew the drill, and from what I already knew about Peg Goldberg, I was pretty certain that she was anything but diligent in her investigations of the origins of the mosaics.

The second surprise was the very big size of that FedEx box that was filled with various legal background papers on the case.

And I was going to get paid to read them: five hours meant $500. That sure beat preparing lectures on Byzantine art for adults in my Smithsonian Resident Associates' classes at $55 a shot.

I was flying high that spring. Not only did I have this expert witness gig, I had just been retained by a Greek PR firm to provide a series of radio and television interviews in and around San Francisco to help promote *Holy Image, Holy Space*, which was opening at the Legion of Honor there on April 25th. I was staying at the grand old St. Francis Hotel on Union Square and was being driven from interview to interview in a sports car by an attractive Greek-American woman.

The opening festivities were wonderful. All the rich Greeks of San Francisco were there on a beautiful, very warm spring evening, with the ladies in their minks. I took the red-eye flight home the Friday after the opening and, as the taxi pulled up at my house, I saw that the FedEx van was already there. For me, I asked? Yes, and the guy in the uniform started to unload box after box of depositions. I'm rich I thought, and how lucky I'm a slow reader. It was about that time that I bought a red Acura Integra, and later that summer we had the house painted. The stack was as tall as I am. And only later, during the trial, did I learn that among all the lawyers of the four firms involved in the trial, two for the plaintiff and two for the defense, not one needed to read all the depositions. I was the only person whose job it was to read *everything*. Time was short, the trial was pressing, and all the high-paid legal talent was assigned to their individual segments of those boxes. But not me.

ON MAY 26TH, A FRIDAY, I was in New York and on the clock. I was there with one of the DC lawyers whom I didn't know very well named Tom Kline, who soon became my hero. We were in the

Solow Building, that modernist skyscraper from the '70s with a slop-
ing base just south of the Plaza Hotel, on a very high floor looking
out a huge north window in the direction of New Jersey. (New York
in general and buildings like this particular one were very hard for
me in those days, as I had a profound elevator phobia.) I was stand-
ing next to Tom Kline's father, a lawyer who had a huge office on
that floor, and he was pointing in the hazy distance toward where he
lived in what I assumed was a big fancy house. Tom was about my
age, and I learned that after graduating from Columbia he went to
teach in an inner-city school. That, I truly admired. So when Tom
disappeared around the corner for a second, I asked his father if this
Kanakaria thing was a big deal, and his answer was immediate and
surprised me: "It's the case of a lifetime."

As it turned out, this case of a lifetime was intense for the legal
teams to an extent I did not initially understand. A few among them
on both sides totally wilted under the pressure to prepare and per-
form. I recall specifically a handsome, very suave lawyer in the Indi-
anapolis firm retained by Cyprus. He was the lead guy one morning
of the trial and he did poorly. He kind of stuttered and wandered. I
don't recall why I was in his office over the lunch break, but there I
was. He was greenish-gray and slumped in his chair. I thought he was
going to be sick. The reason I recount this is that during this trial I
witnessed a kind of metaphor of life, fast and in real time: the pres-
sure of it, and people who rise and people who fall. Tom rose, and
maybe that's why, in that photo in *The Saturday Evening Post* article
on the trial, he is seated at the center of the legal team, and he alone
among them all is looking into the camera and seems totally assured.

Tom loves cookies, and there were warm chocolate chip cook-
ies in the kitchenette next to his father's office. So he had a few, and
then next to the cookie table he flexed his legs like he was going to
do the high jump or pole vault. Tom was wired, and for good rea-
son. We were in town to depose André Emmerich in a conference

room not far away on the Upper East Side. Emmerich had been retained by Peg Goldberg as her expert witness, but unlike me, he was not going to Indianapolis nor did he read any depositions. At that point he was in his mid-60s, elegant, articulate, and refined. André Emmerich was the third generation of a German-Jewish art-dealing family and had fled the Nazis via Amsterdam with his parents in 1940. There we were, a kid lawyer and a kid Byzantinist, hoping that somehow we could make this truly great dealer in all things from Morris Louis and David Hockney to Aztec stone gods flub up—but of course, we could not. For a while that day, André Emmerich just made me feel sort of small.

André Emmerich's position on the movement of cultural property—which is invoked among collectors and dealers to this day—was well known and simple and seemed to suit Peg Goldberg's situation perfectly. He believed in the free market, which meant that antiquities, wherever they might turn up, should go to the highest bidder since that would guarantee that they would be valued and cared for. This was the whole point, and it made sense. He was going to be videotaped saying more or less that for his presentation at the trial, and lawyers for the plaintiff had the right to be present and ask questions.

I recall his hypothetical very clearly. It involved a Greek guy who was digging a ditch and found an ancient sculpture. Now, if this find is not his to keep or sell, but rather is illegal for him just to possess, he may think it is more trouble than it's worth and destroy it. But if it legally belongs to him, he will care for it and, depending on its quality, the sculpture will eventually find its way to its appropriate rung on the free-market ladder of value. About that time a spectacular Cycladic head sold at auction in New York for more than $2 million and, of course, I assumed some Greek guy on the island of Paros had been digging a ditch.

Tom and I felt pretty good about ourselves when we left the deposition, not because we had made André Emmerich say something

wrong, but because what he said right was so at odds with the facts and the spirit of the Indianapolis trial. Those mosaics did not come up by chance in a ditch; they came off the walls of an important historical monument that had been photographed and studied in depth. Simply stated, they were stolen property, not so different from a painting that someone might take off the wall of a museum. We were pretty jolly as we set off down Madison Avenue. I was trying to coax Tom into a stop at the Oak Room of the Plaza Hotel for a beer, but he would have none of that. The cookies and the deposition had him all wound up, and he just wanted to walk and walk. Fine. Then it occurred to me that Tom might be ready for a life lesson, like when my father took me to the stockyards in Omaha to show me where T-bone steaks come from. So I directed him toward Ariadne Galleries on the corner of Madison and 76th with the promise that I had something interesting to show him. Torkom Demirjian, who claimed to have been in the Armenian Orthodox priesthood once upon a time, ran Ariadne, and he was always great fun to visit. Not only did he have some of the best antiquities for sale—he told great stories.

When we were buzzed in I asked his very smart scholar-assistant if we could go downstairs and look around. She said that was fine since she knew me. We sat for a while alone in that darkened little gallery looking at a glass display case every bit as finely made and lit as anything at the Met. It had a few really big Greek export vases, the kind that are immediately identifiable as coming from southern Italy and specifically Apulia. Literally tons of such pots were coming out of Italy in those days and I knew Torkom had some of the best. After we sat there in silence for a while, I pointed at the base of one of the pots and asked Tom what that was. Dirt he said—like fresh dirt. And I said: "Tom, where do you think that dirt comes from?" No reply. He didn't get it, he told me, until much later: Beef cattle don't die of old age in Omaha, and Greek pots aren't dug up on the Upper East Side.

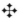

I was wearing the T-shirt that the DC lawyers had sent me with a picture of the Kanakaria Archangel and the words: "Kanakaria Mosaics—Recovery Mission—Indianapolis 1989." I arrived in the later afternoon of Monday, May 29th; the trial was set to begin the next day, and I figured I'd be there through Friday, which I was. I picked up my red Celica convertible, drove to the Hilton just off Monument Circle and opposite the Federal District Court House, and then stopped at the bar before our scheduled recovery-mission team meeting at the First National Bank of Indianapolis. In those days I had a modified buzz cut and was really skinny, and so I looked like a small-town Minnesota version of David Bowie. And I was wearing jeans. I can still see the face of that stuffy-looking Cypriot official who saw me as I got off the elevator, like he wanted a BB gun for Christmas and got a sweater instead. It was obvious that he thought my looks didn't measure up either to "eminent Byzantinist" or "expert" in anything.

The morning of the first day was all about those pesky lawyers for the Turkish Republic of Northern Cyprus who came to claim the Kanakaria mosaics as their property. But they were sent on their way in short order by Judge Noland for one simple and uncontestable reason. The Turkish Republic of Northern Cyprus is recognized by no government in the world other than that of Turkey. This meant that it had no standing in US Federal Court to press its disingenuous case for the return of stolen art that we all knew it was complicit, on some level, in stealing.

The facts of the case as presented later that day were not much in doubt. Peg Goldberg, a small-time dealer in mostly modern art from suburban Indianapolis—that really big and boney blond woman sitting just in front of me—had gone to Amsterdam at the end of June in 1988 to check out a Modigliani nude on behalf of a

Japanese client who wanted to buy one. Had the deal gone through, it would have been her biggest to date by far. Peg met up there with her sometimes Indianapolis partner, Robert Fitzgerald, who had in tow his nattily dressed California lawyer, Ronald Faulk.

Bob Fitzgerald was in those days a handsome, husky guy with bushy white hair who had many ingenious ways of making money, inside and outside the art world, and an amazing menu of aliases, including Bob Jones. The Fitzgerald scheme that stuck in my head I learned about in a two-part article on the trial in *The New Yorker* by Dan Hofstadter, and it had to do with ocelots, which are "dwarf leopards," and Las Vegas. Bob Fitzgerald's idea, that apparently worked, was to parade these exotic cats through the gaming halls of the casinos late at night. And sure enough, some pretty blonde on a rich someone's arm would coo, and that rich someone would be engaged by Bob in conversation that would lead to the sale of the ocelot. Bob took care to give his phone number because he knew that when the couple had sobered up and the cat had chewed up the sofa in their room and pissed on the carpet they would want to give it back—so Bob could sell it again. Very clever.

Peg had a cash commitment from her banker friend and neighbor, Otto "Nick" Frenzel III, Chairman of the Board of his family-owned Merchants National Bank. And so she could have closed the Modigliani deal on the spot, with Frenzel's backing, at £3 million. The trouble was it was obvious to her and to Bob that the Modigliani was not a Modigliani. So there they were, on Friday, July 1st, flush with cash and consoling themselves at the outdoor café of the Amsterdam Marriott Hotel, just a few blocks west of the Rijksmuseum. Who should show up just then but Bob Fitzgerald's old friend Michel van Rijn—a descendent, he claimed to Peg, of Rubens on his mother's side and Rembrandt on his father's side.

After introductions and Michel's cautionary aside that he had been falsely convicted in France of having forged Chagall's signature

on some prints, he pulled out black and white photographs of the four Kanakaria mosaic fragments now in the Indianapolis bank vault. It seems that their owner, a Turkish "archaeologist" living in Munich named Aydin Dikmen, had stomach cancer and was now forced to sell. (Dikmen, of course, was the same person who was the un-named "Turk" of my midnight conversation with Hopps in June 1983 regarding the Lysi frescoes.) The mosaics had been found in the "rubble" of an important early Byzantine church on the island of Cyprus, a church that was now "extinct." It had been studied and published by Dumbarton Oaks, and this official Turkish archaeologist, Aydin Dikmen, had all the appropriate export papers. As her story goes, Peg immediately "fell in love"—I guess sort of like Dominique de Menil fell in love five years earlier when Yanni Petsopoulos showed her photographs of the Lysi frescoes.

The game was afoot and proceeded with lightning speed. By the following Thursday, the four Kanakaria mosaics and $1.2 million in cash had changed hands. The plan was that Goldberg and Fitzgerald would go to the free port of the Geneva airport to meet Dikmen and examine the mosaics close up. The deal for $1,080,000 was drafted by Faulk and signed by Goldberg on July 4th. Lawyer Faulk got $80,000 for his legal expertise. And Peg held back $120,000 to "cover expenses," which she did not mentioned to Frenzel. Because this was presented as a cancer-driven "fire sale," it was understood by all that the resale price of the mosaics Peg Goldberg had fallen in love with, yet was eager to sell, would be much higher than the purchase price. As evidence of that, van Rijn and his sometimes business partner Robert Roozemond each wrote appraisals in the $3 million to $6 million range, backdated to July 1st, three days before the contract was signed.

The initial price quoted to Peg was $3 million, at which she "hemorrhaged," as she later told Bill Honan of *The New York Times*. (Sadly, both van Rijn and Fitzgerald were just then having cash flow

problems and so couldn't cover any of that nut.) But Peg had soon
bargained them down to $1,080,000, contingent on their retaining
hold of nearly one-half of the proceeds from the resale as finders and
negotiators. So Peg called Nick Frenzel late at night Indianapolis
time and got him out of bed. After telling him that she had passed
on the fake Modigliani—news which likely bolstered Nick's faith
in her judgment—she went on in rapturous tones to describe her
all-but-miraculous find. She told him about the appraisals and then
asked that he wire $1.2 million to a bank in Geneva in her name.
And he did.

It was not clear that the real Dikmen was even in Geneva for the
meet-up on July 5th, but the mosaics were, and they fully lived up
to the love Peg had already bestowed on them. She was "in awe."
The wire transfer took a bit longer than expected, but finally, on
July 7th, it was time to close the deal, with Peg literally holding
two big bags filled with strapped $100 bills. As for her old friend
Bob Fitzgerald and her new friend Michel van Rijn, they, together,
were guaranteed 45 percent of the proceeds from the resale, with
Faulk in at 5 percent. After Fauk's fee and what she had withheld
there remained a balance of $1 million in cash in those two bags,
which Peg assumed was mostly destined for Aydin Dikmen's bank
account. (Some months later van Rijn and Fitzgerald sold one-half
their 45 percent resale cut to an Indianapolis doctor named Stew-
art Blick for $780,000. Blick, in turn, sold an 8 percent interest for
$390,000 to banker Frenzel, who, as part of the initial loan of $1.2
million, already had a guaranteed 5 percent interest in the resale.
Again, very clever.)

But in fact, Faulk had secured the mosaics from Dikmen for just
$350,000. So, do the math. Let's assume that Bob or Michel picked
up the tab for the coffee at the Marriott: Dikmen gets $350,000,
which leaves $650,000 in play for Fitzgerald and van Rijn to split,
as they delectate over the prospect of another $1 million-plus each

if the mosaics do in fact sell for $5 million. All of this, for less than a week of work and with no cash outlay. And, of course, the lucrative Blick transaction for $780,000 lay just a few months ahead. Brilliant. So the mosaics were packed up, very poorly as it turned out, and shipped off to Indianapolis on July 8th. Some of the tesserae fell off in transit, so Peg hired a conservator from the local children's museum to stick them back on; he used Elmer's Glue.

What got us into this Indianapolis courtroom? It was the hubris of one of the several dealers who were fronting the mosaics for Peg that fall, namely, that (slightly) Hapsburg-jawed great-great grandson of Emperor Franz Joseph I, Géza von Hapsburg (a.k.a. Archduke Géza of Austria), an aristocratic dealer in things mostly Fabergé. In October he contacted Marion True at the Getty, where she was then Curator of Antiquities, and offered the Kanakaria mosaics at $20 million. ("Holy Doodle!" Marion muttered to herself, as we learn in the book *Chasing Aphrodite: The Hunt for Looted Antiquities at the World's Richest Museum*, by Jason Felch and Ralph Frammalino.)

Was it because curator True was then preoccupied with buying that spectacular mega-statue of Aphrodite, that had been smuggled out of Sicily, for $18 million (and that has since been repatriated)? Or was it because the Getty just doesn't buy this kind of stuff, as she said in her deposition? In either case, she sent Géza packing. And then she tattled on him to her dear friend Professor Vassos Karageoghis, Director of the Department of Antiquities of Cyprus and, for most of his professional life, the very personification of Cypriot archaeology. (For this, Judge Noland saw in Marion True—"the aptly-named Dr. True"—the very embodiment of curatorial ethics.)

Karageoghis in turn contacted US officials by way of the Embassy of Cyprus, and US Customs took the lead, initially staking out von Hapsburg's New York shop, while all the while, the mosaics were *chez* Peg, in the Indianapolis suburb of Carmel, which they soon figured out. Lots of fancy lawyers got involved, Peg retained

her own high-end public relations agent, with ties to the Reagan White House, and even Indiana's Senator Richard Luger got into the action. But by late February, word came from on high at US Customs that Peg had violated no laws. So, on March 29, 1989, Cyprus filed a civil suit in her home town.

The trial was covered day-to-day for a week by Bill Honan for *The New York Times* and Steve Mannheimer for *The Indianapolis Star*. Steve happens to be an artist as well as a journalist, and he did a drawing of me on the stand that I treasure. Mostly, as I said, it was about due diligence. Who tried harder? Later on day one, we heard the gnarly caretaker of the Kanakaria church, Theodoros Avraam, whose forlorn face was straight off that children's art wall in the Embassy of Cyprus. Through an interpreter he told his chilling story of what happened in his little town of Lythrankomi after the Turkish invasion: "We were loaded in busses, taken to Turkey, where we were beaten up, imprisoned for thirty-five days, then returned home." When he left for the southern part of the island in 1976, Avraam locked the church. Three years later, in November 1979, visitors to that town reported that *Panagia* Kanakaria had been looted.

My time to testify was rapidly approaching, and it was clear that I would be the linchpin for Cyprus, provided that I performed as they hoped I would. But was I up to it? It was just after eight in the evening on that Tuesday, May 30th, and I was in a conference room on the 18th floor of the First National Bank of Indianapolis. I had just returned in my Celica convertible from what I was told was the second best restaurant in Indianapolis. I was being paid well for my time and expertise in Indianapolis and I intended to enjoy myself. Monday evening I asked the concierge what the best restaurant in town was, and he said *Peter's*, so I went there and ate alone. And the second evening I asked for the second best restaurant, and this continued through the week. I had spent the day on a rock-hard, church-pew-like bench in the courthouse, just across the street to the

Venus with a Mirror, oil on canvas, Titian; Venice, around 1555. The National Gallery of Art, Andrew W. Mellon Collection. *(Photo courtesy the National Gallery of Art)*

The first painting I fell in love with—at age eight.

Cub Scout Gary Vikan at age ten in the basement of Hope Lutheran Church, Fosston, Minnesota, 1957. *(Photo by Franklin Vikan)*

Warner Sallman's *Head of Christ* is in the background, as if speaking in my ear.

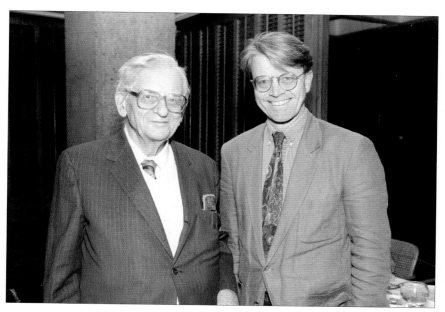

I was with my professor, Kurt Weizmann, at Princeton University in 1993, shortly before he died. *(Photo courtesy Princeton University)*

Illuminated Greek Manuscripts from American Collections, the Princeton University Art Museum, 1973. *(Photo by Gary Vikan)*

My first exhibition: no visitors, no review.

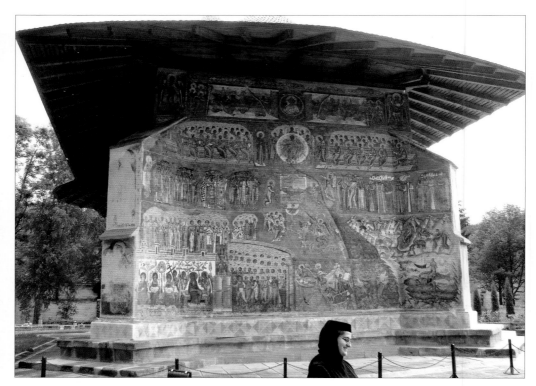

Last Judgment, fresco, Voroneț Monastery, Romania; Post-Byzantine, 1547.
(Photo by Adam Jones; adamjones.freeservers.com)

Romania's answer to Michelangelo.

Wedding party, Agapia, Romania, 1975. *(Photo by Gary Vikan)*

The day we became guests at a wedding.

Signet key ring of "Panaretos," gold and niello, from Constantinople; Byzantine, 9th century.
Ring: Dumbarton Oaks, Washington, DC. Key: the Menil Foundation, Houston.
(Photo courtesy the Menil Foundation, Houston)

I reunited the key and the ring in 1979 after a separation of more than a millennium.

Paralytic Raising His Bed, painted limestone relief, reputed to be from Sheikh Ibada, Egypt; 20th century forgery. The Brooklyn Museum.

(Photo courtesy of the Brooklyn Museum)

One of the most audacious of the huge group of Sheikh Ibada fakes that I uncovered in the late '70s.

Healing of the Blind Man, marble relief, reputed to be from Constantinople; 20th century forgery. Dumbarton Oaks, Washington, DC.

(Photo by Gary Vikan)

My discovery of this fake caused a firestorm at Dumbarton Oaks in 1981.

Saint Peter (detail), icon, tempera on wooden panel, reputed to be from the Church of Saint Prokopios, Verioa, Greece; Byzantine (Macedonia), early 14th century. Dumbarton Oaks, Washington, DC. *(Photo by Gary Vikan)*

Residue in the rows of small aging cracks in the saint's hair told me a disturbing story.

Looter's drawing of a nonexistent Byzantine church reputedly discovered by workmen bulldozing the dirt from a hillside to build a youth hostel in the area of Binbirkilisse in southeastern Turkey. *(Photo courtesy the Menil Foundation, Houston)*

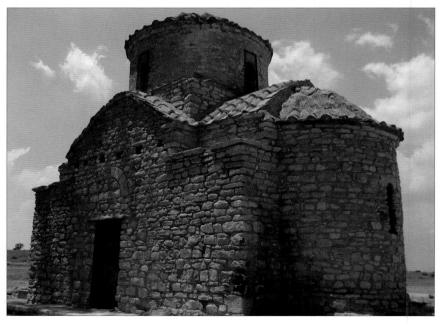

Church of Saint Euphenianos, Lysi, northern Cyprus; Byzantine, 13th century.

The real church from which the "Lysi frescoes" were looted.

Christ Pantocrator with Angels, fresco, dome looted from the Church of Saint Euphemianos, Lysi, northern Cyprus; Byzantine, 13th century. Now in the Byzantine Museum, Nicosia, Cyprus. *(Photo courtesy the Menil Foundation, Houston)*

Lysi dome fresco showing the looter's cutting lines. The image (sans cutting lines) was copied from the *Annual Report of the Director of the Department of Antiquities* for the year 1972 (Nicosia, 1973).

Security in Byzantium, Dumbarton Oaks, 1979. *(Photo courtesy Dumbarton Oaks)*

I managed to put an entire exhibition in a single mind-numbing wall case.

Holy Image, Holy Space: Icons and Frescoes from Greece, the Walters Art Museum, 1988.

(Photo courtesy the Walters Art Museum)

The day I captured the "numinous"—and the Plexiglass was covered with kisses.

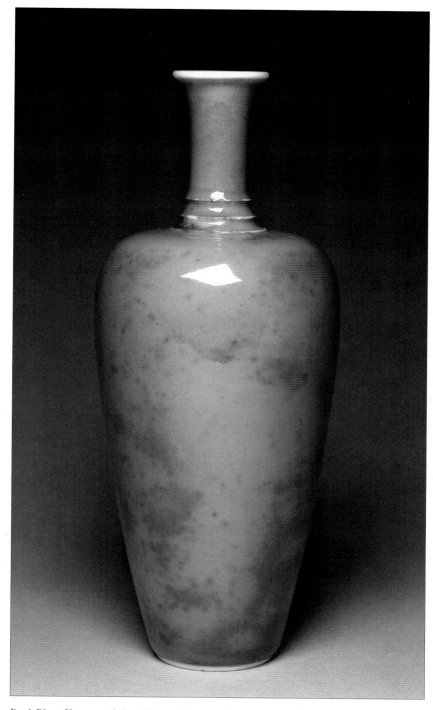

Peach Bloom Vase, porcelain with peach bloom glaze; Chinese (Qing), 1710–1722. The Walters Art Museum. *(Photo courtesy the Walters Art Museum)*

This Walters treasure was missing from its case for days, and no one noticed.

Greg Bartgis, 2016.
(Photo courtesy Greg Bartgis)
The Walters' master art thief.

Walters guard held in theft of 145 objects

$100,000 bail set for night shift chief; 84 books also taken

By John Dorsey

A 30-year-old security supervisor who had worked at the Walters Art Gallery for 1½ years was charged yesterday with the theft of 145 objects from the museum — 64 more than it had previously said were stolen.

In addition, 84 scholarly books dealing with Asian art, also stolen from the Walters' 80,000-volume reference library, were recovered.

Bail for the supervisor, Gregory Bartgis, of the 400 block of Rosebank Avenue, was set at $100,000

The Baltimore Sun, August 25, 1988.
An inside job.

Church of *Panagia* Kanakaria, Lythrankomi, northern Cyprus; Byzantine, 6th century.
(Photo courtesy Alamy)

The church from which the "Kanakaria mosaics" were looted.

Reporter Steve Mannheimer's drawing of a dour Gary Vikan on the stand during the Kanakaria repatriation trial in Indianapolis, 1989.

Judge Orders Art Dealer to Return Rare Mosaics to Church of Cyprus

By WILLIAM H. HONAN

In a decision that museum officials say will be used to set guidelines in the acquisition of antiquities, a Federal judge in Indianapolis ruled yesterday that an art dealer who acquired four sixth-century Byzantine mosaics was not a good-faith purchaser and must return the rare fragments to the Autocephalous Greek Orthodox Church of Cyprus.

The Federal Republic of Cyprus and the Church of Cyprus sued to recover the mosaics last spring when they learned that the dealer, Peg L. Goldberg of suburban Indianapolis, was trying to sell them to the Getty Museum in Malibu, Calif., for $20 million.

"Because the mosaics were stolen from the rightful owner, the Church of Cyprus," Judge James E. Noland declared in an 86-page decision, "Goldberg never obtained title to or right to possession of the mosaics."

"The significance of the decision is quite profound," said Gary K. Vikan, the curator of medieval art at the Walters Art Gallery in Baltimore, who testified for the Cypriots at the trial. "We are going to use this decision as the basis for formulating a policy on the purchase of antiquities." The Walters Gallery is one of the world's leading collectors of Byzantine art.

"We will ask such questions as is the price appropriate?" he said. "Was the work attached to a building? Was it removed in time of war? The more suspi-

A detail from one of the mosaics ordered returned to Cyprus. It depicts an adolescent Jesus.

cious the circumstances the more circumspect the buyer must be."

Joe C. Emerson, a lawyer for Ms. Goldberg, said he was uncertain about whether he would appeal.

Asked whether the court ruling would bankrupt Ms. Goldberg, he re-

Continued on Page C25, Column 1

The New York Times, August 4, 1989.

Our day of triumph, on the front page of the *Times.*

Walter Hopps and Dominique de Menil, 3363 San Felipe Road, Houston, 1980s.
(Photo courtesy the Menil Foundation, Houston)

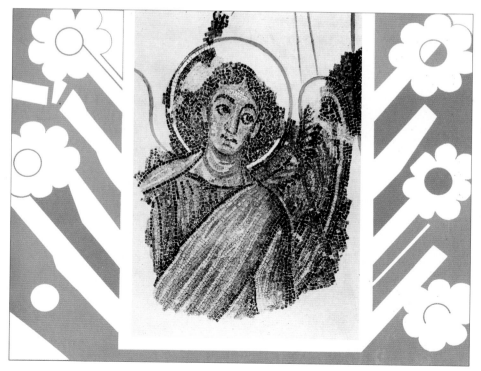

The first, and last, Christmas card I ever received from the president of Cyprus, in 1991.

"I simply love them, Patriarch Abune Paulos of the Ethiopian Orthodox Church says of the protesters who dog his every step in this country."

The Abune Paulos,
The Washington Post,
October 15, 1993.

Ethiopian demonstrators at the Walters Art Museum, October 16, 1993. *(Photo by Gary Vikan)*

Mary and the Infant Jesus Flanked by Archangels (left half of a diptych), tempera on wooden panel, Fere Seyon; Ethiopian, later 15th century. The Walters Art Museum. *(Photo courtesy the Walters Art Museum)*

One of the finest icons in the finest collection of Ethiopian art outside of Ethiopia.

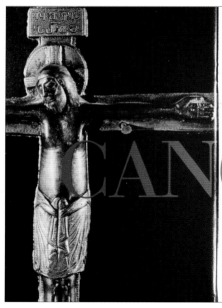

A new traveling
exhibition of
5,000 years of
Georgian art
is already
ancient history

CANCELED

JACK MEINHARDT

Look at this crucifix," said Gary Vikan, the director of the Walters Art Gallery in Baltimore. He pushed a book across the table and pointed to a photograph of a silver sculpture of Jesus nailed to the cross. The statuette was made in tenth-century A.D. Georgia, on the east coast of the Black Sea. Jesus' face, hair and waistcloth, as well as the cross itself, are covered with gold; Jesus' head tilts softly to his right, while his body is taut and angular, as if stretched on a rack.

"There's no Byzantine equivalent for that," Vikan

bition of Georgian art, called *Land of Myth and Fire: Art of Ancient and Medieval Georgia*, was scheduled to travel from Georgia to the Walters last October, and to San Diego and Houston next year. But today the crucifix remains in an art museum in the Georgian capital, Tbilisi. Nearly for packing crates, still empty, specially designed to transport fragile works of ancient art

On August 4, 1999, after two years of preparations and outlays of about a million dollars, the Walters issued an official statement calling off the show.

Archaeology Odyssey, January/February, 2000.

The failure of my Georgian exhibition was announced with a banner headline.

The "Cabinet of Wonders," the Walters Art Museum. *(Photo courtesy Lee Sandstead)*

Door from a Torah ark, wood with traces of paint, Ben Ezra Synagogue, Cairo; 11th century and later. Jointly owned by the Walters Art Museum and the Yeshiva University Museum, New York City.

(Photo courtesy the Walters Art Museum)

How did this ancient wooden door get from Cairo to Miami?

Intact Torah ark, wood with traces of paint, Ben Ezra Synagogue, Cairo; 11th century and later.

(Photo from The Torah *[Israel Museum, Jerusalem, 1978])*

Who took that photo—and, more important, when?

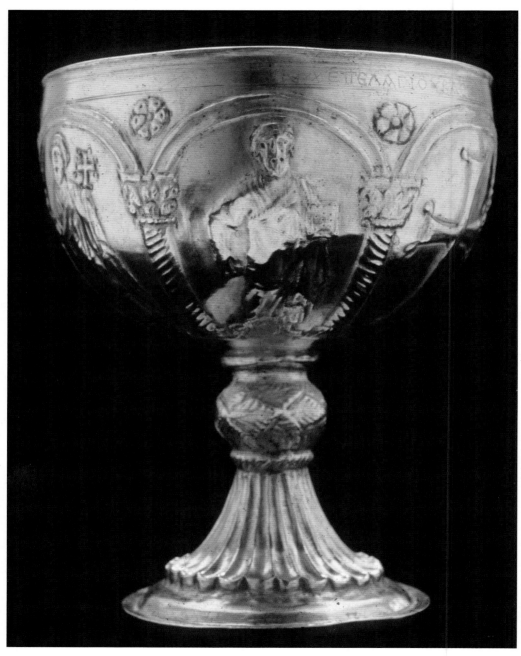

Cross flanked by Apostles, chalice from the Kaper Koraon Treasure, silver, dug up by looters in northern Syria in 1908; Byzantine, early 7th century. The Walters Art Museum.

(Photo courtesy the Walters Art Museum)

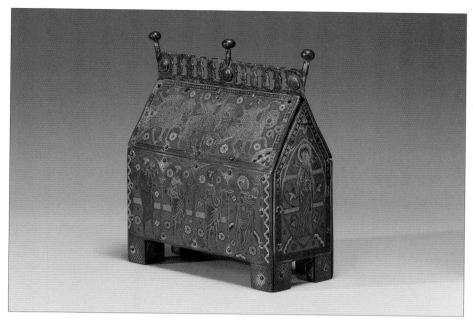

Story of the Magi, reliquary, *champlevé* enamel, reputedly stolen from the Church of Saint Martin, Linard, France; French, 13th century. The Walters Art Museum. *(Photo courtesy the Walters Art Museum)*

Volée ("stolen") the French local mayor proclaimed.

Medieval Galleries, the Walters Art Museum. *(Photo by Gary Vikan)*

Paysage, bords de Seine, oil on linen, Pierre-Auguste Renoir; 1879. The Baltimore Museum of Art.
(Photo courtesy the Baltimore Museum of Art)

This Renoir was missing from the Baltimore Museum of Art for more than half a century.

Mailing label received at the Walters Art Museum, May 1, 1986.

A tale of love and regret.

west of the First National Bank. So it was all very convenient and meant I didn't drive that nifty red convertible very much.

When I asked my amiable young lawyer-coach, Doug Lavin, of Manatt, Phelps, Rothenberg, & Phillips, what I should say as an expert witness once I got on the stand, which we assumed would be late Thursday or Friday, he asked me if I had ever seen Perry Mason on television. He had in mind the old black and white version with an agile Raymond Burr and all the original cast. Of course, I said, I had seen them all in reruns when I was a graduate student. Two episodes were shown back-to-back every night starting at midnight, when I got back from the art library, and I watched them both, to get things Byzantine out of my head. Doug's idea was that I should pretend that I was a witness on Perry Mason and craft my own testimony just as I wanted to give it. And once I had done that, he would turn around and ask me those very questions for which I had just written up the answers. Very clever and comforting, I thought, and with a few prompt questions from his side, I had drafted my testimony the week before.

Our job now, there on the 18th floor each night after my fancy dinner, was to hone my testimony. But by Tuesday, at my third coaching session, it was clear that Doug didn't think I was doing very well, and time was getting short. I was supposed to be firm and damningly judgmental of the defendant, Peg Goldberg. I had never met her, and saw her only at a distance in the courtroom, but I had read hundreds of pages of her deposition testimony. In truth, I felt sorry for her, and like any academic, and any good Lutheran, I was trying to figure out what made Peg do what she did. This meant that I was trying to explain away her totally bad behavior in buying and then trying to resell these looted Byzantine mosaics. I suppose I was hoping to make another Dominique de Menil out of her.

But as Doug made absolutely clear, this was not what I was being paid to do. I had to come down hard and definitively in my

testimony so that Judge Noland would come down hard and defini-
tively in his judgment and take the mosaics from her and give them
back to Cyprus. I was, after all, the only witness for the plaintiff who
was empowered to draw the threads of the evidence together and
express an opinion. That's what an expert witness is all about. Any-
how, I really didn't get the point until Doug told me something that
may have been lawyerly manipulation, but at the time I believed:
"Vikan, she thinks you're shit!"

ON WEDNESDAY, DAY TWO, there was this totally wound-up Acting
Director of the Cypriot Department of Antiquities named Anasta-
sios Papageorghiou—the one who on Monday evening when I got
off the elevator was so clearly disappointed. He had the finger-point-
ing, lecturing manner of a school teacher. Papageorghiou was fol-
lowed by the much more affable and engaging Marios Evriviades,
Press Officer at the Embassy of Cyprus. Their shared message was
simple. Yes, we told the world that this church had been violated.
The trouble was, as Joe Emerson drove home in cross examination,
Marios' scores of press releases were picked up almost exclusively
by Greek newspapers, and so their message really didn't reach the
broader art-buying market. We all recognized this as the high water
mark of the trial for Peg and her defense team.

The next day, Thursday, things were put right for Cyprus by
their star of stars witness, Father Pavlos Maheriotis, Abbot of the
Holy Monastery of Machaeras, with his long beard, black robes,
stovepipe hat, and golden-topped staff. Father left by the east side
entrance of the courthouse every day after the proceedings, and
there were cameras there to capture that moment of solemn drama.
Because Peg's legal team must have assumed this quiet and digni-
fied man, who seemed literally to radiate his profound faith, was

somewhere up there in the Orthodox stratosphere, they didn't prepare well. His message on behalf of Cyprus and *Panagia* Kanakaria was simple and clear. The mosaics belong to the church and have for 1,400 years. The ancient church has *never* been abandoned, and only the high administration of this church can authorize the movement of parts of the church out of the building. And it has never done that and never would.

Then the defense lawyer, Ezra Friedlander, who had that sleaze quality that some lawyers have, with clothes too fancy and a tone too glib and condescending, got up to make Father Pavlos look parochial and naive. This was a big mistake. I can still hear Father's deep sonorous voice and English accent when he told Mr. Sleaze, Esq. that he had a PhD in theology from Oxford University. Somehow, just then, I knew we had won, and I think everyone else knew it too. Tom Kline and his crew took as proof of this the rumor that Judge Noland had asked to go see the mosaics in the bank vault.

The defense side was sometimes just straight-out comical. There was young and diminutive George Feldman, Peg's business partner, who described in some detail how he would scrub Peg's back in the bathtub after she had hurt her wrist and could not scrub herself. And there were the very entertaining personality of Bob Fitzgerald, a.k.a. Bob Jones. Two things made us laugh. The first was when one of our lawyers asked Fitzgerald to read back a portion of his deposition, and he said he couldn't find his glasses. Since this exchange went on for a while, Judge Noland called for a glasses-finding recess. In the meantime someone else's glasses were found as a stand-in, and then it seemed that the truth was that Bob couldn't read. Maybe that wasn't so funny, but it was certainly odd.

The other odd or funny moment came when our lawyer asked Bob, on the basis of his deposition, why he had never told his friend and partner Peg Goldberg that the actual purchase price from Aydin Dikmen was $350,000 and not $1 million. His response made the

next day's newspapers in Indianapolis and New York: "It was just none of her business." As I understood it, Peg, who was still seated right in front of me, learned that for the first time there and then. After that, they weren't friends anymore.

The Cyprus legal team had retained a second expert who arrived from California after the trial had begun. He was Arthur van Mehren, a Harvard Law graduate of 1949, who was a world-renowned scholar of international law and comparative law. Just being around this hugely dignified and accomplished man made me feel the way I felt just a week earlier at André Emmerich's deposition. It was van Mehren's job to argue that the *lex situs*—the applicable law for making a judgment in this case—should be that of Indiana, where the money came from, where the buyer lived, and where the mosaics ended up, and not that of Switzerland, where the merchandise had never even left the free port of the Geneva airport.

And even *if* Swiss laws were applicable, Peg Goldberg did not qualify as a good-faith buyer. By US Common Law a thief can never convey good title, no matter how many intermediary buyers there may have been or how diligent and how much good faith the last buyer had used to investigate the circumstance of the sale. By Swiss (Napoleonic) Law, on the other hand, a good-faith buyer can under some circumstance obtain title to stolen property, provided they had exercised sufficient due diligence. And here is where the van Mehren-Vikan team came into play. In a moment of magic on the 18th floor of the First National Bank on that Wednesday evening, with the old and wise van Mehren at the center of one side of the conference table, me at one end of the table, and various members of our legal team scattered between us, it all gelled beautifully.

I had made up a real-world hypothetical as a memory aide. It involved a Rolex watch offered for sale by a tough-looking young man on Seventh Avenue in New York City, just north of Penn Station. There is broken glass on the sidewalk, an alarm is going off, and

people are running out of a building. The young man has six genuine Rolex watches on his arm that are over his shirt but under his jacket. He's in a big-ass hurry to sell and that $1,500 Rolex is offered at $100.

Arthur van Mehren had extracted the basic principles of this kind of sale: the suspicious object from a suspicious place, a suspicious seller, suspicious circumstances, undue speed, and a crazy price differential. And then I applied those principles—at the conference table that evening and on the stand on Friday—to the facts of the Goldberg mosaic purchase of July 1988. It involved sacred Christian mosaic icons from a famous church in a (once) Greek village under hostile occupation and a Muslim Turkish owner who is reputed to be an official "archaeologist," but is in the business of selling antiquities. This archaeologist just happens to find some precious and valuable mosaics in the "ruins" of an "extinct" church. An intermediary to find a buyer, Michel van Rijn, identifies himself as a convicted felon. There is a bizarre urgency to sell—the million-dollar deal unfolds in just over six days. And the established sale price, a choice of $350,000 or $1,000,000—is totally out of whack with the $5 million appraisal, and exponentially more out of whack with the $20 million price tag when the mosaics are offered to the Getty the following October by von Hapsburg. We rehearsed a bit and all felt pretty good about it. And, after all, "She thinks you're shit."

I was up last, after Bob Fitzgerald, on Friday. I liked that sequence. After me, Tom Kline rested the plaintiff's case for Cyprus. Although he wasn't there in the courtroom, Dan Hofstadter, in his two articles in *The New Yorker* of July 1992 and in his 1994 book, *Goldberg's Angel,* captured what I like to think was true:

> *The most withering of the plaintiff's expert witnesses turned out to be Gary Vikan, the curator of medieval art at the Walters Art Gallery, in Baltimore, who was eloquent, wry, and conversant with all manner of Byzantine lore. Vikan wearily spelled out 'provenance'*

for the court stenographer and made coolly cutting remarks about art dealers—including Michel van Rijn, whom he seemed to know something about. When Kline asked him what he would have done if he'd been offered this deal, he replied, 'Walked.'

Whenever Vikan spoke there was absolute silence; whenever he finished there was a murmur of approval.

As I've said, my job, for which I had rehearsed with Doug Levin for more than two weeks, was threefold. First, I needed to convince Judge Noland that the Kanakaria mosaics were historically and religiously very important and should be treated seriously. (By that time, he certainly knew that without my help.) Second, it needed to be understood that the Cypriots had done their due diligence in getting the message out that *Panagia* Kanakaria had been violated. This was critical, since if you "sit on your rights," that might suggest you have dirty hands, and you will eventually lose your right to press your case in civil court.

Joe Emerson's cross-examination of Papageorghiou and Evriviades two days earlier made my job a little tougher than it might have been. Had Cyprus only been talking to its Greek choir? Well no, I said. By targeting places like Dumbarton Oaks and people like Marion True, they would certainly intersect with any and all potential good-faith buyers, who, given the unusually sacred nature of the merchandise and the sky-high price, would be few in number. My point was that whoever might consider this purchase would for sure consult one or more Byzantine specialists, and these were the people Cyprus had taken care to reach. And this was good.

And third, there was the issue of Peg Goldberg's "good faith" or lack thereof as a buyer, should Judge Noland decide to measure her actions by Swiss Law. Here is where the von Mehren due diligence strategy kicked in, and all I had to do was to fill in the blanks. It was as easy as that, and immensely satisfying. For some reason the

metaphor of a smelly fish seemed useful to me at that moment. Those mosaics were a smelly fish with "Cyprus" written on its side. And there was only one way to get rid of the stink: call the Embassy of Cyprus. Which, of course, Peg Goldberg did not do. Why? Because she was not looking for the bad news. Or for the truth. She was only doing enough to rationalize her greed and avoid a roadblock. And I finished with a phrase that was visually powerful, and it stuck: "All the red flags are up, all the red lights are on, all the sirens are blaring." And still, no phone call to the embassy.

My cross examination was predictable, and I had rehearsed well for it. What surprised me, though, was that the defense lawyer, Joe Emerson, wasn't better prepared. He presented me with the van Rijn publication with Saint Peter on the cover and said something to the effect that "is it not true that" you bought this icon from that "shady" (my word) Michel van Rijn? No, I said, we bought it from a Dutch businessman named Stoop and, in any event, we exercised appropriate due diligence by contacting, among others, officials in Greece who enthusiastically endorsed the purchase. Does the Walters have any Cypriot art? No, I said, almost none. (He could have checked that.) Do you yourself collect art? No, I said, just Boston Terrier paraphernalia. (Here I stopped to spell that word, and to explain what I meant: little ceramic Boston Terriers.) Are you being paid to testify? Yes, I am. Pretty much that was it.

It was a beautiful Friday afternoon and the plaintiff's case was over. Monday and Tuesday of next week were for the defense, and they were, for Peg Goldberg, a disaster. During what became known among the Kanakaria insiders as Tom Kline's "cross of Goldberg," it became fully apparent through Peg's own words that she had been on the inside of the van Rijn-Fitzgerald conspiracy.

The story as presented by Michel van Rjin to Peg initially was that Dikmen was very sick and had to sell. Over the course of the trial, though, this "dealer opportunism" scenario was gradually

supplanted by a "tail-end-Charlie" scenario. The deal was driven not by Aydin Dikmen's health, which turned out to be fine, but by the conspiratorial ingenuity of van Rijn and Fitzgerald feeding on the greed of a compliant Peg Goldberg. The basic notion is that there will always be someone down the line who is naive enough and greedy enough to buy stolen merchandise that is so hot it cannot be sold to anyone else. That last person is the tail-end-Charlie, that unlucky last one, named after the all-but-doomed tail gunner on the highly vulnerable US bombers in World War II.

Gradually, clarity had emerged. Michel van Rijn and Bob Fitzgerald hatched this scheme together, and it began with a simple bait and switch. The bait was the Modigliani that they both knew was a fake. The point was to get Peg Goldberg to Amsterdam with cash backing from Nick Frenzel. As planned, that deal fell through and Peg was deeply disappointed and susceptible to a rebound opportunity. Fitzgerald's lawyer, Robert Faulk, who drew up the sale agreement, had paid a visit to Aydin Dikmen in Munich about a possible impending deal before Peg arrived in Amsterdam.

Everything gels when Peg falls in love with the mosaics. Discretion is maintained about the real sale price, with van Rijn and Fitzgerald pocketing hundreds of thousands of dollars just for snaring Goldberg and making the Dikmen connection. The ultimate tail-end-Charlie is Nick Frenzel, who eventually has to make good on Peg's loss out of his own pocket. As he told *The Wall Street Journal* at the time, "it did cause some embarrassment."

Peg's role was that of a compliant, self-interested pigeon. A critical distinction was drawn out by Kline's questioning. Peg was in the business of determining whether the Kanakaria mosaics had been *reported* stolen, not whether in fact they *were* stolen. And since she was aware of the Dumbarton Oaks publication at the point of sale (referencing it to Frenzel), it was obvious that she had to have known from the beginning that the mosaics were stolen. Pretty much end of story.

But on that Friday we were all giddy. We knew we had won. We believed we had done something really good and right. And for the moment, I was the star. I did interviews with Honan and Mannheimer, and then the entire Kanakaria mosaics recovery team was hosted at a Greek restaurant just south of downtown Indianapolis, by its owners. I don't remember what we ate but I have vivid memories of vast amounts of retsina and ouzo. And I think we broke some plates in the fireplace. It was that kind of night. And it was a high point of my life. The next afternoon, Saturday, June 3rd, much hungover, I watched events unfold in Tiananmen Square on television at the airport as I waited for my flight back to Baltimore.

IT WAS AN ELEGANT TWIST that Judge Noland's decision was announced on August 3rd while I was at another Vikan family reunion in northern Minnesota, in this case at a log-cabin style lodge on the north shore of Lake Bemidji. June 1983 redux—sort of. This was the most memorable among our reunions for the arrival of that news, but also for the fact that it was then that my mother finally told the family what each of us who cared already knew, namely that her father, our grandfather or great-grandfather, E. C. Johnson, had "blown his brains out" with a pistol in 1923 when she was 13. I remember being troubled that it took her so long to tell us (she was then almost 80), but was mostly upset that no one paid much attention. It was windy, we were outside, kids were running around, and we were grilling hamburgers.

On that unusually hot day, a Thursday, Elana and I had driven my father's burgundy Lincoln Town Car the forty-five miles back to Fosston. And then we took a right and went north twenty miles or so to the tinier town of Clearbrook, where a nearly-blind farmer's widow living in a trailer was making quilts. After bargaining poor

Mrs. Opus down to $300, we bought two. Elana and I stopped by the Vikan house in Fosston before heading back on Highway 2 for Bemidji and I noticed this pink telephone message in the kitchen. It was left, I assumed, by Mrs. Busse, who cleaned for my mother every now and then. (She was the one whose Ojibwa cousin had been scalped in a post-barroom two-person brawl in the back seat of a car twenty-five years earlier. I had vivid memories because I went with my father on a snowy Saturday in December to a remote gravel road on the White Earth Indian Reservation when he took photographs for the coroner.)

Well, the note was short and sweet and, at least for me, meant something very important: "Cypress Won, check out *The New York Times* tomorrow. Tom Kline." I called him back. We had nailed it, and one of Noland's clerks said the Judge relied heavily on my testimony. We'll be on the front page of the *Times*, tomorrow. Wow, I thought, how sweet.

Back with the family in Bemidji, no one seemed to care much about my news, and of course there was no *Times* to be found in that neck of the woods, though I tried—no *Times* until I got to the Minneapolis airport. And there we were on page one; there I was on page one. Judge Noland went 100 percent our way, and Bill Honan quoted a short passage of his eighty-six-page decision near the end of his article, and that phrase of mine about red flags and red lights and sirens was the clincher. Yes, I had done a good thing. But I soon found I couldn't put it down.

Chapter Ten

The Men Who Knew Too Much

I'm a Kanakaria junkie. There are only a few of us, but when we get going, even now more than a quarter century after the trial, the conversations are intense. I suppose we're like those conspiratorially minded sleuths still preoccupied with the Kennedy assassination and the Warren Report. Our equivalent to Chief Justice Earl Warren is Judge James Noland. Did Noland get it right? None among the junkies is convinced that he did, and we all have our own way of reassembling the facts and finding the truth. This fixation began for me shortly after the trial when I heard from Chris Mitchell, a London-based documentary film producer for Tartan TV. He was making a short film on the Kanakaria case called *Plunder: The Looting of the Kanakaria Mosaics*, and he was eager to interview me.

A few weeks later, Chris and I sat down to lunch at a small restaurant just south of the Walters. He said immediately that there was something about the trial that puzzled him, and before he could finish by telling me what it was, I jumped in and completed his sentence: "Where was Vassos Karageorghis?" We each nourished and enriched the other's conspiratorial thinking, which I have since elaborated and refined in conversations with another junkie (he invented

151

the term), Dan Hofstadter, the author of *Goldberg's Angel*. (*Goldberg's Angel: An Adventure in the Antiquities Trade*, 1994, was Hofstadter's elaboration on his two articles on Kanakaria in *The New Yorker* in July 1992.) Dan led me to realize that the Kanakaria case was an adventure in shades of gray involving an active interchange between Turkish smugglers and Greek Cypriot officials.

I HAD AN EPIPHANY AS I sat on a rock-hard bench at the back of the Indianapolis courtroom on the morning of the first day of the trial. It suddenly occurred to me: "Where is Vassos?" It was Vassos Karageorghis who, in his capacity as Director of the Cypriot Department of Antiquities, had initiated action in this case through the Embassy of Cyprus the previous October, after the tip-off from Marion True. He was the very personification of Cypriot archaeology and, more than that, the voice for justice on the world stage for the grievous cultural losses of the Orthodox Greeks of northern Cyprus after the 1974 invasion. The Kanakaria story was the story of the Fall of Constantinople to the Turks on "Black Tuesday," May 29, 1453, played out in microcosm right now and almost before our very eyes. And Vassos Karageorghis owned it.

There was no Vassos the night before at our Kanakaria team bonding session at the First National Bank, and no Vassos for the next week of the trial. Vassos couldn't be found? He wouldn't be found? (As it turned out, Vassos Karageorghis was at that moment squirreled away in a library on the outskirts of Princeton at The Institute for Advanced Study.) I figured that Vassos was intentionally AWOL from Indianapolis. And then I did a mental inventory of my recent paid reading, and I realized that I had not read a Karageorghis deposition. There was none. This was strange, since who could better speak for the co-plaintiff, the Republic of Cyprus?

(Vassos later claimed that he was eager to provide a deposition, but the legal team for the defense said he in fact had refused.) And then I recalled a brief conversation at a cocktail party at Dumbarton Oaks earlier that month during their annual Spring Symposium. Someone mentioned to our group that Vassos Karageorghis had just resigned, abruptly and to everyone's surprise, from the post he had held since 1963. And isn't it strange, I thought, that his resignation coincided to the week with Walter Hopp's sudden and stunning resignation as Director of the Menil Collection.

The headline on the first day of the trial in *The Indianapolis Star* spelled out the core question to be addressed: "Who Tried Harder?" For both the defendant and the plaintiff it would be a question of due diligence. Had Peg Goldberg asked the tough questions about the origin of the Kanakaria mosaics before she bought them? Had the Cypriots gotten the message out in a timely fashion that the Kanakaria mosaics had been stolen, thus alerting potential buyers to beware? And had they been diligent in trying to discover who had stolen the mosaics and where they were, and then aggressively seeking their return? This second point is especially critical, because if the Cypriots had known about Aydin Dikmen and his Munich warehouse full of Cyprus loot and had *failed* to act on that knowledge, they would have, in legal terms, "sat on their rights." This means that Cyprus might be deemed not to have standing in US court to pursue civil action against Peg Goldberg.

Two star Kanakaria players, Walter Hopps and Vassos Karageorghis, suddenly resigned from their positions and then avoided Indianapolis. Was this because they knew things which, if they came out at trial, might have destroyed the Cyprus repatriation case by revealing the truth, that the Cypriots knew all about Aydin Dikmen and his loot and yet didn't go after him?

Neither Walter Hopps nor Vassos Karageorghis would likely have had to resign if Walter had kept his mouth shut. But he didn't.

When a reporter for *The Indianapolis Star* called him in early April for a quote on the impending trial, suspecting that there were connections between the Lysi fresco deal and the Goldberg case, Walter jumped in with both feet. This got the attention of Peg Goldberg's lawyers, who figured Walter must know something. They then deposed him on May 15th, ten days after he resigned his directorship which, I assume, he did just after he was notified about the forthcoming deposition. Walters' resignation, in turn, was almost certainly the catalyst for Karageorghis' precipitous actions.

The trouble was, both men knew Walter's big mouth had created a big problem, and so Walter had to fix it as best he could in his deposition. He would certainly be asked about what he had seen in Aydin Dikmen's warehouse and apartment *besides* the Lysi frescoes. So he would have to account for what he did about that stolen Kanakaria Apostle mosaic, and then convincingly insulate the Cypriots with whom he would be negotiating the Lysi frescoe deal just a few months later from knowledge of Dikmen and his Kanakaria loot. Then hope that Peg Goldberg's legal team could be held at bay and that Judge Noland would be fooled.

Walter Hopp's fix-it scheme played out in his deposition in two dramatic acts, both of which involve Aydin Dikmen who, in Dan Hofstadter's book, calls Walter's two yarns outright lies. Lies or not, they worked: Judge Noland not only believed what Walter Hopps had to say; he paraphrased Walter's testimony in his decision on behalf of Cyprus.

Both narratives grow out of Walter's recollection of the day in June 1983 when he and Dominique visited Aydin Dikmen in Munich to examine the Lysi frescoes. And there, as a vexing bonus, he saw at least one Kanakaria Apostle mosaic and learned that it had been published by Dumbarton Oaks. They knew immediately that the mosaic was historically very important and that it was stolen; so what were they going to do about it?

According to Walter, Yanni Petsopoulos announced a bold scheme to get that mosaic (along with any others that Dikmen might have) back to Cyprus where it belonged. He would go to Dikmen's villa near Konya, in Turkey, for a social visit, and after dinner emotionally confront him. For what? For the lie Dikmen had told him about the Lysi frescoes—the claim that they had been discovered in a long-lost Byzantine church buried beneath the sand in southeastern Turkey. This was Dikmen's lie, and Petsopoulos was going to make him pay for it by browbeating him into returning to Cyprus any and all Kanakaria mosaic fragments he might have, at no charge. (Hofstadter's book reports that Constantine Leventis helped things along to the tune of 180,000 Deutsche Marks.)

At this point, Walter Hopps' deposition moves into a cinematographic mode. After a congenial dinner, Yanni gets emotional and throws a crystal decanter into the fancy fireplace. Aydin apparently crumbles and, not long thereafter, via Petsopoulos, hands over not one but *four* Kanakaria mosaics. These are then delivered to Constantine Leventis, who, as I learned from Dan Hofstadter, had for some time been active in buying back looted Cypriot antiquities for the museums in Nicosia. Sure, two of the four were bad fakes, but as Hopps claimed and Judge Noland believed, with this transfer Dikmen's Kanakaria inventory was depleted. This meant that no amount of due diligence on the part of Cyprus at that time, nearly six years before the trial, would have done any good in retrieving Kanakaria loot from Aydin Dikmen.

No one in Indianapolis, including Judge Noland, expended much energy trying to figure out how Aydin Dikmen replenished his supply of Kanakaria mosaic fragments back up to at least four by the summer of 1988. Nor did anyone seem concerned about the claim Walter Hopps made in his deposition that neither of the two genuine Apostle mosaics returned via Petsopoulos to Leventis was one and the same with the Apostle mosaic he had seen over Dikmen's sofa in 1983.

But surely, Walter Hopps *must* have revealed the name of Aydin Dikman and the address of his Munich apartment to Vassos Karageoghis and others in Nicosia at some point after the Lysi deal had been consumated and the frescoes shipped to London. Why wouldn't he? The answer comes in Walter's second deposition vignette that, for we Kanakaria junkies, is nothing more than another fairy tale concocted to build a firewall to keep the Cypriots off Aydin Dikmen's trail and thus protect their due-diligence-facade standing in court. Constantine Leventis, in his videoed deposition in Indianapolis, said that he pressed Walters Hopps repeatedly for the name of the person who possessed that Kanakaria Apostle mosaic that Walter said he saw with the Lysi frescoes in June 1983.

But Walter swore under oath that he was mum and unrelenting. This was because he claimed that if discretion in these matters was not maintained, as Dominique de Menil had insisted, either one or both of two very bad things could happen. First, Dikmen might destroy the mosaics and thus the evidence against him. And second, he might send his henchmen in reprisal against those individuals involved in the recovery as well as their families. According to Walters Hopps, Vassos Karageorghis understood this danger of reprisal and recounted one instance when the "quarters" of some individual helping Cyprus recover some antiquities were bombed. As Judge Noland paraphrased Walter Hopps on the issue:

> *It was pointless and destructive to require the plaintiffs to have taken additional steps to investigate the recovery of its property if it was reasonable that such steps might result in physical harm or destruction to human life or to the art itself.*

The net effect of these two Walter Hopps yarns was to wash away for Judge Noland the big problem created for Cyprus that day in June 1983 under the heading of due diligence. Though oddly,

Walter's two fairytales contradict one another. Fairytale one was concocted to create the impression that Aydin Dikmen's Kanakaria inventory was reduced to zero not long after that fateful June encounter in Munich, thanks to the intimidating rage of Yanni Petsopoulos. Fairytale two, on the other hand, was meaningful to Judge Noland precisely because it assumes that Aydin Dikmen still had Kanakaria loot that he might destroy.

The stakes in Indianapolis were much higher than the fate of four early Byzantine mosaics. The trial was a morality play in which the Greeks of northern Cyprus were the victims, the invading Muslim Turks the villains, and the Greeks of the south the heroes. Worse by far than losing the mosaics to a crooked small-time art dealer in the American Midwest would be losing that narrative, that is, the moral and political high ground. Walter Hopps and Vassos Karageorghis had together touched the third rail, in the person of Aydin Dikmen; they knew too much, and they had to go.

So where did I fit in? That night in Indianapolis when we were all drunk on retsina and ouzo I found out how they had picked me, the (then) third-tier David Bowie look-alike from a small town in Minnesota. My advocate was Marios Evriviades, Press Officer in the Embassy of Cyprus. Marios was sitting next to the Ambassador in November 1983 when the Ambassador hurled invectives at me intended to be passed on to Dominique de Menil, whom he regarded as blackmailing his country by saying, in effect: "Cyprus, take this generous deal of mine or risk losing the Lysi frescoes forever. And, by the way, I'm not going to tell you where they are." Was it that I was the only Byzantinist that Marios Evriviades knew, and so the only one he could think to recommend to Tom Kline's

team? Or was it because he knew that I was already in the circle of the compromised myself, thanks to the Saint Peter icon and Walter Hopps' midnight phone call?

Michel van Rijn, in that rant of a website of his, and in his confessional, *Hot Art, Cold Cash,* said something that I at first thought was totally nuts. He said that "the Greeks" protected Gary Vikan from embarrassment over his role in buying the Dumbarton Oaks Saint Peter icon because Vikan had an important role to play on the propaganda stage of the Indianapolis trial. Now I think maybe that's true.

At the end of August 1988, I welcomed the Greek Minister of Culture, Melina Mercouri, to the Walters. She was on a quest at the time to get back the Elgin Marbles for Greece, and she seemed to be making some progress. But she had no interest then in pursuing the Dumbarton Oaks Saint Peter icon that was among the highlights of the exhibition she had come to Baltimore to inaugurate, *Holy Image, Holy Space.* Was that because she didn't know that it was hot or because she had been advised to leave Vikan alone? Perhaps some people in high places had already scripted me into the happy solution to another "thorny problem," whose name is Peg Goldberg.

There is a subtlety that I figured out only very late in the game: that there are Greeks and there are Greeks. This is obvious, I suppose, but initially not to me. When Yanni Petsopoulos sells a looted Cypriot icon to a Greek aristocrat, and I see it in that aristocrat's penthouse apartment, I take comfort in the fact that they both are Orthodox, and they share a common love of their Hellenic cultural heritage. It somehow justifies and cleanses things. It is rather like the green light that the Greek scholar Manolis Chatzidakis gave us at Dumbarton Oaks when we bought the Saint Peter icon. But what I for the longest time did not consider is that neither Chatzidakis nor Petsopoulos nor that Greek aristocrat can speak for the members of the parishes, typically poor, from which the icons, frescoes, and

mosaics were stolen. Nor can they speak for the looted artworks' legal owner, as introduced to us all in court by Father Pavlos.

These artworks are all, in technical legal terms, "immovable assets," and only the Church (the official Church, with a capital "C") can authorize their removal. This makes much of the religious art in secular settings, specifically museums, works without title, which means that many of them are, technically, stolen property. As for people like Chatzidakis, Petosopoulos, and the Greek aristocrat with the penthouse, they are the academic, economic, and social elites who live in a world much closer to mine than that of a local parish in the countryside of Greece or northern Cyprus.

Yes, these two categories of Orthodox gravitate toward the same icons, but in the case of the elites, not for communal veneration in the churches for which they were created centuries ago, but rather for aesthetic and art-historical delectation on the walls of their houses or apartments, or maybe for the museum in Nicosia. It was for this group, de facto, that I was working for hire in Indianapolis; and this is the group I have always chosen to side with. I do this because I understand them and think like them, and I find comfort and support in their endorsement of my ethical values and actions. And the outcome I want is the outcome they want—the movement of first quality sacred works of art into private collections and ultimately into museums.

I NOW ASSUME THAT MANY (perhaps all) of the mosaic fragments looted from the Church of *Panagia* Kanakaria were in Munich with Aydin Dikmen, perhaps as early as 1978. I also assume that many players in Cyprus, London, and Amsterdam were aware of this. The Kanakaria mosaics are a big rung above the Lysi frescoes in

importance, by virtue of their early date and their exotic medium, and because they were studied and published by Dumbarton Oaks. Perhaps this explains why that merchandise did not move. It was simply too hot. But then, in the summer of 1988, after ten years, things suddenly changed. Why?

While the tail-end-Charlie narrative that emerged in Indianapolis is neat and tidy, and got the Kanakaria mosaics back where they belonged, I think it is an incomplete narrative. I now suspect that there was a grander initiating force that set this van Rijn-Fitzgerald clockwork in motion. This scenario, the "Dikmen chapter two" scenario, is ultimately driven not by Dikmen's health or Goldberg's greed, but by events unfolding during the spring of 1988 in Houston in connection with that other great rape of Cypriot art, the Lysi frescoes. And it answers the puzzling question: "Why then?"

That spring the Lysi frescoes were finally delivered to the Menil Foundation from the London studio of conservator Larry Morroco after four years of meticulous restoration work. Plans were taking shape for their coming out party for the American Byzantine scholarly community in November as the highlight of the annual Byzantine Studies Conference. I believe that as all of this was unfolding in Texas in the spring and summer of 1988, it must have occurred to more than one inquiring Byzantine art-dealer mind that now was the time to move on from Dikmen's first horde of stolen art, the Lysi frescoes, to his second, the Kanakaria mosaics. Could something as elegant as the laundering and eventual return to Cyprus of the Lysi trove be duplicated?

I learned an interesting detail during my paid pretrial reading that apparently no one in Indianapolis on either side found compelling, but I did. A passage in the Von Hapsburg deposition describes a meeting in Houston toward the end of August 1988, shortly after the Lysi fresco press release and celebratory article on Dominique

in *The International Herald Tribune*. It took place in a social setting, which I recall was a bar, and involved Yanni Petsopoulos, Géza von Hapsburg, and Walter Hopps. The two out-of-towners had come to Texas to see Walter with the idea that Dominique de Menil might now wish to buy the Kanakaria mosaics from Peg Goldberg, restore them, show them for a time in her museum, and eventually return them to Cyprus. Lysi redux. The deposition does not reveal whether that idea in any way resonated with Walter or would have worked for his boss Dominique de Menil. The conversation never got that far. The issue was money, and money took this idea off the table. Whatever price may have been quoted to Walter, it probably made no difference. There was a recession going on, the oil industry was especially hard hit, and Houston was suffering. Plus, the Menil Foundation was just then opening its spectacular new museum and had a $35 million tab to pay. Pretty much end of story.

According to Bill Honan of the *Times*, Géza von Hapsburg said in an interview that he told Peg Goldberg that "the most graceful way out would be to find a donor who would purchase them (the mosaics) and donate them back Cyprus." That had clearly been his aim in Houston in August. And I think this August encounter helps to explain why Walter was so eager to get his moral-high-ground sound bites in with that reporter from *The Indianapolis Star*—the sound bites that got the attention of the Goldberg defense team. Walter was venting, as usual. Petsopoulos and von Hapsburg had come to ask him to buy back a second batch of Cypriot plunder at a very high price when he was cash poor. And now, lo and behold, that very plunder was almost certainly going back to Cyprus where it belonged by way of a civil court action at no expense to anyone other than Peg Goldberg and her banker friend Nick Frenzel. Walter must have felt a bit smug about all of that, since he had already done his part for the poor Cypriot people.

Things could have turned out much differently. What if Peg hadn't "fallen in love" with those photographs that Michel van Rijn pushed across the table over lunch in Amsterdam on July 1st? Or imagine if Nick Frenzel, in his pajamas over the phone with Peg, had balked at the $1.2 million loan idea. Imagine what might have happened if this little conspiratorial group of bottom-dwellers, van Rijn, Fitzgerald, and Goldberg, had not moved so quickly and successfully to extract the mosaics from Aydin Dikmen in those frantic seven days in July, just as the Lysi fresco drama was beginning to exit the stage. There was, I suspect, a much classier alternative team poised for action at pretty much the same time.

This, of course, was the group already in place from the Lysi fresco adventure of 1983. And by contrast, they were aristocrats. There was the suave Greek dealer, Yanni Petsopoulos, descendent of an esteemed Constantinopolitan publishing family, now abetted by the Archduke of Austria, Géza von Hapsburg. And close by were Constantine Leventis of the enormously successful, hugely philanthropic Cypriot business family, as well as Walter Hopps, the UCLA-educated museum director, and, of course, Dominique de Menil herself, a French aristocrat of wealth and sensibility. Focus on the two leading ladies, Dominique and Peg: one is a soft-spoken spiritual wisp, while the other is big, boney, and brash. Both "fell in love," one to fix looted frescoes expertly and at great expense in order ultimately to give them back, and the other to fix looted mosaics hastily and poorly in order to resell them. One was perceptive, subtle, and generous of spirit, the other naive and greedy. But both were ultimately in cahoots with that same Turkish art smuggler in Munich.

So imagine it is the spring of 1988 and Aydin Dikmen is ready to part with those all-but-unsellable mosaics that have been moldering in his Munich apartment for years. And his price is $350,000. This figure is on scale with his price tag on the Lysi frescoes in 1983

which, when shown to me in April of that year by Yanni Petsopoulos, with his deal-maker's markup, was $600,000. Imagine that order of magnitude and no Peg Goldberg with Nick Frenzel's bank account to jack up the price, and then revisit that conversation in Houston in August 1988. The aristocrats might well have pulled off Dikmen chapter two with the elegance they pulled off chapter one. The mosaics would have been restored at Dominique's expense and for a time they would have been shown in her new museum. But ultimately, and to much acclaim from all sides, they would make their way back to that tiny new Byzantine Museum in Nicosia to be installed beside the Lysi frescos she also paid for.

But that didn't happen, because Michel van Rijn acted first. I have never met Michel van Rijn, but I think I know him—from his actions in this case, from Dan Hofstadter's book, *Goldberg's Angel*, in which he has plenty to say, and from his own self-serving confessional, *Hot Art, Cold Cash*. But most of all, I know Michel van Rijn from the bizarre rant of a steroid-driving website he posted until he was sued for libel and had to take it down. He was flat-out vicious on that website, using crude pet names for people he didn't like, which was mostly everyone.

Certainly Michel van Rijn was and is always motivated by money, and he seems to enjoy lying, but there is an overriding pernicious streak in him that reminds me of that kid I knew as a child who liked to put salt on salamanders just to watch them squirm. I can image the adrenaline high of fixing the aristocratic asses of Yanni Petsopoulos, Walter Hopps, and Dominique de Menil all in one stroke by using that crude hammer of Peg Goldberg. And in the meantime, making on the deal more money than Aydin Dikmen by a factor of two. Therein, I think, lay the ultimate prime mover of the Kanakaria caper of 1988. It was a simple question of timing, and the most greedy and mean-spirited of all the players, Michel van Rijn, jumped first.

I SAW THE KANAKARIA MOSAICS only once. They were on display in a small exhibition at the Indianapolis Museum of Art. I attended the opening on Friday, May 30, 1991, two years to the day after my first epiphany on the courtroom bench a few miles away. The Greek ambassador spoke, and everyone seemed happy. Insofar as I could tell, Peg Goldberg was not there. Peg and her legal team had appealed Judge Noland's decision to the United States Circuit Court of Appeals for the Seventh District, in Chicago. (As she said at the time: "George [her business partner] and I have never been quitters, particularly when we believe we have been grievously wronged.") Peg's agenda was driven not by anything new and exculpatory in her story, which no one really contested, but rather by her passion to prove that the other guys had dirty hands too. Her appeal was an attempt to deny the Cypriots legal standing on grounds that they "sat on their rights." That is, they had done next to nothing to find and get back the Kanakaria mosaics when they could have.

The appeal cited new evidence from a Yugoslav named Savo that cast further doubt on the integrity of the Cypriots' due diligence. Specifically, Savo claimed that it was generally known that Dikmen, Leventis, Karageorghis, and Petsopoulos did business with one another, buying back looted Cypriot art, before that initial viewing of the Kanakaria mosaic in Dikmen's apartment in June 1983. (Aydin Dikmen seemed to enjoy some magical immunity through all of this. No authorities went after him directly until 1998, when, ironically, or maybe not, Michel van Rijn played the key role in fingering him. More than fifty crates of art were seized.)

Savo's testimony notwithstanding, Chief Judge Bauer upheld Noland's decision in October 1990, in rapturous tones that followed upon the recitation of the opening lines of Lord Byron's *The Siege of Corinth*. Not only the spirit but the letter of James Noland's decision

prevailed. An attempt was then made to get the attention of the Supreme Court, but in the spring of 1991 that was turned down. So finally, the trip back to Cyprus was scheduled for July 1991 after this Indianapolis exhibition.

The reception of the recovered plunder by the Cypriots was rapturous as well. Thousands turned out. The president spoke, Archbishop Chrysostomos spoke, Judge James Noland was lauded, Tom Kline was lauded, and maybe my name was mentioned. I do know that I got a signed card from the President of Cyprus, George Vassiliou, and his wife that Christmas. It had a photograph of the Kanakaria Archangel on the front. He said I should visit, but I never did.

Chapter Eleven

"Vomiting Blood!"

A*frican Zion: The Sacred Art of Ethiopia* was both cursed and a great triumph. The show was scheduled to open at the Walters in October 1993 and then travel over two years to seven US museums, four of which are devoted to African American culture. It was the first-ever exhibition focused on the Christian art of Ethiopia, and it had spectacular loans coming from remote monasteries all over the country.

Ethiopia is the Old Testament Cush, and its inhabitants are the descendants of Ham; it lays claim to the Arc of the Covenant by way of King Solomon and the Queen of Sheba. These "tall, handsome, and long-lived" people, as Herodotus described them, converted to Christianity in the early 4th century by way of two Syrian missionaries. Ethiopia's Christianity has a unique admixture of the Judaism from which it sprang and co-existed with for seventeen centuries; it has dietary laws and observes the Sabbath on Saturday. Ethiopians built their greatest churches around 1200 in Lalibela, as monoliths of volcanic rock carved down into the earth. Theirs is a unique manifestation of ancient black Christianity in the Horn of Africa; their sacred language, Ge'ez, is preserved to this day.

Ethiopia's sacred art dates mostly from the 15th through the 18th centuries. It looks a little like early Italian panel painting

167

and a little like Byzantine icons, but is distinct from both. Its colors are much richer and more varied; its faces are clearly Semitic, with large, black, staring eyes; and its crosses elaborate wildly on the simple cruciform that defines crosses in rest of the Christian world. Ethiopia's greatest painter, Fere Seyon, is a match for his two renowned 15th-century contemporaries, Rogier van der Weyden in the Netherlands and Fra Angelico in Italy. But despite my Princeton PhD and ten years at Dumbarton Oaks, before this exhibition I knew next to nothing about Ethiopia and its art.

The idea for the show was brought to me in 1986, during the International Byzantine Congress, by a brilliant St Andrews-trained scholar of early Christianity named Roderick Grierson. Striking in his stylish cowboy boots and fancy suit, Rod then ran a tiny non-profit called InterCultura, whose scruffy office was above a dentist in a two-story commercial building in Fort Worth. As we stood in the Walters lobby, Rod quickly sketched out a vision for future collaborations that I immediately bought into. The idea was to bring the exotic flavors of Orthodoxy and its art to America through a series of exhibitions, and he picked the Walters as his preferred partner. I assumed this was because of the critical success of *Silver Treasure from Early Byzantium*, the attraction that August day for participants in the congress. Rod's role would include the diplomatic negotiations and logistics, the scholarly team, and the catalogue; my role would be to create the exhibition and secure the venues for the national tour. The enormously successful *Gates of Mystery* was our first collaboration in 1992 and *African Zion* our second and last, as InterCultra imploded.

IN JUNE 1993, FOUR MONTHS BEFORE the exhibition opening, I learned that monks in the highlands around Tegre were vomiting blood. Or maybe it was just one monk. It made no difference; this

was not stomach cancer or ulcers, it was a sign from God that they should not lend their sacred books to *African Zion*. And it seemed to be contagious; that divinely induced anti-lending sentiment was pervasive among the monks and priests not only in Tegre, but also in the Lake Tana region and around Lalibela. In fact, it was so pervasive that it looked as though we were going to lose two dozen loans. We had to do something fast. The Walters has a very small temporary exhibition space, but not so small that this reduced show wouldn't look puny. We needed to fill a third of that space with something else. But what?

By good luck, a photographer for *The New York Times* named Chester Higgins, Jr. had a feature spread about that time in the *Times Sunday Magazine* on the diaspora Ethiopian Orthodox community in Yonkers. This is a vibrant group of Ethiopian immigrants whose images of Jesus are fully black—as the Ethiopian Jesus never is—and with a huge Afro. Not only that, they then had their own schismatic leader, Archbishop Abba Yesehaq, who had declared the Ethiopian Orthodox Church in the Western Hemisphere independent of the mother church—which put him in direct opposition to the recently-appointed Abune ("father" or Patriarch) Paulos in Addis Ababa.

I went to see Chester Higgins at his home in Brooklyn, and he was eager to do a show of those prints in the final third of our temporary exhibition space. We called it *A Legacy of Faith: Ethiopian Orthodoxy in America*. And by another piece of good luck, I learned of a New York dealer in African art named Joseph Knopfelmacher who had an excellent collection of Ethiopian works, and he was eager to lend. So I was cobbling things together and hoping for the best or, rather, hoping that the worst was behind me. Though on some level, I knew that if the religious forces energized by divine gastronomic distress far from Addis Ababa had the power to withdraw so many loans, then nothing in the show was safe. But for the

moment, *African Zion* was back on track. Little did I know that the worst was yet to come—and his name was Paulos.

I F A WALTERS EXHIBITION HAD RELIGIOUS ART as its focus, like *African Zion,* we would invite the head of the National Church, who in this case was the Abune Paulos. And much to my amazement, the Abune decided to come, not only for the members preview but also for the press preview three days before. In fact, His Beatitude had built his week's activities around the Walters, and it all looked very impressive. His itinerary, which was faxed "eyes only," had him giving a speech before the UN on Monday and meeting with President Clinton on Friday, and then, tacked on after Baltimore, was an excursion to Georgia for a consulting session with President Jimmy Carter. As it turned out, none of those planned events ever took place.

Of course, since I had invited the Abune I assumed that the Walters would have to pay. Too late to revisit that. And when I learned that His Beatitude was coming with six Archbishops, this had the makings of a financial catastrophe. But gradually I warmed up to the idea. After all, we'd have the publicity. This was great, but just as important, I was led to believe that those accompanying Archbishops were going to bring along a half dozen of our missing Ethiopian manuscripts from out there in the hinterlands. That would make them official couriers, which means I could expense them to InterCultura and the tour. What luck.

Plus, I saw the Abune's CV and, wonder of wonders, he had done his PhD at the Princeton Theological Seminary in the same years that I was a PhD student in art history at Princeton University. Maybe I already knew him, but if not, we would surely hit it off since we had so much in common. So I decided to host a party for the Abune at my home on Friday, October 15th, the day before the

members' preview. What could be better than an Autocephalous Patriarch of the Orthodox Church in my house, in his flowing robes and ceremonial hat. I had a very good friend who was a caterer, and she would do an Ethiopian meal. It would be perfect.

Well, not so fast. I now recalled my brilliant idea for the last third of the show, the Chester Higgins photo essay on the schismatic Ethiopian church in Yonkers. I never expected that the "real" Abune would ever see the exhibition, so it never occurred to me that should he see it, he would certainly be profoundly insulted to discover that his nemesis, the rebel Abune, Archbishop Abba Yesehaq, was being celebrated. (Only later did I learn that Paulos and Yesehaq, by then arch enemies, had been boyhood friends and Princeton classmates.)

But not to worry; I could solve that. I knew that Chester Higgins had also taken a portrait photo of the Abune Paulos, so I asked if we could borrow it, and I put it prominently at the front of the exhibition. I made the assumption that the Abune would see the exhibition only in my company—this was how it worked with dignitaries—and therefore, I could take a large, folding room divider and block off the last third of the show so he would never figure out that it even existed. Brilliant. Another fire was put out.

I came into the Walters house, #5 West Mount Vernon Place, on the Monday preceding the Saturday members preview for *African Zion* when the Abune and I would be on the stage together at the Walters. Our receptionist told me that she had received many calls that day relating to the upcoming visit of the Abune Paulos. She said Howard White, our head of PR, was tracking them and wanted to see me right away. Fine, so much for the secret itinerary. In came Howard, and his story was so strange that I recall being initially irritated at him because I thought he might be making it up. More than sixty calls had come into the Walters switchboard, and they were all from angry Ethiopians living in the area. (By that time I knew that

Washington, DC, had the largest Ethiopian community in the coun-
try.) They were all enraged at the Abune Paulos, a few to the point of
threatening his life. They saw him as a puppet of the current repres-
sive president, who had recently been associated with the massacre
of more than a dozen worshippers in a church in Gondar Province.

This I knew nothing about, but I figured we had a problem. And
to make things worse, we were without a director; Bob Bergman
had gone to Cleveland in May and his successor, Michael Mezzat-
esta, had been welcomed to Baltimore in late June but would only
be official as Director at the end of November, which was six weeks
off. The Acting Director was the Walters Director of Development,
Kate Sellers. But this was my show; I was the one who invited the
Abune and I saw this as my problem to fix. There was no graduate
seminar on this at Princeton University.

This was a job for the State Department, I thought, and in no
time, a young spokesman for the Bureau of African Affairs was sit-
ting next to me at the conference table in the director's office. His
message was brutally simple: the State Department considers a
threat against the head of the Ethiopian Church on a level of seri-
ousness only a short rung below a threat against the president of
the country. But no, the State Department does not provide protec-
tion, that's the job of the Baltimore City Police. So the next thing
I know, its Tuesday afternoon and I'm showing a Baltimore police-
man around the museum and describing the threatening phone
calls. His advice was also brutally simple: keep him away. And the
reason was obvious. When the doors of the museum opened at 7:00
p.m. that Saturday evening for the members preview, we expected
to receive more than 2,000 people in a matter of a few minutes. We
had no metal detectors and no way to screen those many people.

I had by that time read the account in *The New York Times*
of the Abune's misadventures the day before in New York City. It
seems that he attended a dinner meeting at a restaurant with some

church dignitaries and as they came and went, protesters threw eggs and rocks, and windows were broken. That gave chilling credibility to the threatening phone calls, but it also suggested to me what I later learned to be true, that the Abune was not interested in a low profile and discretion. On the contrary, he seemed eager to confront the protesters and receive their abuse. "My office," he would later say in *The Washington Post*, "is not to run away. It is to listen, to be insulted. . . ." I called the Abune's Princeton thesis advisor, my friend Kathleen McVey, and asked her what kind of person he was; would he be reasonable? Her answer was academically round-about, but my interpretation was, no, or at least probably not. So I scrapped the idea of the party at my house.

On Wednesday, mid-morning, Black Entertainment Television was setting up their cameras for the press preview just outside the temporary exhibition space. I was in the parlor of the Walters house, all by myself, awaiting the Abune and his entourage, who were flying into Baltimore-Washington International Airport from LaGuardia. Howard White had rented a van to pick them up. I had no idea what to expect, but although I was not optimistic, I could not then have imagined how bad things would get, and how quickly.

I can still see them getting out of the van, slowly: six bearded men all in black with bulbous black hats of wrapped fabric shaped like large, squat balls. They were followed by a single bearded man all in white with a fabric hat shaped like an inverted cone. And finally, there was a man in a cheap reddish-brown business suit. His Beatitude, of course, was the one in white and the man in the suit I was led to believe was his brother and his spokesman. Howard White was the last to leave the van and when he did, it was obvious that those half-dozen manuscripts I expected to see were in fact just one manuscript. It was large and carried by one of the Archbishops. It had no box or wrapping of any sort, but it did have a man's belt tightly buckled around it. He carried it by that belt tab.

They all came into the parlor and we sat there together in a circle, in silence. I offered coffee and tea and asked about the other manuscripts, the ones we had built exhibition cases for and that were now open and awaiting their content. No reply was the reply, which was typical of our non-exchanges going forward. I explained to the "brother-spokesman" that the press preview was about to begin, but that I first wanted to give His Beatitude and Your Eminences (the six in black) a brief tour of the exhibition. So we processed, single file and very slowly and solemnly with the Abune at the back, through the Walters house, then though the metal security door that leads directly into the third floor of the Walters palazzo. And finally, we went down the freight elevator to the first level of that building to the temporary exhibition space lobby where chairs and cameras were set up for the press preview.

As we walked toward the exhibition's entrance, the Archbishop carrying the large manuscript with a man's belt asked me when the opening was, and I said Saturday. He responded, "Good, because we're leaving to return to Ethiopia early next week." In that instant I realized two scary things. First, he assumed that the *African Zion* "exhibition" was a one-day affair and that one day was Saturday. This meant that he was taking that big manuscript back to Ethiopia next week.

And second—and this really frightened me—I thought that the Abune might "call in" the entire show after that one-day opening. I thought that we had a fundamentally different idea of what an exhibition was about, and that His Beatitude had the power and perhaps the intention to end the show after only one day. I was immediately so angry that I told that Archbishop with the one big book that if he was going to take it away the next week there was no sense in putting it in the case and showing it at all. He should just take it away right then, and I didn't even want to look at it. And then, I wondered how this would look in the newspapers. What would the headline be?

Numb is the right word. I was numb. The tour of the show was very brief. The Abune had no reaction to his Chester Higgins photo at the beginning and seemed not to notice the room divider closing off the last third of the exhibition space. We did though have a brief exchange in front of a 15th-century icon when I made the mistake of describing it as having been influenced by early Italian panel painting. His Beatitude used the word "autochthonous," which I had never heard anyone else use before, and in using that word he was insistent that Ethiopian icons were 100 percent indigenously Ethiopian and that there was not any outside influence.

And when he bent over to have a closer look at the icon I was talking about, I noticed a deep dent in the top of his head. And I recalled that before he became Ethiopia's Abune he had been imprisoned by the Communist regime for seven years and tortured. So yes, we were at Princeton together, and yes, we both understood what autochthonous meant, but beyond that, Gary Vikan and the Abune Paulos could not have been more completely different. The press preview came and went with the Abune in his remarks making it a point to restate the truism that Ethiopian icons and manuscripts are like no others in Christendom—that they were the unique creation of the Ethiopian Orthodox people.

And now the time had come for the heart-to-heart, and by that I mean the difficult conversation about the necessity that the Abune stay away from the Walters on Saturday evening. I had my friend from the Baltimore City Police at my side, and I thought it best that I make my case to the man in the suit, the one I understood to be the Abune's brother. I pointed to the glass entry doors just to my left, referenced the 2,000 or so visitors who would be crowding through those doors on Saturday, and told him about the threats to His Beatitude's life that we had received over the phone. I suggested that for their safety, the Abune and his group would be wise to stay away on Saturday.

Well, this did not go over at all well, and in fact, the brother's
reaction was so swift and unequivocal and so angry that I suspected
that mine was not the first of the Abune's recent disinvites. What I
was told then, for the first of many times and with only slightly variant
wording, was that for me to withdraw my invitation to His Beatitude
to the opening of *African Zion* would be a profound insult not only to
His Beatitude but to the whole Ethiopian Orthodox Church, which
numbered nearly 40 million people. I had never bargained for this.

AFTER THE PRESS EVENT, THEY all piled into a van and were off
to Washington, DC, for an audience with the Dean of the National
Cathedral and a different set of protesters with a different set of eggs
and rocks. I then had a great idea: there would be *two* openings on
Saturday, one private, with just VIPs, for His Beatitude and his entou-
rage in black, and the other would be the regular members preview,
sans Abune Paulos and friends. A perfect solution, I thought, and I
called brother, via the Embassy of Ethiopia, to let him know that we
had moved beyond the disinvite to a happy, special place, and while
I'm not sure I heard him say yes, I certainly did not hear the word no.
I took that to mean we were on for Saturday, in the parlor of the Wal-
ters house, with our Mayor Kurt Schmoke and Congressman Kweisi
Mfume, both African Americans, and the latter the honorary chair-
man of the exhibition committee. We were to converge at 4:00 p.m.
with some fancy *hors d'oeuvres*, some appropriate celebratory remarks,
and a private tour for the group which, all in, probably numbered no
more than a dozen people. This meant that by 6:00 p.m. the bearded
prelates would be gone.

Well, perhaps the brother did say no and I just didn't hear
him. In any event, 4:30 p.m. Saturday came and went, and it was
now 5:00 p.m., and a few in the VIP group had to leave for other

engagements. I had no way of reaching the brother, who, I had to assume, was on his way in the van with his sacred, bearded cargo. I wondered if they were lost. Maybe one of the protesters had injured the Abune, or worse. Then the phone rang and it was the brother, asking for Vikan. It seems that the group was still at the ambassador's residence in DC. It was after 5:00 p.m., and they hadn't even left yet! A little mental math put them at my doorstep at 6:30 or so, a half hour before the members' preview was to begin. I decided that I would give those patient VIPs in the parlor a quickie tour of the show and get them out the door. The Abune and his friends would arrive around 6:30, and I'd give them a super-quickie tour and get them out the door before 7:00 p.m.

What was going on outside, and had been going on since the early afternoon, was a crowd of protesters. There were lots of them, and it seemed to me that they all had grocery bags that sagged, as if perhaps filled with big rocks or eggs. If you could see the Walters' city block from above, looking south, you would see that the main entrance is at the south center of the block on Centre Street, at 12 o'clock. The entrance to the palazzo is at 9 o'clock, and the entrance to the Walters house, #5 West Mount Vernon Place, is at 6 o'clock. The protesters were at all three entrances, and I have no idea how they knew that the Abune came and went through the Walters house, but they did.

I went outside to mingle. And why not? No one knew who I was or what I looked like. I started to ask some questions and before I knew it someone asked me if I knew who "Vikan" was. I didn't respond. But he had a message for me to convey to this Vikan guy, and it was that "Abdul" somebody was looking for him. I didn't think that sounded like a good thing.

It was almost 6:30. Two Baltimore televisions stations had shown up and klieg lights were all over the place. Traffic had been stopped on Centre Street, and there appeared to be more than one thousand

Walters members milling around in the street with a smattering of the protesters with grocery bags among them, and plenty of police.

There was one fortunate thing: the klieg lights and TV stations attracted most of the protesters to the museum's entrance at the south side of the Walters block. So when the Abune's van finally arrived at 6:30 and pulled up at #5 West Mount Vernon Place, most of the protesters were elsewhere. This meant that the Baltimore City Police stationed there were able to keep a small group of protesters waving signs and holding sagging grocery bags at bay (with Mace and night sticks at the ready) as the sacred procession slowly went by. And there I was, taking pictures.

I had a quick conference with the brother. I told him we would have a tour, a really short one, and then it would be time to get back in the van since this was not a safe situation. Again, I don't recall much of a response, but then, that was the way we communicated. We replicated the procession through the museum of the previous Wednesday and, at the precise spot just outside the exhibition where the Archbishop with the book told me he was soon to take that book away, we paused. The Abune was at my side. Kate Sellers, the Acting Director, was standing and listening, and the Director-to-be, Michael Mezzatesta, was standing and (I thought) not listening. (I have no memory of him at any other juncture that evening.) And for some reason, I guess because things were heating up during the week and he couldn't be there himself, Bob Bergman had sent his brother Edward in his place, all the way from New Jersey. Ed was energized and standing at the ready.

What happened next I could not have scripted in the most bizarre moments of my distorted thinking. The Abune's brother turned to me to ask if I had a quarter. Did I have a quarter? What was this about? Well, I did, and I gave it to him. And *tout de suite*, he disappeared down the hall, and then reappeared. He had a message for me. He told me I had a call. This meant that he had placed

a call for me on the pay phone next to the entrance to the palazzo. He said, "It's the ambassador." "Great!" I responded.

So there I was, sitting in the darkened cloakroom at the palazzo entrance on one of those tall cylindrical ashtrays, maybe three feet high. I will never forget what I heard. "Is this Gary Vikan? This is Ethiopian Ambassador so and so; I have called to tell you that I consider this an international incident, for which I hold you personally responsible."

Well, I now assumed I had reached the bottom. It can't go any lower or get any worse. An "international incident"? I suppose the whole idea went back to the "insult" to His Beatitude, to the Ethiopian Orthodox Church, and now, to the entire nation of Ethiopia, committed by me in withdrawing my invitation to participate in Saturday evening's members preview.

The crowd, the lights, the TV cameras, and the protesters were all visible, some thirty feet away, through the double set of glass doors of the museum's main entrance. Luckily, there was a tall iron gate, still locked, that separated those glass doors from the sidewalk and the crowd. We inside could see them, and anyone out there who tried could see our little troupe inside: two versions of the director, me, the PR guy, our head of security, Bob Bergman's brother, six bearded prelates in black and one in white, the guy in the reddish-brown suit, and finally, a Baltimore City cop. That's what I remember.

All congeniality was now gone. I said to them that I would give the tour and that then they must go. The Abune replied that he had already seen the exhibition, so no tour was necessary. But he was not going to leave—he was not going to be insulted. I hadn't yet shown the brother the auditorium and its entrance was just to the side of the entrance to the exhibition. I thought it was worth a try. There we were, inside the door of the very large Walters auditorium, looking down toward the stage. "See that stage," I said to the brother. "To

get there to give his remarks, His Beatitude will have to walk down that aisle, past at least four hundred in the crowd, and we have no way of controlling who those people will be. Any among them could leap up and attack the Abune." At this point the brother topped the behavior of the ambassador. He said: "I would rather have the Abune's blood on this carpet than have him insulted." Blood! This whole miserable misadventure in hyper-religiosity began four months earlier with vomited blood, and now we're talking about martyr's blood, not in the hinterlands of Ethiopia but right here in the Walters auditorium.

But he wasn't done with me yet. Brother then moved on to the "apology." I must now apologize for insulting the Abune. Not only that, it had to be before television cameras. And what would that get me in terms of his departure from the Walters? Nothing, it seemed. So for the second time that week I got really angry. I refused to apologize, since I had nothing to apologize for.

But I thought of a tactic that might just be my salvation. Howard White could say some nice apologetic-like things. And as for the TV camera, I sent the head of security to get our new camcorder, big and bulky and official looking. He was the "TV cameraman" and Howard White was the apologizing spokesman for the Walters and, I suppose, for all America. We quickly brought out a podium and some chairs for the "audience," which consisted of the prelates, Ed Bergman, our two versions of Walters Director, and a few others. The brother protested as, this time, did the Abune himself, saying: "This is not a real TV camera and that is not a real TV reporter." But we barreled ahead with our little charade. A vague, micro-apology was made, to which we received no reaction. But then, that was typical.

By this time it was 7:00 p.m. and the crowd was pressing toward the iron gates, expecting them to be swung open and the festivities to begin. I had no indication that my Ethiopian guests would *ever* leave. In fact, I was pretty sure that he and all of them were enjoying

the metaphorical martyrdom of the "insult" to which I had subjected them. And they had this huge audience and real TV cameras just a few yards away. I was standing next to the Baltimore City cop, just inside the glass doors. He was fully aware that we had reached the climax of this crazy event. I can still see his face, and see his hand now resting on that wooden nightstick of his on his belt.

He had a question that startled me: "Do you want me to take him out?" Wow! The "out" part I took two ways. The second was that he'd escort him "out of the building," but the first was the critical "out." I took that to mean that he, the cop, would act with some force, and that he might just have to bop the Abune on his already-dented head to give him some attitude adjustment. (I had gone far enough along these lines in my thinking to wonder how that would mesh or not with his inverted-cone fabric hat.) Well, that's brilliant, I thought. A white Baltimore cop roughing up an Ethiopian Patriarch dressed all in white in full view of hundreds of people and the cameras of two Baltimore television stations. The ambassador, the State Department, the press, the headline ("International Incident at the Walters") together would spell the end of Gary Vikan's museum career.

It was time to cut bait. I sent Howard White to find some poster board and a magic maker. This seemed to take forever. And I quietly told my friend the cop that for now, I was going to do nothing—absolutely nothing—and that in two hours, at 9:00 p.m., we would revisit our options. I also told him and the rest of the Walters crew that under no circumstances were they to tell our Ethiopian guests where the bathrooms were. (There were none on that floor, which was good.) As for the poster board and the magic marker, I told Howard White that the members preview was now officially canceled and he should write something to that effect on the poster board and wedge it between the bars of the iron gate. He did, and it read: "CANCELED. Dear Members Please Go Home." This seemed odd to me—that he instructed our members to "go home."

Once that sign was in place our world suddenly changed. The Abune and his group stood up in unison and walked the fifteen feet over to the freight elevator, pressed the up button, and all got in. It seemed like magic. I thought I was all but free. But suddenly my claustrophobia kicked in, and where did everyone go? These eight Ethiopians had finally decided to leave, but I could not force myself to get in that elevator with them. Then Ed, Bob Bergman's brother, suddenly appeared and manned the elevator, the door closed, and I raced up the steps. They processed slowly though the building, retracing their path from forty-five minutes earlier. I got ahead of them, and by the best of luck, all the action on the Centre Street side of building meant that there were no protesters or cameras or cops on this side of the building. Miracle of miracles.

But the van? Howard, where is that goddamn van? Run! It finally appeared, and they made their ceremonial exit from the Walters house. I stood in the door of the double parlor as they walked passed me, down the narrow hall to the door, down the steps, and into the van. This happened very, very slowly. And each one, including the brother, stopped in front of me as they departed and gave me a hug. Each one, and that made for eight hugs. Did I take that to mean that I was their "brother in Christ"? That we had bonded through this ordeal? Or, that I had given them what they wanted, an "international incident" with symbolic martyrdom? I have no idea.

The van pulled away from the curb, went the half block down Monument Street, then took a left down Cathedral, all very slowly, and I walked alongside the van up to the light at the intersection of Cathedral and Centre Streets. The TV cameras, the protesters, and the rejected members were all caught up in a flurry of activity at the museum's entrance, no more than twenty yards away from the van. So no one noticed as it quietly slipped away and went south back to Washington, DC. I was finally free. So I strolled over to the TV cameras and did some interviews. Happily, the protesters joined in;

they weren't angry at me, it was the Abune they hated, and the Ethiopian president who appointed him.

"DEAD CAT BOUNCE." I KNOW it's A Wall Street term, applicable to a brief upturn in the market that typically follows a huge sell-off. The idea being that even a dead cat, if he falls far enough, will bounce. But I like it and use it for my own purposes. *African Zion* had a version of the dead cat bounce the next morning, Sunday, October 17th. I was there at 11:00 a.m. when those glass doors opened and people started pouring in. It seemed wonderful. It was as if last night, last week, were a bad dream and now I'm awake.

But not so fast. I was sitting behind the entry desk with the folks selling tickets, and in comes this scruffy looking guy in military fatigues with a fist full of Xeroxed flyers. I could see that his hands were covered with that white paste that we had in grade school that some kids were fond of eating. And his eyes looked totally crazed. He gave me one of those flyers of his, said nothing, and was out the door. I'm then looking at a virulently anti-Semitic statement from the "German-American Voice," signed by its chairman, Duncan Edmister, whom I take to be the guy with the paste on his hands. I get it, he has no idea what this show *African Zion* is about, but it must involve Blacks and Jews.

At that instant, I was looking out the glass doors of the museum toward where all the action was the previous evening. There was a cop car, and I ran out the door to flag it down. But it was gone. But then, out of the corner of my eye, I saw Mr. Neo-Nazi gluing one of his flyers to the light pole at the corner of Charles and Centre Streets. So I ran that way. (What, after all, could he do to me?). And when I got to the corner, I saw him turn into the Peabody Mews alley that bisects the Walters' block. I ran again. And then, at the far end of the

alley, I saw him disappear around the corner of Cathedral Street. So I ran that way. But that's the last I saw of him. I felt good about myself, and that little cat and mouse game added a bit of unexpected luster to my performance the previous evening and, in fact, the whole week. I was taking charge of things. I was being the boss. And I liked it.

I took the flyers down and returned to my spot with the Walters ticket sellers. In just a few minutes I looked up and one of our docents was beckoning me to step over near the entrance to the show. I obliged, of course. It was getting crowded, and it was not even noon. "What's up?" I asked. Well, she said, that gentleman over there, the tall one, is looking for you. His name is Abdul. I froze. And he was coming my way and reaching out! It was big hug #9, and I had never even met the guy. He said he wanted so much to thank me, in person, for bringing the art of his native country to America. And he made the point of telling me he was Muslim.

AFTER THOSE BIRTHING PAINS, *African Zion* blossomed into an enormous success. It was critically praised in *The New York Times*, was celebrated far and wide in the media, and it drew wonderfully large and diverse crowds in Baltimore and throughout its national tour. Not only did this exhibition introduce a rich, sophisticated, and profoundly spiritual artistic tradition that virtually no one in America had previously encountered, it brought before us all the provocative truth that Jesus, a Semite like the Ethiopians, was "a man of color." I loved all of this, and I was eager to buy some Ethiopian art for the Walters, some icons and illuminated manuscripts, and a few of the elaborate bronze processional crosses. The trouble was, no Ethiopian art was then for sale.

It was the middle of May 1995, and I got a call from a wonderfully generous and good-spirited art dealer in Soho named Bill

Wright. He was about to offer items for sale from the collection of Joseph and Margaret Knopfelmacher. There were a large number of Ethiopian icons, manuscripts, and crosses, some of which had been in *African Zion*—and he was giving the Walters first pick. I immediately went to see Bill at his gallery on Houston Street in what appeared to be abandoned warehouse with an open garage on its ground floor. I gathered up my courage and went up to the 4th floor on a rickety freight elevator activated by a bent coat hanger dangling from the ceiling and entered a cramped but sparkling new white exhibition space with a shiny pine wood floor. I found it filled with the most wonderful Ethiopian art I could imagine. Bill said I had my pick and offered me a box of those little sticky red dots to put on the icons and what else I wanted.

They were magnificent, and at just $10,000 or $15,000 each, they were so inexpensive that I thought I should get out my credit card. I was there for less than an hour and it took only two passes to find fifteen pieces I wanted for the Walters. Among them was a huge, spectacular, and extremely rare painted liturgical fan. At $60,000, it was by far the most expensive item. We were just then beginning to plan the reinstallation our Centre Street Building, and my heart was set on giving special emphasis at the center of the new medieval galleries to those Ethiopian works that I had just blessed with the little red dot. But I had a problem: Our acquisition budget, the Jones Fund, had a very small balance in it. How was I going to come up with the $200,000 I needed to redeem those works now marked in red?

Time went by and I waited. Bill Wright called me, and then called me again, and again. It seems that the Minneapolis Institute of Art wanted some of the works I had marked; they had the money and were ready to pay. I needed to come up with the cash or Joe Knopfelmacher's wonderful pieces from Ethiopia would go to Minneapolis. Wait, I told him; Bill, please wait. By then it was the middle of December, and Bill Wright finally said time's up. He had

to sell. He had given me all the time he could, and now my option is up. I asked for just three weeks, until the end of the first week in January.

My hope was for a year-end market rally. I was hoping against hope that the Jones Fund would surge through the ceiling of the Dow and that by year's end I would have the cash to pay for what my red dots had reserved. Thankfully 1995 was not 2008. The market did its good work, the Dow was up that year by more than 30 percent, and our Jones Fund went up with it. It was just enough, in the end, to pay my friend Bill Wright and to bring to Baltimore what was, and remains, the finest collection of Ethiopian art outside of Ethiopia.

Eighteen months later, in August 1997, we had a joyous opening celebration to welcome our new collection of Ethiopian art to the Walters. Mayor Kurt Schmoke, Governor Parris Glendenning, and Congressman Elijah Cummings were there, along with state legislators and local VIPS. And the Ethiopian ambassador was there, too. It was a high point of my life. There I was, standing next to Ambassador so and so, and I asked him, "Were you the ambassador in 1993?" He said yes, and smiled. I smiled back, thinking oh, yes, the dead cat bounced.

Chapter Twelve

My Father's Obit

A second, smaller, and certainly quieter opening party for *African Zion* was scheduled for Saturday, November 6th. Much had changed at the Walters and in my life during those three intervening weeks since the cancelled members preview of October 16th. What I learned in that crazy week leading up to the 16th was that I enjoyed taking charge. There was an eminently competent acting director always near at hand, Kate Sellers, and the director designate, Michael Mezzatesta, appeared every now and then, but I was the one who took the leadership role. I found I liked it, and was good at it. This was one important change, but I could hardly have expected that it would converge with two other watershed events in my life, both of which unfolded between 5:00 and 6:00 p.m. on Thursday, October 21, 1993—totally by coincidence. What was the first clue that something was different? If someone were very attentive, they might have noticed that on that Saturday evening of the rescheduled members preview, when I was on stage at the podium, I was wearing a new suit. It was the first in years. But it was much more than a new suit; it was the bearer of its own meaning.

Carol Vogel of the *Times* called what had happened the "Battle of Baltimore," and Paul Richards of the *Post* called it the "*affaire* Mezzatesta." The story had broken in *The Baltimore Sun* on

November 11, 1993: "Walters axes choice for director." The previous day, the Board of Trustees of the Walters had formally withdrawn the offer it had extended to Michael Mezzatesta to be the museum's new director to replace Bob Bergman, who in May had gone off to be Director of the Cleveland Museum of Art. This was done despite the fact that the Baltimore mayor and the governor of Maryland had both enthusiastically and very publicly applauded the new appointment when it was announced at the end of June with multiple public appearances and a celebratory press release. Although the effective date of Mezzatesta's appointment was, on the day he was officially fired, still three weeks away, he was already in the possession of the director's credit card, had moved into and begun redecorating the director's office, and for more than three months had been meeting with staff to plan projects and exhibitions.

Technically, though, Michael Mezzatesta had not yet signed a contract with the museum, nor had he formally resigned from his previous job, which was Director of the Duke University Museum of Art. A few weeks earlier, on October 21st, the Walters board leadership had asked Mezzatesta to go away quietly but he had refused; legal counsel was retained, various threats made, and a financial settlement eventually reached.

The Walters had not gotten that much bad national press since the summer of 1988 and the debacle of the art theft by the head of night security. The official version of the back story, as presented by the out-going Board President, Jay Wilson, was that there were "irreconcilable differences . . . of vision and values," and a disagreement on compensation. What apparently had been an adequate salary in June was inadequate by October; moreover, Mezzatesta reportedly wanted a significant increase in the director's contingency fund. It was also clear that his commitment to contemporary art was more aggressive than the board had initially imagined, and there were already signs of friction with the staff.

A more nuanced and in-depth investigative piece by Kathleen Renda appeared in the January 1994 issue of *Baltimore Magazine*. In it the events of the *affaire* Mezzatesta are made to unfold in real time, with quoted dialogue, through the eyes and sensibility of Jay Wilson. The moment of high drama comes in the later afternoon of Thursday, October 21st when Jay and incoming Board President Adena Testa ask for a private meeting with Michael Mezzatesta in the director's office. According to the Renda article, Jay Wilson's first words were: "I've got some bad news for you." At that moment I was in my office on the fifth floor of the Walters 1974 Wing; soon I would go down to the auditorium to introduce America's leading authority on Ethiopian art, Marilyn Heldman, who was going to speak on illustrated Ethiopian manuscripts. My phone rang, and it was my sister Linda. She said she had some bad news for me. Our father Franklin had developed severe jaundice and had been taken to the hospital. It wasn't another episode in his struggle with diabetes; they thought it was cancer.

MICHAEL MEZZATESTA HAD COME TO see me in Baltimore in May to ask if I thought he should apply for the Walters directorship. I said yes, and I would say nice things about him to the search committee. I had met Michael and his wife Nancy Kitterman a year earlier, in line at a "pork pull" at the Ackland Museum of Art at the University of North Carolina at Chapel Hill. He was there in his capacity as Director of the nearby Duke University Museum of Art and as co-host of the annual spring meeting of the Association of Art Museum Directors. I was there at the invitation of my director, who was on the program committee for that meeting and wanted me to be part of a group of curatorial presentations on new ways of approaching art exhibits. The title of my paper was "Working the Numinous."

Michael Mezzatesta and I are nearly the same age, which means younger than most everyone else at the pork pull, and I think he, too, was a bit in awe of the crowd. So we sat together and bonded.

To me, this meant that in May 1993 when he came to Baltimore to discuss the Walters directorship with me, he and I were all-but-best-friends. I was not surprised that he turned to me for advice and support when he decided, eight months into the Walters search, to apply to be the museum's next director. Michael's timing was perfect. The search committee (I was on it) had by that time seen everyone out there; the job had been offered to Max Anderson of the Michael C. Carlos Museum at Emory University, and he turned it down. Committee members were exhausted and dispirited, summer was approaching, and Bob Bergman had just left for Cleveland.

After Michael Mezzatesta's appointment was made public, our relationship went south so fast and with such a thud that I could only conclude that his congenial behavior in May, just a few weeks before, was Mezzatesta theatre. I recall a specific meeting, just Michael and me, in early August. It was about future exhibitions, and he started talking about a Pre-Columbian show he had organized at Duke called *Painting the Mayan Universe*. It was centered on an impressive collection of Mayan pots that Michael had secured for Duke from a private collector in New York. Michael got on to the fact that his grant application for that show to the National Endowment for Humanities had been turned down, and how he was prepared to sue them. Someone on the peer-review panel had torpedoed it, he said, because the Mayan pots did not have traceable provenance before the mid-80s. He lingered on this "person" on the panel, on the provenance question, and how he was going to sue the NEH, which seemed to me all but impossible and, in any event, not a very healthy way of thinking about the past. By his tone, though, I was pretty certain that he knew that I was on that panel, and that he thought that person was me.

I was convinced at that moment that I had no future at the Walters. And yes, I did recall then, and often, what Bob Bergman had said to me over the phone the night in September, 1992, ten or so months earlier, when he called to tell me he was going to Cleveland. He said that they had "a lot of dough." The reason I remember that is not because his choice of words seemed odd; what struck me at that moment was that I felt I was doing pretty well at the Walters already with not a lot of dough. I knew that Bob wanted me to join him in Cleveland, but I was not at all sure I wanted to do that, dough or no dough.

So that's where I was in late summer of 1993: I had been at the Walters for nearly nine years and by that time had organized three major exhibitions that had been reviewed in *The New York Times*, something that had never happened at the Walters before. And we had just closed a Sisley exhibition, in collaboration with the Royal Academy and the Musée d'Orsay, that broke attendance records. So I was doing great, and yet not so great at all. Sure, Jay Wilson had taken me out for drinks before the search committee had their first meeting to ask me whether I wanted to apply to become the next director. I immediately said no, without equivocation, mostly because I liked what I was doing already and I didn't think I would like Bob Bergman's job. But also, because I understood that Jay's real agenda was to get us both past that question. I knew he didn't think I was right for the job and, then, neither did I.

I thought of myself as a curator; it was the right fit for me, I enjoyed it, and I imagined that was to be my career. To me, it was the difference between being the lead singer in a band and playing backup. I simply didn't want that much of the spotlight, and I certainly didn't want it all to depend on me. And that aside, I thought of myself as I thought of my father, as an introvert of the Scandinavian sort and very much a product of our quiet little farming town of Fosston. I could not then imagine wanting to—or being able to—play

the public role that I knew the Walters directorship required. I'd have to dress up every day; I'd have to give up swearing; I'd have to go to lunches with rich people I didn't know and probably wouldn't like; and I'd have to ask for money. None of that sounded like Gary Vikan. But I also knew that Jay Wilson, and I assumed the entire Board of Trustees, wanted me to stay at the Walters.

THE LAST TIME I SAW MICHAEL MEZZATESTA was at a staff meeting on Friday, October 22nd, the morning after that fateful Thursday "bad news" evening. He was sitting opposite me, clearly agitated, and all of a sudden he just got up and disappeared. That Friday evening was the last time I spoke with my father. I called around 7:00 p.m., and it was clear from his tone and frail voice that there was not much time left. I said I would come out the next day, but he was going to St. Luke's Hospital in Fargo, about one hundred miles west of Fosston, to get a definitive diagnosis and a treatment plan. So he wanted to let that unfold, and I then could come, and yes, he said, we'll go for a drive out by Cross Lake. This was my father's favorite thing to do on a Sunday afternoon. This would be okay, I thought, since I was scheduled to lecture on Russian icons at Bates College on Monday; that could go forward as scheduled, and then I'd be off to Fosston. But when I hung up the phone, I suspected I would never hear my father's voice again.

The next Monday, as I was driving up the New Jersey Turnpike on my way to Lewiston, Maine, I imagined that my father was being driven to the hospital in Fargo. Somewhere near the Tappan Zee Bridge I stopped to eat, and it occurred to me, out of nowhere, that I could be Director of the Walters, that I could do the job. It was not so much that I felt more empowered myself, but I did a rundown in my head of all the candidates that had been interviewed by the

search committee, and I knew many of them. If they thought they could do it, I certainly could do it. So I let that thought hover. What I did not know was that at about that same time, my father had decided on no treatment and no more diagnostics; he had turned back to Fosston to die, on his terms.

My mother did not share that plan with me, and so I settled on Thursday as my departure day for Minnesota. I know I understood this to be the end, since I took my old suit, my single white dress shirt, and my formal silver and black striped tie. My father's intestinal cancer was tentatively diagnosed six days before he died; we all understood this to be the final chapter in a lifetime of Norwegian stoicism. I flew to Minneapolis, a trip of a bit over three hours, and then it was more than five hours by car to Fosston. The weather was typically gray and unusually cold, and snow was in the air, which is a possibility any time after mid-October. Fosston Hospital is just off Highway 2 as you enter town from the east. These were the days before cell phones, and I had not called in and did not know if my father was still living. I drove through the small parking lot of the hospital looking for my sister Linda's car, since I knew she was already in Fosston. It was not there, so I knew he was dead.

My mother was sitting at the kitchen table when I arrived, with Linda. On some level I assumed that Dean's balsa wood planes and my stacks of *National Geographic* magazines had disappeared decades earlier from the room upstairs we shared in the '50s, which was now our mother's room. But our family kitchen was pretty much the same as it was in 1955 when I was eight. So we just sat there, receiving family friends who came bearing hot dish, as is the custom in Minnesota when someone dies. Elana and our two children, and Gail, Dean, and Bonnie, and their spouses and children, appeared at intervals over the next twenty-four hours, and we drank vast amounts of cheap wine, which was mostly the white zinfandel my mother liked.

Pastor Paul Magelssen of Hope Lutheran Church came by for prayers and to discuss the service, as did the funeral director, Gary Carlin, whom we all knew from high school. And then the editor of *The Thirteen Towns* called to ask about Frank's obituary. My mother told us to look in the black tackle box in the cabinet to the left of the desk in the den. We assumed she had been directed to this by our father shortly before he died. I was aware of that black box because it was there that my father kept the collection of Indian Head pennies he gave to me some years earlier. And there also he kept the letter he received in the late '30s from J. Edgar Hoover in response to his application to become a fingerprint expert with the FBI—an offer he declined. But that tackle box contained other important papers as well. Franklin Vikan, like all good newspapermen, had already written his own obituary, and that is where he kept it. This was welcome news, but when we looked, it was clear that he had not updated his obit since the mid-'70s, though he had kept a clippings file and a list of all the civic positions he had held in Fosston over the years.

I volunteered to update Frank's obituary, and as I wrote it I discovered a side of my father that I didn't know. As Treasurer of the Fosston Volunteer Fire Department, President of Fosston's Community Club and Rotary Club, President of Hope Lutheran Church, and, most of all, as Editor and Publisher of *The Thirteen Towns* from the late '30s to the late '80s, my father was truly a civic player who had a major hand in shaping much of what our hometown was all about for half a century. Of course I knew all of that to be true on some level, although for all of my adult life I had packaged these civic parts of my father within his Scandinavian demeanor and self-effacing manner, and his predisposition toward gloom and drunken benders.

But as I was writing his obituary, I had the realization that my father's life was a life above all of public service. It was, perhaps, the most basic ingredient in who he was. And I recognized through him

that public service might be in me as well. The "could" part of my thinking about the Walters director position now had a "should" part—maybe this is something that I *should* do.

Back in Baltimore on Saturday afternoon, November 6th, I joined Elana on her excursion to Nordstrom at the Towson Town Center, which was very unusual for me. On some level of my thinking I may have had a plan; I don't recall. I wandered into the men's department and the display of suits. The one suit I owned and wore to my father's funeral the previous Saturday was now too small, as was my dress shirt. This made the tie look odd and made me feel very uncomfortable. I took a Joseph Abboud suit jacket off the rack and tried it on; it was dark blue with pointed lapels, double-breasted, two over. It looked great, it felt great, and it was really expensive. But I wanted it. So I said to the salesperson that I wanted to try on the full suit. By good luck, the jacket fit perfectly; the trousers, though, needed to be cuffed. I was gripped with an idea, which I'm now certain must have been bubbling in my head for at least a few days. I said, "If you can cuff these by 6:00 tonight I'll buy the suit." It's Nordstrom, after all, and of course the answer was yes. So there I was on stage at the Walters at 8:00 p.m. for the members preview, talking about the arts of Ethiopia. I was saying pretty much what I would have said the first time around, on October 16th, but now in my new suit. Did anyone other than Elana notice, and figure out what I was up to? I doubt it, but from my point of view, I was beginning to act "presidential," and this new suit of mine was saying two words: *could* and *should*.

THE STORY BROKE IN *The Baltimore Evening Sun* on April 13, 1994 with the headline "Walters Art Gallery picks new director—a curator from its own staff." Adena Testa, the board's President Elect, said

the board had asked Vikan to apply the first time around—which was news to me. And that it "approached him again" in December. That I was approached then was true. Around that same time, I had gone out to Cleveland to meet the staff and tour the museum; Bob Bergman wanted me to be his chief curator. But after my look around, I decided that the Cleveland Museum of Art was not the place for me. The most interesting passage in the *Sun* article, though, was unattributed. According to art critic John Dorsey: "In recent months, Dr. Vikan has been taking on a more visible leadership role." Had he noticed my new suit?

On my trip to Cleveland, I had two items of business: first, to meet the staff and then decide on the possible move; and second, to inform my friend and former boss, Bob Bergman, what I was going to do. I told Bob and his wife, Marcie, that evening over dinner in their home; it was December 23rd. I told them I would say no to the Cleveland chief curatorship and would say yes, I hoped, to the Walters directorship. Bob, who was a wise, instinctive, and thoroughly honest man, said immediately that this would be a big mistake. Why? I remember his exact words: "Because you can't just say 'fuck it.'"

What did I imagine lay ahead? I'm not too sure, though I recall that the day I was appointed director was the opening party of Art Blooms, which was then turning into the Women's Committee annual spring fundraiser—flower arrangements responding to works of art in the galleries. I shook lots of hands that evening, and liked it. But more generally, I was keen on a metaphor for what I imagined I was going to do: I was going to "turn up the heat."

Chapter Thirteen

Ready to Explode

That's how I looked and felt, and Raoul Middleman captured it. According to the review in *The Baltimore Sun*, the "movers and shakers" of the Baltimore art world—fourteen of us—were all there, both at the opening in early February 1996 and for eight weeks thereafter on the walls of the Steven Scott Gallery, just south of the Walters. Steven had asked the well-known and much-loved Baltimore artist Raoul Middleman to paint portraits of the major players in the local art scene, and among them, I was the new arrival. I had sat for Raoul in his cavernous warehouse and studio the previous October. It was unusually hot that day and I didn't want to be there. Raoul gave a quick tour of his racks and racks of canvases. He is both fast and prolific, he loves to talk about philosophy, his undergraduate major, and he paints with the honest gooeyness of Rembrandt, his favorite Old Master. Raoul's style is gritty, on the ugly side of realism.

That day I couldn't sit still. I didn't want to sit still. Just minutes before I left my office one of my favorite Walters staff members, a talented designer and a friend, had come in to tell me she was leaving. She loved working at the place that was "the little engine that could" she said, but now things were changing at the Walters and, for her,

not in a good way. I was confused, agitated, and hot, as I watched
Raoul wield his dripping brushes in broad and aggressive strokes. I
was tense, and a little afraid. Raoul smoked a pipe, and he seemed
continuously to be lighting and relighting it, as he mixed turpen-
tine and wiped whatever extra paint was flying around, which was
plenty, on his baggy trousers. I imagined not simply a fire, but an
explosion—the whole goddamn warehouse going up, with us in it.
But then, I thought, he must have been doing this for years, and he's
still around. Gradually, in the course of that sitting, a strange peace-
fulness came over me, a peacefulness that I otherwise only knew in
the presence of monks or in a medieval church. It was very odd, but
that was the power of Raoul's intense charisma and the discipline of
holding a pose for more than an hour with my arms crossed.

I know I examined my portrait before I left, I know I was wear-
ing my new double-breasted blue suit, and I think I was generally
pleased with what I saw, though my head seemed overly large. But
I was hardly prepared for my revisit with Raoul's version of Gary
Vikan in swirling oils at the Steven Scott Gallery four months later.
The *Sun* reviewer loved my portrait in particular and spoke of the
sense of "coiled energy" of a guy who "seems anxious to get back to
his own work," which was true. But what I saw in that portrait was
a man about to explode. And I knew why: because the Walters itself
was about to explode.

I had certainly jacked up the heat. By the fall of 1995, eighteen
months after becoming director, I had tried one of just about every-
thing a director can try and taken much of the museum apart in the
meantime. There was no idea for an exhibition that I didn't like, and
the more shows the better, even if that meant turning the stately Wal-
ters into a three-ring circus. Dodge Thompson, Chief of Exhibitions
at the National Gallery, called to offer me an exhibition of the Geno-
ese Baroque master Bernardo Strozzi for the fall of 1995, a show they
could not manage to squeeze into their schedule. But somehow, I could

make it work at the Walters. We have a great *Adoration of the Magi* by Strozzi, Genoa is Baltimore's Sister City, and I had long wanted to do a Strozzi show. So of course, I immediately said yes, pretty much ignoring the fact that I had already committed to two exhibitions for that fall 1995 time slot, and each in its own way was more ambitious than any show that the Walters had ever done before.

The first, the "tradition buster" in the words of *The Baltimore Sun*, was *Going for Baroque*, a collaboration between the Walters and Baltimore's Contemporary Museum that would, for the first time, bring the works of eighteen contemporary artists into our galleries, including Jeff Koons, Cindy Sherman, Frank Stella, and Andres Serrano. The organizing criterion was that these artists were in some way fascinated with Baroque and Rococo art, and each work was installed next to the type of art that had inspired it.

This meant that the show was spread out on both floors of the museum's palazzo building. A chrome Louis XIV by Koons was set near its marble 18th-century ancestor in the sculpture court, a seeming French Rococo tureen in the gallery behind the Koons bore a sly self-portrait of Cindy Sherman as Madame de Pompadour, and a huge abstract bronze by Bryan Hunt, called *Cloak of Lorenzo*, was installed in the center of the floor above in the Old Masters gallery near the Walters' diminutive bronze of *The Risen Christ* by Bernini. The Hunt was so heavy that it made the floor sag. And worse than that, throughout these recently reinstalled galleries I was doing the almost unforgivable, namely, forcing pins through and putting sticky tape on the pristine Scalamandré fabric that covered the walls. Contemporary art was bad enough in the eyes of Walters traditionalists (one of my older trustees refused to enter those galleries while the show was up); tampering with those beautiful spaces that my predecessor, Bob Bergman, had created just a few years earlier was tantamount to a sin.

The planning of *Going for Baroque* was fraught with peril. My collaborators at the Contemporary were insistent that we include

Serrano's famously controversial 60" × 40" *Piss Christ* photograph (which shows a crucifix in a glass of the artist's urine) beside our Murillo *Virgin of the Immaculate Conception*. While this made perfect sense to me both visually and conceptually, I told them that I might as well resign right on the spot if we decided to include that work in the show. Just a few years earlier, in 1989, the Corcoran Gallery in Washington, DC, had cancelled an exhibition of homoerotic and sadomasochistic photographs by Robert Mappelthorpre for fear of the firestorm of protest that would ensue. This act of self-censorship was widely and universally condemned in the art world. The director left, and some believe that this was the beginning of the end for the Corcoran. So I couldn't win. If I showed *Piss Christ* I was convinced that my board would send me packing. But if I chose not to show it, which is what I did, would I have a Corcoran problem? Well, in theory, no, provided that the conversation and decision stayed in my office and remained confined to the four of us then in the room. Only years later did I learn that one of my Contemporary collaborators marched off to the local art critic for the *Sun*, John Dorsey, and told him that I had capitulated to self-censorship in the manner of the Corcoran director. John chose to ignore her.

And then there was the mini firestorm surrounding the small companion show organized with students from the Maryland Institute College of Art, who had also "gone for Baroque." As it turned out (and to no one's great surprise), one among the students had gone blue, by devising a computer-based installation wherein Baroque art was somehow linked to contemporary pornography. This, too, had to go, and in this case the reason I thought was obvious: The students' work was to be installed on a public path through the museum and we could not restrict access by children. It was simple; that work is out of the show.

Well, not so simple. This all must be explained and worked through with the young artist in question, who had a sense of entitlement to self-expression that was generally shared by her

teachers and classmates and everyone else who had an opinion on the matter. So off I went to her studio in a townhouse near the MICA campus. The idea was that she would explain to me what she had created, and I would explain to her why I couldn't include her work in the exhibition. Well, it was pretty obvious that this artist had another agenda. As she showed me her creation on screen, she began to ask some leading questions. And then I noticed this little red light under some papers on her desk. I poked around a bit and discovered a tape recorder that was turned on but mostly hidden, and unmentioned by her. What she was after was a final addition to her work of art, which would be me, on tape, in my act of censorship. I pulled the plug.

I was getting the feeling that my Contemporary Museum collaborators didn't have my career interests at top of mind, and, for a while, I felt sort of friendless. But nowadays, whenever *Going for Baroque* is mentioned, it is celebrated, even by Walters traditionalists, within a warm, hazy afterglow as a great milestone in the museum's history. And it was.

But what I recall most vividly among the many odd and wonderful moments of that show was the opening in late September 1995. The exhibition was cheap and so was the event: beer, wine, and potato chips in the sculpture court next to that chrome Jeff Koons. All of a sudden this big guy with wavy black hair walks in and straight up to me to shake my hand and congratulate me for bringing the Walters into the 20th century. He wore a brown leather trench coat, no shirt, and around his neck, a tattooed necklace in the form of barbed wire. Cool, I thought: my new friend.

THE THIRD EXHIBITION THAT HYPER-INTENSE fall was *Pandora: Women in Classical Greece,* and it opened on November 5th. With *Pandora,* the challenge was one of scale, because its curator, Ellen Reeder,

always thought big. While it was basically in the spirit of my *Silver Treasure* exhibition of 1986, with works from the Walters complemented by loans from around the world, *Pandora* was exponentially larger. With 135 objects from more than four dozen lenders, it could not fit into our temporary exhibition space, which meant that we had to dismantle the entire 19th-century installation on the fourth floor of the 1974 Wing. And the cost, $1.2 million, was four times that of the Byzantine silver show. We were in financial free fall. One day my registrar told me the fee for the loans for packing, transportation, and insurance was on the order of $250,000, and a week later, she said it was closer to $400,000. In fact, it turned out to be almost $600,000, with a single red-figure amphora from a German museum costing us $28,000 for its round-trip to Baltimore (nearly half the total expense line for *Going for Baroque*).

Finding money and dismantling our 19th-century galleries were not my only *Pandora* problems. A small but intense firestorm broke out around our ad campaign; what I considered to be a brilliant marketing image, others took to be soft porn. It was Ellen Reeder who had the idea of going to an outside ad agency to promote the show, and I liked it. I especially liked the concept the agency hit on, namely, that young women in classical Greece were likened to wild bears that must be tamed. The firm came up with an image that I thought was truly exciting: A young woman with bear paws where her hands and feet should be is enveloped in a flowing, diaphanous textile as she seemingly tumbles through space and lands before us. Literally, she was being transformed before our eyes from a bear into a young woman. Wonderful!

But not for everyone. Before the ad appeared in print I had a visitor. It was the only time that I recall, since my secret encounter with Yanni Petsopoulos at Dumbarton Oaks in 1983, that someone came into my office and asked to close the door. In this case, my visitor was one of the most sterling and universally admired among the small

band of stalwart Walters lifetime supporters. A member of the Women's Committee, a docent, a donor—and the mother of a girl about the age of the girl in the ad. And that was her message. This image of a teenager more or less interchangeable with her daughter, who may have gone to the same private school, radiated a sexuality that was inappropriate for the Walters. She went on to invoke Calvin Klein, Times Square, and ads for underwear; these were okay for New York City, but their counterpart was not okay for Baltimore. She came because she liked me, and she was worried. Her soft-porn drumbeat spread, and grew ever louder, so I finally killed the ad. But in the process, thanks to those rumblings, I had used up a big hunk of the goodwill that every new director gets. And I didn't have a whole lot to begin with in some circles, thanks to my devotion to Elvis Presley.

What does Elvis Presley have to do with the Walters? Not much, except that a profile head on the lid of one of the museum's Roman sarcophagi looks just like Elvis, and I have long been fascinated with Graceland. My fascination began in the summer of 1987 with a call from Emory University, inviting me to present the keynote speech at a symposium called Medieval Mania. The idea was that I should reveal how things medieval live on in modern times. The honorarium was $1,500, so of course I accepted, though with no idea of what I was going to talk about—that is, not until August 17th, when I opened *The Washington Post* to discover the banner headline "Saint Elvis." The dateline was Memphis and the reporter was describing what was then unfolding as 50,000 devoted Elvis fans (Presleyterians) were converging on Graceland to mourn the 10th anniversary of the King's passing.

I had written extensively about the art and rituals of early Christian saints, and now in the *Post*, I was reading about a huge figure in popular secular cultural associated with pilgrimage, relics, veneration rituals, and iconic portraiture remarkably like that of the early saints. Medieval mania for sure. So that December I went to

Emory and gave my first Elvis talk, in which I interwove his story with, among other things, the statue of Paul Bunyan with Babe the Blue Ox in Bemidji, Minnesota, that I admired so much growing up in nearby Fosston, and the Shroud of Turin. All, I tried to show, were "eternal images" with "eternal power."

Somebody at the Walters had the idea that I should give my Elvis talk at our 1989 black-tie donor dinner, which I did. I thought I would finish my presentation with the notion, then very popular, that Elvis had not actually died and that he might at any moment reappear anywhere. And then, the tricky part, which lives on as myth and legend in the minds of the four hundred or so in attendance that night. When I got to the point in my talk when I brought up the idea that Elvis was still alive and among us, suddenly the lights in the auditorium were turned off. A pause, in total darkness and in total silence.

Then suddenly, from a little office at the back of our auditorium, came the driving rhythms of a small band. A bright spotlight fell on the door of that office, it burst open, and then, to the grinding beat of a Presley hit of days gone by, appeared an Elvis impersonator of the first order. He weighed the requisite 250 pounds and covered his totally bald head with a huge, wavy wig that looked like black whipped cream. He wore a silver jumpsuit that was at least two sizes too small, and it was opened down the front to his waist. I think his chest hair was pasted on. Singing a deep-throated imitation of Elvis' ("a hunk, a hunk a") *Burning Love* at full sonorous pitch, he leapt onto the stage beside me, sang a few bars, then worked his way up the side steps of the auditorium toward the exit at the top.

Singing all the way, he paused at every third row of seats or so to take a sweaty Elvis scarf from around his sweaty neck and place it around the neck of one of his adoring female fans. A kiss on the cheek and in a flash he was gone. The lights were off again, for just a moment, and then on. Had it really happened? Had the King of

Rock 'n' Roll really appeared at the Walters? I think most of the audience, which had been primed with several glasses of wine, took this as good fun.

That was not the case, though, some months earlier when I gave the same talk, *sans* the imitator, for the first annual John Hopkins Masters in the Liberal Arts Alumni Lecture. The problem may have been the context, which was serious and scholarly, and the title, which was "Looking Behind the Shroud of Turin"—with no mention of Elvis. The audience wanted a serious talk on the Shroud with serious evidence that it might be genuine. And I totally dismissed it, within the context of Elvis and Paul Bunyan, as an obvious fake and bet anyone in the audience 20:1 that it was a fake and would be shown to be a fake by the carbon-14 tests then underway. (The results, dating the linen of the Shroud between 1260 and 1390, were published the following November.)

When I finished, the audience of around two hundred was mostly silent. There was a chill in the air, and all I wanted to do was go home. Then a man near the front leaped to his feet, identified himself as a Jew, and angrily took on the bet (yes, he paid off in November). I retreated to the punch bowl and thought I had found some relief when a large man came up, very close, to ask me where I had gone to school. Princeton, I said, thinking he had gone there and remembered me. His angry response, which captured the feeling that night, was: "What a waste."

The worst, though, was yet to come, in a letter that arrived two days later from a Walters trustee who felt I had insulted his intelligence. He began the third paragraph of his angry two-page diagnostic of the evening with this: "you spent an embarrassing twenty minutes of my time leveling your heavy guns at the Elvis cult unfortunates and *National Enquirer* curious as a demeaning paradigm for the Christian faithful." Yikes. No wonder I felt a little paranoid as the drum beat began to build about that bear-turned-girl.

Pandora: Women in Classical Greece turned out to be a smashing success. I managed to raise just enough money to break even as attendance far exceeded my expectations. Ellen Reeder's enormous catalogue published by Princeton University Press quickly became a college textbook, and the closing day of the show, Sunday, January 7, 1996, was nothing short of spectacular. A snowstorm was predicted to hit late in the day and, in Baltimore, that means a trip to the grocery store for toilet paper, milk, and bread. But on that Sunday, it also meant a feeding frenzy for *Pandora*. I knew there was something wonderfully strange going on when, on my drive in to work, I encountered a traffic jam several blocks from the museum. Once inside, I saw a continuous line from the exhibition entrance back to the ticket desk, and from there, out the front door, down the block to Cathedral Street, and up Cathedral Street to the alley. That had never happened before and has not happened since. This was a Baltimore blockbuster, but one with an unmistakably Walters scholarly flavor. For a museum director, it gets no better than that.

So yes, I had the feeling during that intense fall of 1995 when Raoul Middelman painted my explosive portrait that I was a submarine captain and that I had taken the Walters too deep too fast. The museum was creaking in very threatening ways, and springing leaks. But in fact, the museum more than survived, it prospered. And, looking back, those were the most exciting and productive months of my entire museum career.

Chapter Fourteen

Getting Beat Up
with Shevardnadze

M any exhibition ideas are never realized. Sometimes it's money: The show is too expensive or there's no backer available at any price. Other times it's the impossibility of getting the loans, perhaps because there are overriding conservation risks. Often, though, it's simply the realization on the part of those who make the decision, usually the director along with senior staff, that the public just won't care even if the critical press does, or vice versa. You often get to "no" pretty quickly, and at little expense, so I don't count these as failures, just as explorations that got nowhere. And as long as this doesn't happen too often, no harm is done. What makes for a failure is the combination of two things: By the time you cancel, you have already gone public; and in canceling, you will have lost a significant amount of money. These failures, true failures, are very rare, and their symptom is some ugly press. You have made a dumb mistake, and the only people who take pleasure in such failures are other museum directors.

Fifteen years into my career organizing exhibitions and five years into my Walters directorship, I had just such a public failure. The loss was in the $120,000 range and the embarrassment was significant,

because it involved a head of state, and a prominent one: Eduard Shevardnadze, President of the Democratic Republic of Georgia who, in a previous career as Mikhail Gorbachev's Secretary of Foreign Affairs, had helped disassemble the Soviet Union. In truth, if I were destined to fail, this is how I would want to do it; there was something exhilarating about failing in that kind of company.

I first set eyes on the "Silver Fox" on April 24, 1999, in the Mayflower Hotel in Washington, DC. He had met with President Clinton earlier in the day, and my partner and guide in this particular venture, Greg Guroff, had arranged for me to attend a dinner in his honor that evening. To my surprise, the gathering was tiny, in a private dining room with only a few tables. Daniel Shorr, then Senior Analyst for NPR, orchestrated the conversation over dessert, and I recall that it involved, among others, Bud McFarlane, National Security Advisor under Reagan, and Edward Nixon, the former president's youngest brother and look-alike. Greg had told me that Eduard Shevardnadze was charismatic and I had wondered how that would be apparent. Now I found out. From the moment he entered the room (he came in last) it was clear to me why they called him the Silver Fox. And the Shevardnadze charisma? Was it his piercing eyes, his flowing white hair, his hulking build and movements—or was it the reputation that preceded him, the three assassination attempts, and his role in the peaceful dissolution of an empire? I don't know, but I was certain that he was looking just at me and talking just to me.

And then, the following afternoon, Eduard Shevardnadze was talking *about* me. In the same hotel, the Silver Fox, standing next to Arthur Hartman, former US Ambassador to the Soviet Union and now Board Chairman of the Foundation for International Arts and Education (FIAE), announced what he described as a great artistic event. The show, the Georgian National Exhibition, as he called it, would open at the Walters in Baltimore in a mere six months, and

he was going to invite President Clinton. Shevardnadze explained to all assembled—and to cameras recording for posterity and his home audience nearly 6,000 miles away—how the art of Georgia was for the first time coming to America. And this was thanks to that visionary museum director there in the front row, Gary Vikan. If announcements guaranteed realities, I was fast nearing the acme of my career.

The show was called *The Land of Myth and Fire: Art of Ancient and Medieval Georgia*, and it was scheduled to open at the Walters on October 14, 1999. The idea had been brought to me by Greg Guroff, a wonderfully gentle bear-like man who invariably wore a blue Oxford-cloth shirt with an ivy league tie that was always askew. You could not help but like Greg, who was of that Sputnik-era generation of young Americans drawn to Russian studies and from there into the Cold War. After he received his PhD at Princeton in 1970, all things Russian and Eastern Bloc became Greg's life. For twenty years he had been part of the United States Information Agency, rising to the rank of Cultural Attaché in the US embassy in Moscow in the '80s. Now, in post-Soviet times, he was founder and President of the FIAE, a Bethesda-based nonprofit whose mission is to facilitate academic and cultural exchanges between the United States and nations of the former Eastern Bloc.

The Ambassador of Georgia to the United States, Tedo Japaridze, suggested to Greg in the fall of 1997 that the FIAE organize an exhibition of Georgian art to tour the United States, and he said it would have Shevardnadze's support. With that in his pocket, Greg went to New York and presented the idea to Helen Evans, Curator of Medieval Art at the Met, who had organized the enormously successful *Glory of Byzantium* exhibition the previous spring. Helen, I later learned, told Greg that the Georgians had been particularly difficult to work with in securing the few loans she could manage for her show. And then she steered him my way. That was fine with me since I had

been committed for some time to exploring the art of the exotic cor-
ners of medieval Orthodoxy, and the art of Georgia seemed to be a
perfect sequel to my successful Russian and Ethiopian exhibitions.

I partnered with Greg to organize an exhibition of art treasures
from Georgia, a mythical land at the eastern edge of the Black Sea,
where only a very few Americans ever go, and few Georgians ever
leave. Since no such exhibition had ever come to the US, and we
had a willing collaborator in the Director of the State Museum of
Georgia, we ambitiously set our sights on a broad survey. *The Land
of Myth and Fire* was to include one hundred fifty items covering more
than three millennia, from an exquisite gold lion just one inch high
dating to around 2000 BC, to an icon of Christ the Savior of 1550,
set in a gold frame liberally sprinkled with rubies, garnets, ame-
thysts, and pearls.

The *Myth and Fire* in the exhibition's title were related to the
Greek myths of Jason and the Argonauts and of Prometheus. Pro-
metheus was bound by Zeus to a rock on a mountain in the Cauca-
sus (northern Georgia) for having stolen fire from Mount Olympus,
and he was condemned to have his liver pecked out daily by an
eagle. And as for the legend of Jason and the Argonauts, its connec-
tion to Georgia was the Argonauts' pursuit to the Colchis region on
the east coast of the Black Sea of the winged ram with the Golden
Fleece. The idea of "golden fleece" probably derives from the ancient
practice of affixing fleece to wooden frames and then suspending
these frames in the rivers that descend from the Caucasus in order
to capture some of the abundant gold particles being carried toward
the Black Sea.

To this day, and through the five millennia or so of their cultural
identity, the Georgians have been addicted both to precious metal
and to jewels, and they are fabulously gifted at crafting them into
exquisite works of art. This is what *The Land of Myth and Fire* was
mostly about. In 1981, at the International Byzantine Congress in

Vienna, I had seen an exhibition of medieval Georgian art. I was amazed at the distinctive play of gems and metalwork. Stylistically spare and crafted in relief, the icons looked like Romanesque sculpture, but in silver. I had never seen anything like that in the sacred art of any other Orthodox people, and I was captivated.

Part of the signed protocol for the 1999 exhibition was to assure that this splendor would be preserved. The Georgians knew that their collections needed a level of professional conservation attention that they were not trained or equipped to provide, especially for the medieval metalwork and the manuscripts on the loan list. And they knew, because they came to Baltimore to see at first hand, that the Walters had a superb conservation lab and staff—specifically Terry Weisser for metalwork and Abigail Quandt for manuscripts. This was a critical part of the coming exhibition's *quid pro quo*: not only that specific important works of Georgian art would receive much-needed conservation treatment, but also that Georgian conservators and scientists would be brought in as partners to acquire expertise and form working relationships that would carry forward well beyond the exhibition. The idea of making an ongoing contribution to the treasure's upkeep made me almost as proud as the prospect of the exhibition itself.

THE LEAD UP TO MY encounter in the Mayflower Hotel with the Silver Fox had been smooth. A year earlier, Greg and I signed a protocol with the president's representatives that detailed our plans and our mutual obligations. It's not that I assumed everything would run smoothly from then until the opening. After all, when this art had last left the country in the early '80s, Georgia was under an authoritarian regime, and Shevardnadze, as First Secretary of its Communist Party, could do pretty much whatever he wanted to. But what I

could not have guessed was that now, at the end of the '90s, a repeat of the earlier show would turn out to be impossible.

My earlier visit to Georgia was built around a tour of the museums of our collaborators, each of which had its own peculiarities. The history museum, the State Museum of Georgia, is on the main street of town, the beautiful Rustaveli Avenue, but for some reason we entered from the small street behind, through a surreal courtyard. We looked up to the second floor of the museum and saw that the windows had been shot out. We were told this happened during the violent coup d'état of December 1991 that deposed President Zviad Gamsakhurdia. We also learned as we inspected this damage that Levan, the museum's director standing next to us, had come in as the street battles were raging just outside and put the fires out. We assumed that had he not, the museum and everything in it would have been lost. To our right in that courtyard was an old Soviet-era bus whose tires had gone flat, and to our left was a huge glass box— really huge—with thick glass that was cracked in places and broken. And in this glass box was a complete mastodon skeleton.

We then proceeded down a dark, low passageway into the lower level of the museum past a soldier with a machine gun to the threshold of a large vault door that was opened to reveal the Treasury. That is where all the gold was kept. (The bronzes and arrowheads and such were up one floor.) I can visually reconstruct that tour in my head, from the tiny, three-millennia-old gold lion at the near left, all the way around the room, clockwise, to an enormous Roman-period jet bracelet adorned with gold and garnets. The various styles in successive cases—Greek, Persian, Sasanian, Roman, and Islamic—reveal a profound truth about Georgia. This is a land isolated and seemingly protected by the Caucasus and the Black Sea, but at the same time, a land that has historically been a crossroads for every conqueror and occupier imaginable over thousands of years. Most recently, since around 1800, it has been Imperial

Russia, first, and then the Soviets. In that dark, vault-like Treasury, there was only Levan and our little Baltimore group; this was a powerful experience.

The Georgian State Art Museum is close by and accessible from that same street. This is a fairly normal museum by comparison, but for two things. First, we were told that this was formerly an Orthodox theological seminary building and that Josef Stalin, a Georgian like Eduard Shevardnadze, had once been a student here. And second, we learned that it was built over a sulfur spring, as is much of Tbilisi, which means "warm," as in warm sulfur springs. The windows of the galleries with those gilt silver icons were open and you could smell the sulfur, and this, the Walters conservators told me, was perhaps the most corrosive agent that can be applied to silver. No wonder the icons are black and brittle. Sulfur is terrible, as is the blue wool fabric in the cases. So there on the main level of the museum were those wonderful metal icons in relief, suffering, and upstairs, scores of "naïve" paintings by Niko Pirosmani, whom the Georgians want to believe is the equivalent of his French contemporary, Henri Rousseau. He is not, and most of his paintings are simply atrocious. Nevertheless, we were stuck with at least a few of them that would serve to complete the show. That's the nature of collaboration.

The Institute of Manuscripts was a bit farther away, in what I took to be a dicey part of town. I thought this in part because it was among what seemed to be squatter gardens and abandoned sheds that recently became homes for someone, but mainly because all the windows and doors of the institute were covered with heavy steel bars and grills of the sort you see in carry-out places in the toughest part of east Baltimore. The other striking thing about that building, when viewed from the outside, was that it was covered with grape vines. This was not so unusual in Tbilisi, since the Georgians claim to have invented wine 8,000 years ago, and they grow grapes wherever they can find dirt and something like an Institute

of Manuscripts for the vines to grow up on. But the sheer profusion struck me as odd, as did the inside with its overpowering smell. It was a smell that was familiar to me from my childhood: turpentine. It was as if dozens of painters were in there cleaning hundreds of paint brushes. But there were no painters and no paint brushes to be seen. There was just a very noisy air conditioner, a damp cold draft, and the pervasive odor.

The medieval manuscripts came out for our examination from the stacks, and for some reason the assistant to the assistant librarian who transported them seemed to need to carry four or five at a time, even though it was a short distance to our examination table. I can still see her. She sort of teetered forward with the precious cargo of the 11th and 12th centuries all but falling from her hands; books that in some cases were so fragile that parts or all of them could not be opened. For this reason we just looked at the outsides of a few.

There were many star books in that library, but the star among stars was an unbound Hebrew book without pictures called the Lailash Pentateuch. This particular manuscript needed special conservation care of the sort that only a few people in the world could provide and this meant we paid lots of attention to that precious pile of enormous vellum leaves covered with Hebrew writing. The Lailash Pentateuch was slated to come to Baltimore the summer before the exhibition to get intensive care in our lab. This book would turn out to be the metaphorical canary in the coal mine, with its eventual non-arrival announcing the failure of our show before it was official.

Damp air, the smell of turpentine, piles of precious manuscripts teetering along, and works so fragile we could not touch them was followed by an extraordinary lunch. These are the memories I have of the Institute of Manuscripts. We had seen everything there was to see and had gathered in the office of Director Zaza Alexidze. We sat in silence. Our group included Greg Guroff, the two Walters

conservators, a few institute staff, and me. One person from the institute got up to leave, and from our second floor window I could see her drive away. Time went by with no talking. (Silence was best since any casual comment on my part, like about the weather, went from English to Russian and Russian to Georgian, and back again.)

Then, the person who'd driven away reappeared with two bottles of wine and a box filled with luncheon treats I had never before encountered. The oddest and most wonderful looked pretty much like Greek *spanakopita*, although instead of spinach, it was filled with fresh tarragon. But it was not the same kind we get. Rather, it was incredibly pungent and strong; it smelled like licorice and had an almost stinging bite on the tongue. It was magnificent, and I never tasted tarragon anything like that before. It was also a perfect match for the wine that had just come out of an enormous barrel somewhere in the hills above the city and was only a few weeks old. It was sort of like *Beaujolais Nouveau*, but just that much fresher, and even more effervescent.

That was Georgian hospitality made up on the fly. More typically, it came in the evening, with an enormous banquet on the table awaiting you and, at the head of the table, the *tamada* or toastmaster. The dishes were fantastic and mostly unfamiliar to me, with lots of walnuts in various forms and tarragon and plenty of white wine. I know there was a sequence and rhythm to what was eaten when, but I never figured it out—maybe because of the wine. And as for the *tamada*, after things had gotten going, he would stand up and solemnly propose a toast. Then a bit later there would be another toast, and so on. And after a while those around the table would propose their own toasts. For the Georgians, this is a national ritual of great importance, and with a skilled *tamada* it can be poetry.

This meant there may be a toast to our mothers and what they have meant to us, and to our wives, without whom we'd be nothing, and to our children and others, and eventually to our dogs and cats.

After each toast, those at the table would raise a glass of wine, and the *tamada*, depending on his or her stamina, would raise a glass of vodka. I could never figure that out; in Georgia vodka is consumed out of smallish water glasses and in such quantities that I at first assumed it must be water. Periodically, new dishes would replace empty dishes. I recall one with little animal body parts in a creamy walnut sauce. It was wonderful, and no, it didn't taste like chicken, but it looked like chicken. As I was about to ask, I picked up what I thought was a drumstick and discovered at its tip a tiny cloven hoof.

Another distinctively Georgian dish, *khachapuri,* was not on the nightly menu, but became a staple of our workday. Each morning Greg Guroff would distribute the agenda for the day, and it would include nothing before 10:00 a.m. This seemed logical enough, since I took Georgia to be a Mediterranean country with a Mediterranean rhythm. But as it turned out, more often than not the agenda needed updating around 10:00 a.m., the time when so-and-so was to meet us but somehow didn't show up. (No cell phones then made this all a little messy.)

Once we stopped at a little spare and shiny café on the street between the Georgian Art Museum and the State Museum of Georgia to reconnoiter and rewrite the day's agenda. (Ray Charles' *Georgia on My Mind* was on the radio; we heard it often that week.) Since this rewrite could take some time, we ordered tea, of course, and then a little snack, too. *Khachapuri* is a pizza-like dish that is defined by cheeses of various sorts, and by the final addition, as I recall at the table, of a raw egg. Well, depending on how warm that pizza-thing was at the point of delivery, the egg might be sort of cooked or sort of raw. I'm not sure I cared, but I saw others at the table discreetly pushing the un-set egg off the cheese and nearly off the plate.

TWO SUNDAYS AFTER BEING SINGLED out at the Mayflower by the Silver Fox, I boarded a British Airways flight to London with a small contingent of Walters staff for what I assumed would be the last of my working trips to Tbilisi. Everything to that point had been smooth and pleasant. Now we were coming down the home stretch. We were working with Georgian documentary filmmakers on completing a video that would introduce Georgia—its people and their history, their beliefs, and their art—at the beginning of the show. We also needed to measure the individual works for the exhibition cases and mounts that we would soon build at the Walters. And it was critical to get a sense of which works were visually the strongest in order to highlight them in the exhibition design.

Looking back, I wonder how much I suspected that trouble lay ahead. I do recall at the airport in Baltimore, as we waited to depart, I overheard our exhibition designer telling the others about some "problems." It involved something he had seen on the Internet about demonstrations in Tbilisi against the show. I dismissed this immediately, partly because I didn't yet know much about the Internet's trustworthiness as a news source, but mostly because our designer seemed to always find something to worry about. And I did not. My attitude was more cavalier. After all, we were on our way.

The 4:00 p.m. flight on British Mediterranean Airways out of London was how you got to Georgia, and that was all fine except for the fact that the plane arrived at 2:00 a.m. This experience was made strange not only by the odd hour, but also by the visual spectacle of flying in over a city that because of chronic power outages was illuminated by thousands of tiny gas lanterns in hundreds of little kiosks. These had sprouted up everywhere and apparently kept very strange hours, offering their spare inventory of cigarettes, vodka, potatoes, and bread pretty much 24/7, basically to no one.

The vendors just sat there, smoking cigarettes. That's what you saw coming into town, after having passed through security at the tiny, all-but-deserted airport, with its soldiers carrying machine guns, its smoke-filled clearing room lit by dim, grayish florescent lights, and its posse of swarthy men watching soccer and smoking, and not talking or even looking up. In the darkness, in what I understood was the fancy part of town where the diplomats lived, we arrived via a steep, narrow, crumbling street at Betsy's Place, a small elegant hotel, behind a heavy steel door.

Greg Guroff, at about 4:00 a.m., went immediately to the computer in the small lobby. And from there he confirmed our designer's dire report. I can still see and hear him. It turned out that yes, indeed, there had been demonstrations. The former president's wife, of all people, had begun a hunger strike against our exhibit. The seminarians were against us. At about the same time that President Shevardnadze was holding forth on the merits of the Georgian National Exhibition in Washington, DC, a member of the Georgian *Duma*, Guram Sharadze, with the endorsement of Georgian Patriarch Ilia II, had apparently issued a statement denouncing our show in the strongest terms.

As a new day dawned in Tbilisi, newsstands throughout town featured our exhibition on page one with a two-column headline. The story line was clear: The only thing of merit in the otherwise fourth-rate, crime-ridden city of Baltimore was the National Aquarium. No one had ever heard of the Walters. And so on.

From that point before dawn on Monday, May 10th, through midnight, Friday the 14th, Tbilisi offered me two parallel realities. One was the work the Walters staff had gone there to do and was doing; the second unanticipated reality was the intense, ongoing national debate about the exhibition. Along with Greg, I was the voice of and face for its merits and a stand-in for President Shevardnadze, who I quickly gathered was not much beloved by anyone. I

did six hours of live television debates over four days, and I recall that when I arrived in Rome that Saturday to meet up with a group of Walters trustees, they remarked on the sunburn I had acquired under television spotlights. Our main allies were the Georgian Minister of Culture, Valeri Asatiani, and our museum collaborators, Levan Chilashvili at the State Museum of Georgia, Nodari Loumuri at the Georgian State Art Museum, and Zaza Alexidze at the Institute of Manuscripts. We had ongoing logistic and moral support from the American embassy, and the Georgian Academy of Sciences was on our side as well, mostly, I think, because the exhibition represented for them engagement with the West and scholarship.

Those who were against us and our exhibition—and there were many, including museum curators and many academics— kept talking about the money the FIAE and the Walters were going to make and then not share with the Georgians, about the inherent fragility of the works (which meant they should not be moved anywhere), and about their suspicion that the FIAE and the Walters were going to make exact copies of the loaned works and send the copies back and keep the originals. Some of our opponents also entertained the even more bizarre idea that the air in the West was somehow corrosive and would cause permanent damage to the medieval metalwork. (The claim was that the works in that 1981 Vienna exhibition that had travelled on to Paris had suffered grievously from the corrosive Parisian air.)

Feelings were intense on both sides. I paid a visit to a gentle old woman named Leila Khuskivadze, a scholar friend of my professor, Kurt Weitzmann, whose name I had heard around the manuscript room at Princeton many times and always in the warmest and most admiring way. I was there in her cluttered office simply to convey Kurt Weitzmann's greetings. But she immediately got onto the Georgian National Exhibition and, as much as she seemed to want to envelop me in her admiration for Weitzmann, she was

vehemently against it. Her gruesome metaphor stuck with me: "I would rather have my child die of starvation at my side than send him away and never meet him again." Irrational anxiety seemed to trump all logic; it was as if such an exhibition had never taken place in the history of mankind. The true underlying question, Shevard-nadze would later explain in a letter to Ambassador Hartman, was one of Georgia's "democratic development." As it emerged from Communism, would the Georgian State remain where it had been for two centuries, inward looking and under the dominance of Rus-sia, or would it develop into a Western-style democracy? As I heard that question evoked with a typically Georgian poetic flare: "Will our sun rise in the North, or will it rise in the West"?

My first official event of the week, later on Monday with mem-bers of the Georgian Academy of Sciences, started off well enough. There were perhaps a dozen people in the room, and a few were not only academy members, but also members of the *Duma* and sympa-thetic to our cause. Greg Guroff put me at the head of the oval table, and this was my first signal that *Gary Vikan* was really going to be the face and voice for this show in Georgia. I was the academic, not an old Cold War diplomatic type like Greg, and I could speak from the heart. Which I did. I found my narrative in just a few minutes. Greg patiently conveyed this in Russian to someone who then ren-dered it in Georgian. This gave me time to think about what would come next.

I lingered on the fact that I was a Byzantinist and sort of glossed over my director role. I told about my love of Orthodoxy and icons, and spent plenty of time on that 1981 show in Vienna. And I talked about how Georgia in the 12th century was the leading creative force in the Orthodox world. I described the layout of that Vienna show, which I could remember vividly, and how amazed I was to encoun-ter those gilt silver icons in relief. I told them I had recently presented a hugely successful exhibition from Russia, and that this Georgian

show was long overdue and would be even more dazzling. I believed this to be true. The room was hazy blue with cigarette smoke by then, and the ashtray at my left was overflowing. I finished my talk, and then each member of the academy said his or her piece; I'm sure there was an order dictated by their hierarchy, but I couldn't figure it out. I did form this idea that we were acting out a moment of drama not unlike one that must have played out many times among students, professors, and members of the equivalent academy in Paris in the spring of 1968. We had a big adversary, the stakes were high, and we would act on principle—principle of the broadest and a most noble sort: the very future of a nation. The moment was, for me, simultaneously tense, tedious, stifling, and exhilarating.

Things mainly went downhill from there. The press conference at the American embassy, behind the huge steel security doors, was more than a hint of what lay ahead. A bunch of attractive young women reporters, all very smart it seemed and all dressed in black, posed questions that surprised me. They were mostly hostile questions asked with a big dose of cynicism and mostly under the heading of money. It was about money they assumed we were going to make and not share.

When this came up, I saw for the first time the old Greg Guroff in action. The man who had confronted the hardline Communists not so many years earlier was now bearing his combative Cold War teeth. Every point Greg made about the show needed to be argued and nuanced, and those young reporters were his adversaries. At the time, I didn't think that was so wise, since it clearly annoyed them. As for me, I would have played "rope-a-dope" and tuckered them out with my Midwestern earnestness, although I suppose that was naive. In any case, Greg was being Greg, and I marveled at his feistiness and his verbal agility.

At about 10:00 p.m. the following Friday, after half-a-dozen press conferences and an equal number of television debates, Greg

and I were doing a radio show that was hosted by monks of the Georgian Orthodox Church; They had hung a large portrait of our nemesis, Patriarch Ilia II, in the monitor room. I liked the format; it was much less intense than TV, and there were no vocal adversaries in the room with us. The antagonists were all "out there" and were invited to call in, which they did. I remember this moment for the little scribbles of paper that were passed our way by the anchor with the callers' questions that were no different nor less hostile than those we had been hearing all week. And then the electricity went off, which was sort of comical.

But it meant that we fell behind and therefore had to race like crazy for the last TV interview. I did it by myself at what I would call "Live at Midnight" because it was a match for what happens in Baltimore and all over America, namely *Live at Five*. But the show came on at twelve o'clock. We raced through the dark to make airtime, went across a parking lot with no lights but lots of pot holes, and down a dark hallway with a crumpled carpet that seemed set to trip me, to enter a studio and a seat behind a large desk. It was almost midnight, with only thirty seconds to spare, no more. Two things I recall. The poised anchorwoman, with her hair in a bun and wearing a brown suit, said to me just before we went live that she was against the exhibition and was going to ask me difficult questions, and she did. The other thing I remember are the mouse turds all over that desk we were sitting behind. And oddly, that made me feel better.

A final note on the TV debates. The strangest of them had about twenty of us seated in tiered rows being collectively interviewed by a Georgian version of the guy that hosted the TV show of the '60s and '70s called *Let's Make a Deal*. I was in the front row, and there were academics, clerical types, curators, and all three of our director-collaborators beside and behind me. I could not tell who was who, but I certainly didn't feel a whole lot of warmth. What really struck me, though, was that a curator from the Georgian State

Art Museum up there behind me was energetically impugning the integrity and motives of his boss, Nodari Loumuri, who was somewhere between us. This was on live TV, to the whole nation. And I wondered: what happens at work the next day.

How did I imagine this was all going to play out? There would be no vote, of course, and I could only hope that another issue of national significance would arise and push the Georgian National Exhibition off the front pages of the newspapers and out of people's minds. We would then all move on, grudgingly, and the show could go forward—which would make this week of browbeating in Tbilisi an exercise in dues-paying. But we were wondering what if the controversy didn't go away—if it got worse and if someone got hurt. This was not at all an impossibility. I wondered if things were no better in September when it was time to ship the art to Baltimore, would President Shevardnadze have the power and the will to trump all this nonsense and make the show happen?

The patriarch, I felt, was the key. He was more than the voice for the opposition; he was its moral authority. After all, there was almost no conversation about the ancient material, about its condition and the prospect that copies would be sent back. It was all about the medieval works that are, of course, all Christian. We were caught in the middle between two powerful men, one representing a secular future and the West and the other an Orthodox past and the East.

So it was a big moment, and a ray of hope, when Greg Guroff received word from the American embassy that Patriarch Ilia II wanted to meet with us. The showdown came in a late-night audience at his residence in the Old Quarter of Tbilisi. We arrived with the US Deputy Chief of Mission in his black SUV with a motorcycle escort. It was just before 9:00 p.m. when we were ushered into a grand audience chamber with eight great throne-like chairs arranged in a "V," converging on a huge textile icon of Christ's "Holy Face" (Georgia's version of the Veronica Veil), which was

protected behind thick greenish glass in a sturdy brass case. Above, in the open section of the V, hung an enormous Venetian chandelier. The effect of this arrangement was that Christ himself was presiding as chair of the meeting. Patriarch Ilia II sat just to the right of Christ; he was dressed in long black robes and wore a truncated conical burgundy hat with a diamond cross at its center. I was on the left flank of the V, the second in line after the deputy and before Greg Guroff and the embassy's head USIA officer, who had nothing but disdain for academics and little enthusiasm for our show.

The protocol of speech making went down the left flank and then up the right flank, toward Christ. This meant that I was second to speak, and the patriarch would be last. For well over an hour the patriarch said almost nothing, as Greg Guroff and I, with the help of the Deputy Chief of Mission and members of the Georgian Academy, laid out the case for the exhibition. As was customary by then, Greg and I spoke passionately of our love for all things Georgian, of our great admiration for Georgian art in particular, and of the professionalism of those Georgians tasked with caring for it. We promised that we would bring their art back, and we concluded with our conviction that this would be among the greatest art exhibitions ever to tour the United States. The patriarch seemed to be listening carefully; from time to time he would nod and smile. Oddly, his gentle, wrinkled face reminded me of my French Bulldog, and I felt we were bonding. I allowed myself the hope that His Beatitude would simply nod at the end of our speeches, agree to disagree with us, and, ultimately allow the show to go forward.

My optimism evaporated when, around 10:30 or so, after everyone but the patriarch had spoken, a young priest appeared from behind a curtain situated in the space between Christ and the patriarch. He carried the first of four small, wooden tables with refreshments. There were two guests per table, and the mission deputy and I were sharing the first table. On each table was a bunch of white

grapes, a dish of walnuts, two generous pieces of cinnamon cake, two small cups of hot espresso, and two shots of Georgian cognac. I knew then that we were in for the long haul, which was not good, because it inevitably made the patriarch's upcoming speech seem less like a response and more like a stand-alone declaration.

We ate and drank, mostly in silence. And then His Beatitude spoke. There was no hint of conciliation whatsoever; his warm and seemingly benevolent face was at odds with the harshness of his tone and the almost brutal sentiment behind it. Despite the fact that the Christian works in question are in an art museum, they are possessions of the Church, he said, and the Georgian State has no right to lend them to anyone. This meant that he alone would decide. Ilias II went on to say that the millennium is at hand and these works should not be out of the country at such an important time, since they will be the objects of Christian pilgrimage. (I did not believe this, but then he wasn't looking for any response, and certainly not for my opinion.) Then a final point, that the patriarch alone by virtue of his ecclesiastical authority could maintain, that these sacred objects would be permanently defiled by contact with the secular world of foreign museums. They would lose their sacredness, I guess, which was a novel but certainly creative bit of theology-from-the-hip.

If I were really wise and sophisticated in these matters of "bullying" negotiations, I would have realized that it couldn't end there. It could only end when *we*—Guroff and Vikan—somehow said it had ended; otherwise it would remain a standoff. Brilliantly, in order to force resolution, Patriarch Ilia II had something to offer us: a solution to our problem. His counteroffer had two points, neither of which I could have conjured up in my wildest imagination. The first was based on his claim, which bore no relationship whatsoever with reality, that there was plenty of Georgian art in American museums for us to borrow. This being the case, which of course it is not, he said we should go ahead and borrow from our sister institutions

and leave Georgia alone. Again, the patriarch was not looking to be corrected on this matter by someone who had worked in American museums and on Orthodox medieval art in specific for more than twenty years. And apparently the patriarch hadn't heard me when I described my encounter with Georgian medieval art in Vienna in 1981, when I said that I had never seen anything like it before.

After the craziness of point one, point two wasn't going to make any difference, but we got it anyhow. The patriarch had a solution for how Georgian art in Georgia could be in the show after all. And it came in the briefcase of two bureaucrats in stiff gray suits. The pair entered the room around 11:00 p.m. and took positions under the Venetian chandelier just in front of me. The briefcase was opened, and from it emerged what looked to me, and I'm sure to everyone else, to be a sheet of clear Plexiglas. One of these two men in gray put the Plexiglass sheet right below my face and began to wiggle it back and forth under the chandelier's light. Gradually, I could make out a very faint image of what looked to be a saint or maybe Christ. Patriarch Ilias II spoke (as twice translated), telling me that this is a hologram, and that we Georgians (as he said) are very good at making such holograms. And, the kicker: "Dr. Vikan, this hologram is 98 percent as good as the original."

This claim was so patently absurd that we all should have fallen off those fancy high backed chairs of ours, bumped our heads on those ornate little tables now bereft of their midnight snacks, and fallen to the ground in uncontrollable laughter. But we didn't, mostly because a patriarch can say lots of odd things, and we always nod in agreement and from time to time even bow our heads. I just looked at the clock with the sweep hand beside the door and wondered how much longer this was going to go on.

Eventually, as he continued, the tactical aspect of his gambit sank in. He would say he had made an offer, genuine and in good faith. And after all, neither Guroff nor Vikan, nor the Deputy Chief of

Mission, had disputed his two claims: that there was already plenty of Georgian art in America to borrow and that the crummy piece of Plexiglass was 98 percent as good as the real Georgian icon upon which it was based. President Shervardnadze's Georgian National Exhibition was unacceptable for all those reasons the patriarch had enumerated, and which we did not dispute. What happened now? Were we going to take the patriarch up on his proposition? While he didn't really ask us, and I never felt "asked," that absurd counter-offer of his put the ball in our court. And by our de facto rejection, through our silence, we were the ones that had killed this project, not him. How clever! And then, finally, the meeting was over. And out we went, thanking His Beatitude as we left. This reminded me a bit of my farewell hug by Abune Paulos of Ethiopia at the Walters in 1993. Screwed by a patriarch yet again.

As we drove away, the Deputy Chief of Mission said something to me that was a revelation. The Georgians are agitated about the possible loan of their Christian art, he said, because over the centuries, as they have been conquered and occupied, and especially right now, as they are struggling to hold on to their two northern breakaway provinces of Abkhasia and Ossetia, they cling to the two things that make them Georgian: their faith and their language. And so those gilt silver icons in that decrepit museum downtown, with their Georgian inscriptions, are the very embodiment of what makes them Georgians. They are their equivalent of our Declaration of Independence. If that were true, I wondered to myself, would we loan the Declaration of Independence to Georgia?

AS WE LEFT TBILISI AFTER THAT CRAZY week we all knew our chances of success with this exhibition were low. But we had not given up. And we also knew that the question would be called before the

September shipment date for most of the objects in the show. We'd have the answer in July if the few works planned to be sent well in advance of the opening for conservation treatment actually showed up on our doorstep. And the poster child for this was the Lailash Pentateuch, the canary strapped to the top of our metaphorical coal miner's helmet.

In July we were busy building shipping crates, exhibition cases, and objects mounts for the one hundred fifty works of art in *The Land of Myth and Fire*; the show has been designed and we were writing the labels and wall texts. All of this was very expensive. Our signed agreement required that we build a traveling crate for the Lailash Pentateuch and send it off to Tbilisi in advance. The first bad sign (the canary is getting droopy) is that Georgian customs can't seem to track down that crate in that little airport of theirs. And when they do find it, they won't release it to the Institute of Manuscripts. And then we learn that the Georgian courier from the Institute—I imaged the teetering one—could not get a visa. So the canary's head was now tilting ominously to the side. What rather surprised me about these developments was that the customs people and the visa people were in government, which meant they worked for President Shevardnadze.

My moment of clarity regarding the fate of *The Land of Myth and Fire* came on a Saturday morning in the middle of July. I was in downtown Baltimore and had just had my hair cut. Sitting pretty much motionless in the haircutter's chair for twenty minutes gave me ample time to reflect on what Terry Weisser, the head of our conservation lab, had told me earlier in the day. She had just returned from Georgia and left me with two chilling anecdotes from her trip. The first involved a Georgian scientist from the metallurgical institute in Tbilisi. The two were in the gallery in the Georgian State Art Museum with the gilt silver icons discussing the ongoing sulfur corrosion and Terry said it would be best to get the works out and

treated for the show. The Georgian scientist responded: "It's God's will that these objects stay here and die here." God's will? Die here? And then Terry went on to tell me what she had heard was happening "up north" in Georgia in the land of the Caucasus Mountains, black magic, and revenge killings. She said, "Up there in the north, a curse has been placed on you, Gary, and on your family."

Well, I thought I was just caught between a nation's president and its patriarch, but it seemed I was also caught between God and black magic. In that instant, I knew our show was dead.

THE LAND OF MYTH AND FIRE died officially on August 4, 1999, just ten weeks before its scheduled opening. By then the exhibition catalogue was already in production; it began with a celebratory letter from President Shevardnadze proclaiming that: "On behalf of the Georgian people, we are happy to share with you the treasures of Georgian culture and history." At around the same time that the catalogue was coming off the presses (*National Treasures of Georgia* can be ordered from Amazon for $56), Ambassador Hartman received Shevardnadze's letter of capitulation and explanation. It referenced "difficulties," a "breaking point," and "the will of the majority of Georgians." The parliamentary and presidential elections loomed in the fall, Shevardnadze wrote, and this "irksome compromise" was "prompted solely by the best interests in sustaining Georgia's unhindered democratic development." (He would go on to win that election.) The letter also alluded to the "insurmountable obstacle" of the Georgian Orthodox Church that had taken a "clear-cut negative position on the treasures traveling outside the country."

And so, to his regret, the president had been forced personally to abort the exhibition. The inexorable forces that did us in were captured in a single sentence added at the last minute at the front of the

catalogue by Greg Guroff, the Cold War veteran: "Backward-look-ing political forces launched a demagogic and often vicious attack on the exhibit's organizers—a thinly veiled campaign against President Shevardnadze and Georgia's engagement with the West." What a ride it had been, and now, what a crash.

All that was left to talk about was money. On September 23rd, almost exactly five months after the Georgian National Exhibition was publicly launched by Eduard Shevardnadze at the Mayflower, it was privately mourned and put to bed by Eduard Shevardnadze at the Washington Hilton in a conference room just inside the back entrance, the one just outside of which President Reagan was shot in 1981. The Georgian president was back in the US to meet again with Bill Clinton, and he took the opportunity to meet face-to-face with his old friend Arthur Hartman. Greg Guroff and I tagged along. Well after our 10:00 p.m. appointment, we were ushered into a tiny room by two hulking Georgian bodyguards with bulging suits (I assumed, concealing guns) and prominent earphones.

The event was an extended, halting apology from the Silver Fox, who at that moment looked exhausted and defeated. He repeated the sentiments and many of the phrases from his letter of early August. But the nub of the conversation was the money Hartman's organi-zation and the Walters had lost because of the cancellation and the promise Shevardnadze had made to compensate us. I was sitting directly across from him, and I felt embarrassed as an intruder on things private between those two old friends.

I've replayed my mental video of that final moment in the meet-ing over and over, and it gets no better. Shevardnadze said that when he returned to Tbilisi he would introduce a bill in parliament to secure funds to pay the Foundation for International Arts and Education and the Walters for their losses on the Georgian National Exhibition. It was a matter of State honor, of Presidential honor.

And then, he concluded: "But please understand, my friend, we have not paid our army in six months."

As I said, I didn't belong there. But as this last, painful piece fell into place, I realized that I had been granted something that I could not have hoped for, even in success—participation in a national drama whose significance dwarfed our little exhibition.

Chapter Fifteen

A Mitzvah Acquisition

Sometimes God tells us to steal art. The Franks and Venetians of the Fourth Crusade, who in three days in April 1204 laid waste to Constantinople, the greatest city in Christendom, were ruthless in their looting and exalted in their enthusiasm for stealing from churches. On Sunday morning, April 11, 1204, the day before the final assault, a small group of French Bishops sermonized to the twenty thousand or so Crusaders encamped on the Galata side of the Golden Horn. According to one among them, Robert de Clari, the Bishops said that this war was a "righteous one," for the Greeks were "traitors and murderers" and were "worse than the Jews." Within hours, the sacred altar of Hagia Sophia, "formed of all kinds of precious materials and admired by the whole world," was broken into bits and distributed among the soldiers.

Eight months later in that same fateful year of 1204, the famous Sephardic Rabbi, philosopher, astronomer, and physician, Moses Maimonides, died at age 69 in Old Cairo where, for more than three decades, he had been the spiritual leader of its large Jewish community. This is Maimonides of the monumental *Mishnah Torah*, a code of Jewish law comprising 613 *mitzvot* or commandments, which remains the practical guide to almost all imaginable "dos" and "don'ts" in the daily life of devout Jews. It is, for example, a

mitzvah (a commandment) to marry the widow of one's brother who died childless.

When new circumstances arise in life requiring new legal guidance, it is to Maimonides that the Rabbinical *Posek* or "decisor" refers in rendering his opinion. Rabbi Yechiel Weinberg, who died in 1966, was such an eminent decisor, and in that role addressed the question of whether a Jew should ever steal from a synagogue. The answer is yes: it is a mitzvah, literally, a commandment, to take objects from a synagogue that has been "confiscated" by "hostile" local authorities. Among those who collect Judaica from Arab lands nowadays, the object of such divinely-directed stealing is called a "mitzvah acquisition."

It was August 1997, and I had just returned from vacation. In the pile of mail on my desk at the Walters was a large package with a Miami return address. The package contained several Polaroid prints showing a beat-up wooden door about three feet high and perhaps a foot wide bearing Hebrew lettering and decorated with intricate Islamic-style carving. There was also a Xerox from a book, labeled in Hebrew, "Holy Ark. Ben Ezra Synagogue, Old Cairo," showing the door at an earlier point in its history with its companion left-hand door, when it was still part of a complete Torah ark (cabinet).

The package also included a report from Beta Analytic Services with the results of a carbon-14 analysis: the wood dates around AD 1070. An enclosed timeline told me that the Ben Ezra Synagogue had been founded in the 10th century, destroyed by Caliph al-Hakim in the early 11th century, and rebuilt shortly thereafter, when I assumed this door was created. And finally, there was a cover letter from the sender, Barry Ragone, suggesting that the door was for sale and saying, "I am only a temporary custodian."

I recalled from my days at Dumbarton Oaks that the Ben Ezra Synagogue was where in the later 1890s Solomon Schechter of Cambridge University had revealed to the world the famous "Cairo Geniza," a cache of 300,000 Jewish documents dating from the 9th through the 19th century. (A geniza is a dumpster-like repository where a Jewish community throws anything with writing on it against the possibility that it might include the name of God.) Because the Jews of Egypt began communications with the words "with the help of God," the Ben Ezra Geniza remains unparalleled in the number and variety of its documents that reveal all aspects of Jewish life in the Mediterranean. Ben Ezra, the main synagogue in Egypt, is also noteworthy for its identification with Moses Maimonides, who conducted services there frequently during his extended stay in Old Cairo.

When I reached the sender, Barry Ragone, by phone in Miami, I learned two things: first, that he is a pediatric dentist (I could hear screaming children in the background), and second, that he claimed to have bought the Ben Ezra door at an estate auction in Fort Lauderdale without knowing what it was. As I looked again at the Polaroids I imagined Moses Maimonides, eight centuries ago, unlocking and opening this right-hand door of Ben Ezra's ark and removing an ancient Torah for reading at services. I very much wanted this extraordinary piece of Judaica for the Walters, since we had nothing remotely like it, nor did any other major museum I knew. But there were troubling questions. How did it get from a famous Cairo synagogue to a Florida auction house? Had it been stolen from Egypt and is that auction story a cover-up?

Seeking some assurance, I called the Director of the Princeton Geniza Project, Mark Cohen, who I learned had heard from Barry Ragone months earlier, and had helped him verify that his door was indeed from of the Ben Ezra Synagogue. But I got no assurance. On the contrary, Mark made it clear that he shared the view of

the Curator of Judaica at the Jewish Museum in New York that the
Ragone door was recently stolen from Ben Ezra and must be given
back to Egypt. The xerox, he said, was taken from a book about the
Torah published in the late '70s by the Israel Museum, and it proves
that the ark was then both intact and in place in the synagogue. He
told me that Phyllis Lambert, daughter of Samuel Bronfman of the
Seagram Company, had overseen the restoration of the Ben Ezra
Synagogue in the '80s. And it was then, in those heady days after
the Camp David Accord when large numbers of Israelis and Amer-
ican Jews were visiting Cairo, that the door now in the hands of a
Miami dentist was spirited out of Egypt.

This was plausible, I thought, but unlikely. Instead, I chose a
very different scenario. I knew that the Ben Ezra Synagogue had
fallen into disrepair by the later 19th century and that it was demol-
ished and rebuilt shortly before 1900. I assumed it was then, not in
the '80s, that the Torah ark was removed to another location, and
that it was Cambridge scholar Solomon Schechter who took the
photo of the intact ark, and not some Israeli tourist a century later.
I assumed that the ark was then stashed for many years nearby, at
least nominally under the care of the local Jewish community. I
guessed that the Ragone door, now weather beaten, came out of
Egypt many decades ago, long before any export laws would have
existed, and that the remainder of the ark was forever lost.

The only missing piece in my scenario was an American collec-
tor of Judaica who somehow got hold of that damaged door in the
'50s or '60s and who eventually retired to Florida, taking the door
with him. (Perhaps he never knew what it was.) When this hypothet-
ical Judaica collector died, presumably in the early '90s, his children
were as puzzled by the door as was Barry Ragone when he first saw
it. So they consigned it, with their father's other household goods, to
a Fort Lauderdale auction house, where its story intersected that of
a Miami dentist. It *could* have been that simple—and that innocent.

ON SATURDAY JULY 3, 1999, I received a call at home from a fact checker with the *Miami Herald*. Our conversation was brief. Did I know Barry Ragone? Was it true that Barry Ragone had the right hand door from the Ben Ezra Torah ark and that he bought it at auction? And was it true that the Walters had offered Ragone $250,000 for the door? Yes, yes, and yes. I asked that he send me a copy of the next day's paper; it had a large photo of Barry holding the door at the bottom center of the front page. That is almost exactly where the same picture was, with pretty much the same story, in *The Baltimore Sun* two days later.

By then, nearly eighteen months had passed since my initial visit to Miami, when I was shown the Ben Ezra Synagogue door wrapped in a blue beach towel on a table in the conference room of a small suburban bank. Barry Ragone had seemed enthralled that day with my vision for his door at the Walters, namely, that it would be exhibited at the boundary between galleries of medieval Christian art and Islamic art, mimicking the circumstance of the Jewish community in medieval Egypt. But when I offered him $100,000 he said immediately, "I can't take that home," which I took to mean that his wife wanted more money. Of course we both knew that some very influential people in Princeton and New York were saying that the door was stolen. As Barry drove me back to my hotel, I suggested that he go public with his story in order to smoke out any $1 million buyers or anyone with hard evidence that his door was stolen. Two weeks later I upped my offer to $250,000.

I learned from the *Miami Herald* some things about Barry Ragone that somehow had never come up. I learned that Barry had become a cocaine addict after the death of his father and younger brother in a car accident and that as a result of his addiction he lost his license to practice dentistry in 1993. Apparently, for a time Barry

worked in a studio that made documentary films, and in 1995 he pleaded "no contest" to one count of grand theft involving discrepancies in his Medicaid accounts. Perhaps that brush with the law explains why, according to the *Herald*, Barry had retained one of New York's most expensive art attorneys, Ralph Lerner, to represent his interests in the sale of the door. Or did it? And as for the auction, Barry could not recall whether it took place in 1993 or in 1994, but he was certain that it happened on a Friday, at the Trader Auction Palace on North Dixie Highway. He was the only bidder and he got the door for just $37.50. As for the auctioneer, it was the "Fastest-Mouth-in-the-South," Pat Hishon, a personal friend of Barry's who claimed to have no idea where the door came from. But the final words in the article belonged to Barry's Rabbi, who was quite certain the Ben Ezra door was worth $1 million.

Six months later I received a call from someone who I think identified himself as Barry's brother. This person had decided to insinuate himself into our stalled negotiations because the stress of trying to sell the Ben Ezra ark door was affecting the health of Barry's wife. He wanted us to move to closure, which I jumped at, so I suggested that I come to see him in Miami at my first opportunity, which was on the Friday after Thanksgiving, November 26, 1999.

My host picked me up in his SUV at my South Beach hotel and took me to an Israeli restaurant, which seemed appropriate. He told me with great pride that he had just won an Emmy for a documentary he had produced on American GIs who fought in Israel's War of Independence. I already knew that Barry's father and younger brother, the ones killed in the car crash, had been involved in creating an indoor soccer team in Phoenix, so I concluded that the Ragone family had many talents and more than one link to Israel. But it also struck me how much more forceful and self-confident Barry's "brother" was than Barry. He also seemed to not look much like Barry.

At a certain point well into the evening, as my host's monologue was winding down, I expressed my enormous enthusiasm for the Ben Ezra door and described what I would do with it at the Walters, and how I had recently partnered with Yeshiva University in New York City to make the purchase. And then I upped my offer to $330,000, with the warning that this was my *final* offer and, after two weeks, if not accepted, it would be withdrawn. I felt confident that evening that the deal was all but done.

But it wasn't. When I called Barry one day short of my deadline, he seemed puzzled, and when I told him about my visit with his "brother" in South Beach almost two weeks earlier, he seemed totally perplexed. But forget that, I said: do we or do we not have a deal at $330,000? His answer was immediate and crisp: "No, my price is $500,000." With that I flipped my Motorola flip phone shut—and immediately realized that this impulsive act was not a good idea. But with some help from a friend in the Baltimore Jewish community, I soon got back in touch with Barry, and after another month of dickering and another $60,000 from our side, we came to closure. Barry Ragone agreed to sell the Ben Ezra Torah ark door to the Walters Art Museum and Yeshiva University for $390,000. He said he would take the balance of $610,000 on his initial asking price of $1 million as a charitable contribution (so he got a tax write-off, but no additional cash). Finally, after thirty months, the deal was done and everything was in order. Or so I thought.

The first public showing of the Ben Ezra Torah ark door was at the Yeshiva Art Museum in a small exhibition that opened on September 11, 2000, in their new facilities in Chelsea. I gave the guest lecture on the door and its history. The mood was joyous afterward as we shared cocktails in the gallery, gazing at that precious piece of medieval Judaica and puzzling over whether it had a second story—that is, a *true* story.

Then in the course of the reception, two older Jewish gentle-
men came up to me separately to speak privately. Each had the
same message: "I know where the left-hand door is." And then each
slipped back into the crowd. I wondered if they telling me the truth
or just having some fun at my expense.

The next day I went back to the book Phyllis Lambert pub-
lished in 1994 that documented her recent restoration work on the
Ben Ezra Synagogue. I found a group of photographs of Ben Ezra
from the late '70s taken by a well-known Israeli documentary pho-
tographer named Micha Bar-Am—photographs that in my enthu-
siasm for my Solomon Schechter scenario I had chosen to ignore. I
saw that in the pre-renovation synagogue of 1979 there was a very
old wooden cabinet with carved decoration much like that of the
Ragone door, a cabinet that according to Lambert had since disap-
peared. I then did a little investigating with Cambridge University
and learned that Solomon Schechter took virtually *no* photographs
on site when he was excavating the Geniza documents in the late
1890s.

Again, it had been my wishful thinking at work, as I recon-
structed my " innocent and long ago" scenario for the door's exit
from Egypt. But if it didn't come then and that way, how did the Ben
Ezra Torah ark door get from Cairo to Miami? For a decade, I was
content to leave that question alone.

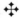

I RETURNED TO THE DISTURBING unfinished business of the Ben
Ezra Torah ark door in November 2013 as I began my memoirs. Per-
haps, I thought, the missing piece to the puzzle is the identity of that
person with whom I had dinner the evening after Thanksgiving in
1999, the man who I think presented himself as Barry's brother. The
Internet is a wonderful research tool now, as it was not fifteen years

ago. In short order, I learned that the Emmy-winning producer of the documentary I heard so much about that evening (it is called *Israel's Forgotten Heroes* and premiered on the local Miami PBS station in December 1998) was not a Ragone, but rather a Levine, specifically, Jerry Levine, then CEO of Higher Authority Productions. I checked out pictures of Jerry Levine on the Internet from newspaper articles of the late '90s and I now believe that I recognize that he is the man who picked me up in his SUV at my hotel. This puzzle piece, once in place, has compelling implications, given that Barry told the *Baltimore Sun* that he had worked for some time in a film production business after his dentistry license was revoked.

Now a very different scenario for the journey of the Ben Ezra Torah ark door from Cairo to Miami came into focus. The hypothetical goes this way: it is 1995 or thereabouts, Barry Ragone is in recovery and working for Jerry Levine, and Jerry is beginning interviews for his *Forgotten Heroes* documentary. Jerry Levine is an Orthodox Jew and (as I learned on the Internet) is very active in his synagogue, and Higher Authority Productions specializes in documentary films about the South Florida Jewish community and about Israel. These activities and this timeline would not only explain Jerry's link to Barry, they also connect them both to a group of elderly Jewish war veterans in their own backyard who would likely have both opportunity and motive for *mitzvah* acquisitions.

My hypothetical continues: perhaps through these connections, Jerry and Barry meet the door's owner and learn that it was his *mitzvah*-driven stealth that liberated the door from Cairo ten or fifteen years earlier. They have a general sense that the object is important but are vague on what it actually is. They know that the right thing to do is to place the door in a Jewish museum. At the same time, they are not oblivious to its financial dimension; doing the right thing can also be rewarding. But given that they suspect that the door had been taken without permission from a very important

historical site, there is both risk and anxiety. Barry is an amateur collector (as he told the *Miami Herald*) and he has time on his hands, so the research falls to him, and inevitably he becomes the public face for the door as he reaches out to scholars and museum professionals around the world. The early accusations of theft by the Curator of Judaica at the Jewish Museum and by Mark Cohen at Princeton nearly expose their *mitzvah* conspiracy, but thanks to Gary Vikan, the Walters Art Museum soon enters to save the day.

By this theory, the Fort Lauderdale auction is a laundry job intended to create "provenance amnesia"; thus the ambiguity about the year it took place and the auctioneer's inability to account for, or, seemingly, even to care about where he got the door. This *mitzvah*-conspiracy scenario also explains much about my experience with Barry Ragone: the secrecy and anxiety that flavored our many exchanges; the fancy New York lawyer, Ralph Lerner; and Barry's consistent refusal to come to New York or Baltimore to see "his" door on public display. It explains as well that strange dinner in South Beach with a co-conspirator who was getting nervous and, most important, it provides a logical and tight connection between Cairo around 1980 and Florida around 1995.

But is it true? I can hardly expect Barry Ragone or Jerry Levine to confirm what I now believe might have happened, and the auctioneer died in 2001. But I should reasonably expect one or both to identify my dinner partner on the evening of November 26, 1999. After all, what's the harm? So I emailed both Barry and Jerry, coincidently, on the day after Thanksgiving, 2013, asking as naively as I could, with whom I had dinner on that warm evening in South Beach exactly fourteen years earlier. Neither chose to answer me. For Levine, I suppose, silence is understandable. But for Barry Ragone, who in our initial email exchanges that fall was very open and eager that I pay him a visit in Miami, silence may be its own answer.

Was I set up? Was I the "tail-end-Charlie" of the Ben Ezra Synagogue door? Perhaps. But I have no regrets. Quite the opposite, for I have chosen to claim this museum purchase as my own personal *mitzvah*—one of a sort that I'm absolutely certain would have pleased the greatest "decisor" of them all, Rabbi Moses Maimonides.

Chapter Sixteen

Working for the President

The beginning of the end of the struggle to reconcile my passion for acquiring and displaying sacred works of art with my knowledge that many of them were stolen came in April, 1997. Senator Paul Sarbanes wrote to tell me that he was supporting my nomination for membership on President Clinton's Cultural Property Advisory Committee (CPAC). I was not surprised, and I knew why it had happened. My testimony on behalf of Cyprus in the Kanakaria trial got the attention of Maria Kouroupas, Executive Director of CPAC. The Hellenic triangulation from Cyprus to Maria to Senator Sarbanes was obvious, and just fine by me. I was a hero among Greek-Americans for Kanakaria and for my icon exhibitions.

I suspect they also knew that I favored the return of the Elgin Marbles to Greece and they had every reason to believe that as a member of CPAC, I would take a hard line on the illicit antiquities trade. I had, after all, laid out the canonical guidelines for appropriate due diligence on the stand in Indianapolis. It's about using all best efforts and asking all the hard question in order to discover the truth of the origin of a proposed purchase or gift. This is what Dominique de Menil did with the Lysi frescoes and what Peg Goldberg did not do with the Kanakaria mosaics.

In the years just after the Kanakaria trial I spoke about the illicit antiquities trade and due diligence on many panels before a variety of audiences, from archaeologists to museum directors to art dealers. My foil was the Association of Art Museum Directors' acquisition guidelines that seemed to me to invite hypocrisy. We directors were admonished "not knowingly" to acquire works of art that had been exported from their country of origin in violation of national laws. Not *knowingly*? So how is it that museum curators and directors, who go to graduate school to learn how to research every aspect of a work of art, are somehow rendered stupid and incapable when it comes to knowing the truth about the origins of the antiquities they're buying? It sounded like Peg Goldberg, and I didn't like it. I'm pretty sure Maria Kouroupas loved me for that and wanted me on CPAC to ensure that CPAC would do the good work of helping to interdict the international trafficking in looted antiquities.

Twice a year I'd drive down to DC for two days of CPAC meetings that took place in a stuffy conference room on an upper floor of an ugly government office building just south of the National Mall. What struck me as I looked around the room on the first day of my first meeting, in the winter of 2000, was that there were only six members of the committee present—six out of eleven. Since that's a quorum, we were legally empowered to review the request on the table from Bolivia. But I had to wonder: who's missing, and why? I was told that those members of the committee who, in the past, represented the point of view of the antiquities trade were now deemed to be flawed by an inherent conflict of interest, so they were not invited.

And then I realized that the two of us who were there to represent the point of view of the museum community were certainly AAMD outliers. Vikan, for his role in the Kanakaria trial and for his outspoken opinion-sharing about the hypocrisy of the AAMD acquisition guidelines, was from the archaeologists' point of view, a white knight. And so was Martin Sullivan, CPAC's chair, who at that point

was not even a museum director. But when he was a director at the Heard Museum in Phoenix, Marty was a leader in drafting NAG-PRA, the Native American Graves Protection and Repatriation Act. This required all institutions receiving federal funds to return "cultural items" (grave goods, human remains, sacred objects) to lineal descendants and culturally affiliated Indian tribes. So Marty, too, was a white knight. I realized that Ms. Kouroupas, the stern and mostly silent woman at the end of the table, had done her work. Of all possible museum members of CPAC, she had found the two with the word "repatriation" tattooed on their foreheads.

This bothered me because the point of CPAC was to bring to the table eleven citizens of good will with different perspectives on the international movement of cultural property: three members of the general public, three archaeologists, three people from among the dealing and collecting community, and two museum professionals. CPAC's implementation legislation of 1983 was based on the integrity of a process that would involve these multiple perspectives and voices proceeding through a series of four questions. First, is the cultural patrimony of the requesting State Party (requesting country) in jeopardy from pillage? Second, has the State Party taken measures to protect its cultural patrimony? Third, will the adoption of import restrictions, if taken in concert with other nations having significant import trade in such material, be of substantial benefit in deterring pillage? And fourth, is the application of import restrictions consistent with the general interest of the international community in the interchange of cultural property?

The makeup of CPAC as I joined was clearly at odds with what I knew the intent of the Cultural Property Implementation Act to be. And it was obvious in no time that there were process problems as well. On the table in front of each of us was an enormous Xeroxed book replicating the request from the government of Bolivia. It was so dense and confusing that none among us, I think, could have

figured it out on his or her own. So we had the benefit of a very smart recent PhD whose specialty was the ancient archaeology of the Andes. This meant that the version of the Bolivian narrative we received was that of the Bolivian government as digested and interpreted by an academic whose career interests were coincident with the requesting State Party.

There was one remaining protocol to assure that we had the benefit of other points of view, if only briefly. It is called the "public session." This is a designated period when the double doors of the conference room are swung open and anyone who has signed up can come in and testify. The testifying group consisted mainly of lawyers in fancy suits, all earnest and well prepared and mostly from New York, representing the National Association of Dealers in Ancient, Oriental, and Primitive Art, Sotheby's, Christie's, and the AAMD. (This group had no access to that xeroxed book from Bolivia.) They would tell us what, from their point of view, was really going on, and this could be very important for our deliberations, especially on the question of whether our actions to interdict traffic of cultural property X from country Y could have any salutary outcome. It would be inappropriate to curtail the actions of Americans for some possible greater international good if that action would have no actual benefit.

If we were to learn from the auction houses that virtually no Bolivian antiquities were traded in the US market, but were traded instead in London, Paris, or Brussels, we should then say to Bolivia: thanks but no thanks. I was also struck by how lackadaisical the tempo of our closed-door sessions was—typically academic and wandering—and how crisp the public session portion of our meetings was. With strict time limits and a ticking clock, it was in and out for those NYC lawyer types, and after they left, the committee went back to the business of helping Bolivia.

The next thing that struck me as odd was how much junk was in that request packet from Bolivia. Somehow we were being asked

to care about the import into the US of ethnographic material of the 19th century that I recall included little clay pipes you blow into, and which have a market value of maybe $25. Why? The implementation legislation requires that to be a qualifying object of ethnographical interest it must be "important to the cultural heritage of a people because of its distinctive characteristics, comparative rarity, or its contribution to the knowledge of the origins, development, or history of that people." Were these tourist-trinket items somehow defining of Bolivian national identity? Were they to be understood as national material assets like oil or tin? And there was another issue: How about modern borders and, in this case, the Bolivia/Peru border? US Customs is asked to stop the import of, for example, a 16th-century wooden beer pitcher (*kero*) that comes from the Bolivian side of the border, but to let an identical one come in that happens to come from the Peruvian side of the border. And why is this? Because Bolivia had asked for such US action but, up to that point, Peru had not. Fair enforcement under such circumstances is impossible.

This craziness brought me back to an *antiquariat* shop in Bucharest in 1975. Elana and I had gone in to look for souvenirs to take home after eight months in Romania. We were told by a surly clerk that one whole area of the shop was off limits, namely, that section where items one hundred years old or older were displayed. Now, from where we stood it was obvious that much of the "stuff" over there was simple, homey, and utilitarian—such as little footstools, pillows, and baskets—and clearly, pretty cheap. But were these trinkets somehow forbidden because they had been nationalized by the Communist State and, much like Romania's citizens at the time, they could not leave the country? This seemed to me not so different from that Communist radio we had in our Bucharest apartment that could get the Leipzig and Dresden stations but not those in Paris or London. And so here I am, in a stuffy conference room in Washington, DC, acting on behalf of the president of the United States, and

it feels as if I'm basically in the same business as Nicolae Ceauşescu, of closing borders. People, cultural property, radio waves, and ideas had all collapsed into one, and it seemed to me I was on a committee that was doing the wrong work in the wrong way.

As it turned out, I was not able to resolve my conflicting thoughts on looted antiquities in the context of CPAC. On April 17, 2003, in the wake of the looting of the National Museum of Iraq and the burning of the National Library, I resigned from the committee. I was angry: "Shock and awe" had not included today's version of the Monuments Men.

Chapter Seventeen

"They'll Scare Away the Rich Old Ladies"

I t was Wednesday, May 31, 2006. Everything about my career at the Walters Art Museum seemed to come together that beautiful spring day under an open tent in Druid Hill Park. True, the crowd watching me in my museum-director's uniform of a blue blazer, khaki slacks, and a dramatic, hand-painted tie was very small. But the press was there, and the people who were must-shows, did show: Mayor Martin O'Malley and County Executive Jim Smith. The honorees were two sets of museum people taking a big step. They included me and my Board President, Bill Paternotte, and my counterpart at the Baltimore Museum of Art, Doreen Bolger, and her Board President, Sue Cohen.

The occasion was a press conference and a symbolic ribbon cutting; there were balloons and confetti. This was the day we announced, formally and to the press, what I had been working on for the previous six years—making the Walters free of charge. Free general admission to the museum would begin the following October 1st, twenty-four years to the week after the first admission fee was introduced at the Walters. It was a moment when I knew I had done the right thing, and I was pretty sure that for doing that, the

world would take care of me. The politicians had made it possible with bridge grants to cover the lost revenue at the two museums over the next three years until we could adapt to the new reality and bear the lost income on our own. And then we could see what had been gained. They believed in us, and we believed in ourselves. It was a great day.

I had reason to feel good that spring day, even before that announcement. The previous October we had opened the renovated and reinstalled Charles Street Building with its Renaissance and Baroque painting galleries and its signature "Cabinet of Wonders" with its natural curiosities and the marvels of human creativity they inspired—including rock crystal carved in the shape of a duck. Plus, on the wall there was a mounted alligator and on the table were trays of butterflies and beetles for kids to look at with magnifying glasses. Everyone loved it.

Four years before we had opened to great acclaim the renovated Centre Street Building, with its ancient, medieval, and 19th-century galleries all reinstalled contextually to show how the works of art were originally experienced. We were on a roll and rapidly closing in on the matching funding for the last of the twenty endowed positions that I had spearheaded—up from just one when I began as director. I had the staff I had always hoped for and a board president with whom I was in full partnership. And the economy had come back. My public profile and my scholarly life were flourishing. I had just been invited to give the closing commentary at the International Byzantine Congress in London that August, and I had been asked by Dumbarton Oaks to update a book I had written while there in 1982. I had inaugurated a blog, the first by a museum director, and soon I was going to start my own weekly radio show, *Postcards from the Walters*, on the local NPR affiliate. The Getty had recruited me as a candidate for its directorship a year earlier; I made the short list but lost out to Charles Brand. That was okay, since I was ready

to end my career in the place I loved. But I wanted the place I loved to be free to all.

I suppose it was in my Midwestern, Hubert Humphrey "happy warrior" DNA to believe that art is for all, and that it can be an instrument for social change. But there was a second level to what motivated me: aesthetic evangelism. The idea I had absorbed as an undergraduate at Carleton in the '60s was that the art experience, the aesthetic experience, was by its nature a spiritual experience, even if it did not spring directly from a religious work of art. To contemplate Vincent van Gogh's *Church at Auvers* aesthetically is, for me, devotional—not because the subject is a church but because the painting's masterful combination of rich swirling colors, dramatic light, and profound mystery has an emotive power for me like that of Chartres Cathedral. In both cases (and many others), I spontaneously hear music in my head when there is in fact no real music to be heard. When I hear that phantom music, I know I am having an aesthetic experience.

That transcendence, which is my version of religion, had fueled in me an evangelical zeal. I wanted everyone to have that powerful and enriching experience of art that I had, and there were two things I thought I could do to help make that happen. The first, which I felt I had addressed through the renovation of our galleries, involved presenting art in such a way as to release its spiritual power. This is the numinous. The second was the elimination of our general admission fee, which I believed was the biggest hurdle keeping many in our community from having a spiritually enriching encounter with the museum's collections.

The idea of "going free" first occurred to me in the late '90s on a visit back to Minnesota, when I learned that the Minneapolis Institute of Art—bucking the national trend to ever higher admission fees—had gone free a decade earlier. As a result, it had seen its attendance skyrocket and its relationship to its city profoundly

change for the better. Together, these raised the MIA's profile in the local philanthropic community to the extent that new donations far outweighed the loss of income at the door. I thought that could work for the Walters. And I recall thinking that the Walters' reputation as remote and aloof behind imposing bronze doors and a place for academics, the intellectual elite, and wealthy older women, was also at odds, along with our admission fee, with Henry Walter's mandate, in his will, that we act "for the benefit of the public."

A first step toward changing how we thought about the museum and what it should be doing came soon thereafter in the fall of 2000. Board and staff together changed the Walters Mission Statement to align with my evangelical spirit. We did this by shifting focus from the collection, which we had formerly been charged "to preserve, enhance, and foster understanding of," to the visitor. And each staff member soon knew the first critical sentence of our new mission by heart: "We bring art and people together for enjoyment, discovery, and learning."

Eliminating our general admission fee was, however, much more complicated. After all, it represented $150,000 in predictable income and was a major ingredient in sustaining the revenue stream from our membership program. The Walters had started charging a fee in 1982 on the advice of Mayor William Donald Schaefer, who saw it as a *quid pro quo* on the museum's part for his promise to raise significantly the city's annual operating support. The Walters, in the years thereafter, followed the pattern of nearly all art museums nationally in periodically raising its admission fee to generate additional operational income. It was that simple and meant that getting rid of the fee to broaden our impact in our community was going to be an uphill battle.

"THEY'LL AWAY SCARE THE RICH old ladies!" These words (or something close) from one of my most influential and articulate board members evoked and galvanized sentiments that I am pretty sure were shared to some degree by many others on the board and by many among the staff. It punctuated the protracted and sometimes heated exchange at the Walters board meeting on March 11, 2003. This was the day I called the question: Will the Walters eliminate its general admission fee, or not?

These "old ladies" were the wealthy older women who were going to be scared away from our galleries if we went free. White women, of course. The "they" in "they'll scare. . . ." were never explicitly described by anyone, but were clearly understood by all to be the demographic reality of Baltimore, which is overwhelmingly African America and substantially poor. Without being described, "they" could be talked about very easily and politely by referencing the troubling predicament of the Enoch Pratt Free Library, one short block south of the Walters on Cathedral Street. Opposite the front door of the Pratt Library is the great Latrobe Basilica and just beside it, in those days, was Our Daily Bread, one of Baltimore's largest soup kitchens, which provided up to 750 meals a day. It was then believed, and it was pretty much true, that the poor and homeless who stood in line for hours at Our Daily Bread spilled over across the street and created havoc in the Pratt Library in their bathrooms, which now had to be locked, and throughout the reading rooms, by sleeping on seemingly any available surface.

The connection was not difficult for anyone to make. If the Walters were free, that spill-over of homeless and their havoc would spread one block north to the museum. And when that happened, our traditional users and donors, whose financial support we

desperately needed, would no longer feel comfortable and would stay away, along with their philanthropic dollars.

Such fears were echoed by our chief of security, whom I had earlier asked to write up his own professional prediction. He quoted his counterpart at the Pratt Library, who said a free Walters would be a total mess. Also aired was the story of the day in the early '80s when a vagrant walked up the fire stairs of the then-free Walters to the curatorial offices on the fifth floor, entered the women's bathroom, and accosted a staff member. And a tale of more recent vintage was circulating about the then-free Art Institute of Chicago, where a sexual predator was said to have molested a child in one of the museum's bathrooms. (The evidence showed the child's mother had made a totally false claim in order to extort money from the museum.)

I simply didn't believe that catastrophically bad things would happen. But conviction alone didn't get me very far with the board or even with the staff. I needed to do some planning and orchestrating. Since the Minneapolis Institute of Art is not in the best neighborhood, I got the director of the MIA on the phone during that March 11th board meeting. Not only did he celebrate the impact of that move-to-free on attendance and on the position of his museum in the community, he went on to say that the MIA had never, in the fifteen years since then, had any problem with vagrants.

The next voice the assembled trustees heard that day was that of the director of the recently-free Dayton Art Institute, which is in a tough part of a pretty tough town. He said that it was simple: at Dayton we don't care what our visitors look like or how they smell, only that they are there in the museum to experience the art and not to sleep on a bench or trash the toilets. You should treat people with the expectation that they will behave well, and his experience in Dayton was that they did behave well—all of them. And I chimed in that this is what I thought would happen in a free Walters.

Before the meeting I made certain that two specific board members would be in attendance. Both were women, one African American and the other white, who were known and respected for their outspoken commitment to full engagement with the challenges that Baltimore presents. Since I framed the issue as one of community service and values first and money second, their collective endorsement, conveyed with just a word or a nod, set a lofty tone for the other trustees. The second critical thing I did was to position the question as contingent on a no net loss of revenue. Or, put another way: the proposition was that the Walters would go free *only* when I found the money to offset the loss of income at the door, something, including lost memberships, on the order of $250,000 annually. For some, perhaps many board members, this turned the question into a benign hypothetical, because in the current economy it was hard to imagine where Vikan was going to come up with that kind of money.

With that no-lost-cash caveat and my orchestrated endorsements, the vote was overwhelming in favor of going free. There was one vocal abstainer, who was not the board member who painted the dire picture of our traditional supporters staying away, but one whose family has a large foundation. He said something to the effect that "you don't value what you don't pay for" and that his family's foundation would not support a free Walters. In response, I compared the museum's collections—which are public assets—to clean air and green space, as something people have an inherent right to have access to. Thankfully, despite the threat, his family foundation continued to be generous to the Walters.

FOR THE NEXT THIRTY MONTHS that endorsing board vote sat, mostly forgotten, awaiting its trigger. Then in October 2005, we reopened the reinstalled Charles Street Building with its Cabinet of

Wonders. Among the hundreds who showed up to see the new galleries was one couple that stayed the entire day, Senator Paul Sarbanes and his wife Christine. They were the last to leave and before they did, they stopped to give me some advice. They had just been to Dublin, and there (did I know?) the museums are all free. Why aren't Baltimore's museums free? Now, that got my attention, mostly because I had just read in *The Baltimore Sun* that the city for the first time that anyone could remember had a budget surplus, thanks to the booming local real estate market. A surplus of $56 million!

The Sarbanes' enthusiasm made me think that it might be just the right moment to approach the city about bridge funds so we could go free at no net financial loss and then ride the Minneapolis Institute of Art's new economic model that would allow us to stay free. The city, then the Walters' single largest funder, had been cutting the museum's operational support in bits and pieces since the early '90s. What if I were to ask Mayor Martin O'Malley to restore funding for the Walters in 2006 to the level that it had been in 2001 and keep it there for three years? In return, we would eliminate our general admission fee.

A few weeks later I met with the mayor's Chief of Staff, Clarence Bishop, whom I had gotten to know well and to admire in my service on a local tourism board he chaired. There were four of us in his office at city hall. The others were Bill Gilmore, Executive Director of the Baltimore Office of Promotion & the Arts, and my Board President, Bill Paternotte, who was 100 percent behind going free. I had crafted a little bar graph showing the decline in city operational support going back nearly fifteen years and overlaid it with a bump up in 2006 to match our 2001 level. Clarence smiled, and I immediately knew two things: first, that Bill Gilmore had already briefed him and second, that we were on our way.

Sounds good, he said, but there are two conditions: first, the Baltimore Museum of Art must be part of the strategy; and second,

Baltimore County must match the city's bridge funding support dollar for dollar. I welcomed both. After all, the Walters and the BMA are both city-owned and city-funded museums, so they should move in tandem to serve the city. And since Baltimore County residents use the two museums as much as city residents do, the county should pay its share. In early February 2006, Doreen Bolger of the BMA and I met at the Walters with our respective board leaders. It was like magic. Not only were our counterparts up Charles Street eager to go free, our respective lost income projections were, by the best of luck, an exact match. There was no haggling, just planning.

A few weeks later we met with Baltimore County Executive Jim Smith. Like Clarence Bishop, his first reaction was a broad smile. He later said the two museums had never before come together with a common goal and a single financial ask. Baltimore County was officially on board. This is what led to that sunny May day in Druid Hill Park and the public announcement that the Walters and the BMA were going free. It was a radical step for both of us. We had done something good, and I was proud. And sure enough, attendance at the Walters rose by more than 40 percent that first year and stayed up there, and participation by African Americans in the life of the museum increased by a factor of three. And no, our traditional supporters did not abandon us. On the contrary, they endorsed what we had done by upping their annual support significantly each year, even during the depths of the recession. For a museum director, it gets no better than that.

Chapter Eighteen

Living with Loot

My entire profession career has been in three art museums, Dumbarton Oaks, the Menil Collection, and the Walters, that are filled with undocumented ancient and medieval artifacts. These are the kinds of works of art that the President's Cultural Property Advisory Committee was created to keep out of the US. I first became aware that I was living with what the archaeologists with me on CPAC would call "looted antiquities" soon after I arrived at Dumbarton Oaks in 1975. I learned that there was a vault downstairs with a huge door and combination lock. Behind this was most of a 6th-century Byzantine silver treasure, the infamous Sion Treasure, that could not be seen by the likes of me and was not even to be spoken of. The Sion Treasure was discovered by villagers in 1962 in Lycia, in southwestern Turkey. Most of it was soon spirited out of the country to Switzerland by George Zacos and his wife Janet, and sold to Dumbarton Oaks for $1 million in 1963.

In the fall of 1981, I intersected with the Saint Peter icon, recently removed from a church in northern Greece by way of Michel van Rijn. And in 1983 I encountered the Lysi frescoes and the Kanakaria mosaics, stolen from northern Cyprus by way of

Aydin Dikmen. Clearly, those who saw me as a repatriation hero in Indianapolis were unaware (or forgiving) of all those years I had spent in cohabitation with the Sion Treasure and Saint Peter and, at the Walters, with the Sion Treasure's Baltimore equivalent, the Kaper Koraon Treasure. My first big Walters exhibition, *Silver Treasure from Early Byzantium*, was a quest to reassemble that hoard of 6th-century church silver that was clandestinely dug up by looters in late 1908 in northern Syria. Henry Walters bought much of it (then called the Hama Treasure) from Joseph Brummer in Paris in 1929. This was considered just fine back then.

By the time I quit CPAC that was all old news. Fresh news—which finally brought clarity to my thinking—came in the spring of 2007 when a Kress Fellow at the Walters came to show me something startling. She opened a glossy French magazine, one of the many that focus on regional French archaeology and art, and in it showed me the picture of a 13th-century enamel reliquary that was identified in its caption as *volée* ("stolen").

Then she produced a photo of a reliquary at the Walters, and it was immediately obvious that the two were one and the same. According to the magazine, that stolen reliquary was, at least until 1890 when it was inventoried and photographed, in the Church of Saint Martin in the village of Linard, near Limoges. We agreed that the right thing to do was to make contact with that town and church to learn the rest of story. Most immediately, was that church still in existence? And if so, how do they, meaning the priest and the mayor, know that the reliquary in question was stolen and not simply sold by the church? Our Kress Fellow tracked down the town's mayor on the Internet. She emailed him and he wrote back with a photo of the church, which was clearly intact and fully functional.

There are, as background, three things to know. First, the 13th century was a time of intense church building in France, a prime example being the Church of Notre Dame in Paris. Second, these

grand new churches needed the implements of the mass. These included patens and chalices for the communion bread and wine and also fancy covers for their sacred altar books, crucifixes, "Holy Doves" to contain the presanctified host during Lent, incense boats, and reliquaries with bits of holy bodies. The incense containers are shaped like boats because incense came to France in boats, the Holy Doves take that form to recall the Dove of the Holy Spirit, and the reliquaries, which in French are called *châsses* ("boxes"), have the shape of a tomb. They are small oblong boxes on stubby feet with gabled roofs; they have a wooden core, are covered with sheets of enamelwork, and have a trap door at the back with a lock to give access to the relics.

An industry developed in the central French town of Limoges to supply these various liturgical objects, and the medium was gilt copper and enamel. This specifically was *champlevé* ("raised field") enamel, a technique of cutting away the metal background and filling it with colored enamel paste with a preponderance of the color blue. The front panel and roof usually bear complementary scenes that may (or may not) relate to the specific relics inside. In the case of this Limoges reliquary, the roof shows the Journey of the Magi to Bethlehem and the front panel shows them presenting their gifts to the Christ Child.

The third and last thing to know, as you imagine yourself standing in my shoes when I learned all of this, is that the Walters has many 13th-century Limoges pieces—almost as many as the Met— and among them, six reliquaries. (There are around seven hundred surviving Limoges reliquaries.) Henry Walters loved medieval art, he loved Paris, and he was collecting in the '20s when an abundance of medieval Limoges was available.

What we know in the case of this reliquary is that Henry Walters acquired it in Paris in 1927 from a dealer named Henri Daguerre. Daguerre bought it from Brimo de Laroussilhe, a dealership formed

around 1910 that had acquired it from its first known owner after the church, Joanny Benoit Peytel, who died in 1924 and would have been in his mid-40s in 1890. Peytel, who made his fortune in Algeria, was a well-known French collector of both medieval and modern art. He eventually gave several important works to the Louvre, including a Sisley and a Watteau, but also a late medieval relief sculpture from a church in a town near Nancy. Interestingly, the website for that town, Pont-Saint-Vincent, notes that no one seems to know how Peytel had obtained that sculpture from the local church.

It occurred to me as I wondered what to do next that the priest of the Church of Saint Martin and the local mayor may have a legal case to make paralleling that made by Cyprus in claiming back the Kanakaria mosaics. Should they choose to sue the Walters for the reliquary's return, the case would likely be tried in a US Federal Court under US (not French) law. The reason for this is that while the transaction took place in Paris, the buyer was American, the money came from America, and the destination of the piece was America. Under US Common Law, a thief cannot convey good title.

So all the mayor and priest would have to prove is that the piece was stolen, and no amount of due diligence on Henry Walters' part (I doubt there was any) and no string of intermediary owners before Henry would alter the outcome: title and rightful possession would still rest with the Church of Saint Martin. And this would be true even if someone associated with the church, like a disaffected deacon, sold the piece to Peytel without the official authorization of the French Catholic Church. (Which is my guess as to what actually happened.) And if it could be shown that transaction took place after 1905, when the French government nationalized church treasure, there would be a State claim as well.

I know that at the time I did not feel any obligation to act; I did not think Henry Walters had done anything wrong and did not believe any aggressive action was imminent from the mayor. Of all

the untitled, looted, or otherwise clandestinely transferred ancient and medieval art that I had crossed paths with in my life, this category of Limoges enamel ranked very low on my suspicion scale. This was because I assumed that the vast majority of those Limoges pieces that were traded through Parisian dealers a century ago, and are still traded today with the modern reincarnation of Brimo de Laroussilhe, had left the medieval churches for which they were made during the French Revolution. (The French have long since come to terms with the churches and monasteries they destroyed and the church property they plundered during the Revolution.) Perhaps I was wrong, but that was my assumption. Besides, the French are so enlightened about these things, and their greatest museum, the Louvre, is filled with Napoleon's plunder. In any event, the mayor was not asking us to do anything, at least at that moment. And since they had our contact information, I had to assume that the local authorities would eventually be in touch.

A FEW MONTHS LATER, IN June, Elana and I were on vacation in France and decided to pay a visit to Linard, which is truly a tiny town that time has forgotten. The local church matched what I recalled from the mayor's email, and it is dedicated to Saint Martin. Just opposite the church was a donkey in a field, who found us very interesting. This seemed almost poetic. I tried the front door and it was locked. I went around to the side, where I discovered an old man laying stones for a terrace in the company of his black and white shepherd mutt and one of the fattest cats I'd ever seen. He said there had been a funeral in the church that afternoon, and that I should try the south door.

It was scruffy inside, for sure. The altar was covered with that plastic some people put on their sofas and lampshades so they will

never have to buy another. And there were only three cheap and ugly silver-plated items of modern manufacture visible: two candlesticks and one crucifix. I poked around all over the place, including the sacristy, where the Walters reliquary was, I assume, once locked away. There were cobwebs, lots and lots of cobwebs. And junky church paraphernalia of the poorest quality. So where did our Limoges reliquary, the "stolen" one, fit into this scene? I had no idea. But before I left, I dropped a note for the mayor in his mailbox at the *Mairie*, saying I had stopped by.

One of my favorite places to enjoy the Walters and to feel the numinous is from a bench in the southwest corner of the medieval galleries, just behind the French Limoges altar we created as part of the 2001 reinstallation. There is a stained glass window with scenes from the life of Saint Vincent just behind me as I look toward the altar. This is a window that came out of the Abbey Church of Saint-Germain-des-Prés in Paris shortly after the French Revolution. Just before me is a French Gothic altar ensemble that only two museums in America could attempt—the Walters and the Met. And we did it first.

So sitting there, I see that "stolen" Limoges reliquary, the one with the story of the Magi, the one I now know somehow inappropriately made its exit from the little Church of Saint Martin in Linard with its attendant donkey. I vividly recall the church's decrepit sacristy. And I ask myself the question for which I do, at last, have the answer. What's right? Obviously, it's right to hold on to our little stolen *châsse*. And in any event, we heard nothing further from the mayor.

THE IMPLICATION OF MY NEWLY resolved thinking on things looted was realized just over a year later in the course of a telephone conversation with the Curator for the Atlantic Arts Partners in New

York, David Joralemon. Tall, extremely bright, with lots of nervous energy, David is always in a hurry and often brutally honest. He called me in early November, 2008, with news of the possible dona-tion of more than one hundred works of Pre-Columbian art, along with a substantial cash gift that could allow me to endow a cura-tor plus a conservator. This was a huge deal for the Walters, and something that I really wanted. I had lived with a superb collection of Pre-Columbian art for ten years at Dumbarton Oaks, and I had become convinced that the future for this still exotic art among schol-ars and the public was all but limitless.

But recently, the antiquities ground rules for art museums had changed dramatically. The previous July, the Association of Art Museum Directors had published new guidelines for the acquisition of antiquities with this critical passage: "AAMD members normally should not acquire a work unless research substantiates that the work was outside its country of probable modern discovery before 1970." Yes, there were some subtle exceptions, but basically, the American art museum community had agreed to the magic year 1970—the date of the UNESCO Convention on the Means of Prohibiting and Preventing the Illicit Import, Export, and Transfer of Ownership of Cultural Property. They had come to Jesus, and had abandoned their "not knowingly" policy of hypocrisy. This for the most part was good—and about time.

The AAMD's dramatic conversion came about thanks to two unlikely (and unwilling) evangelists. The first was a well-known antiq-uities dealer named Fred Schultz who, in January, 2002, went on trial in Federal Court in lower Manhattan under the National Stolen Prop-erty Act for conspiracy to smuggle and sell illegally excavated Egyp-tian antiquities. Schultz's subsequent conviction was on appeal in April 2003 when I resigned from CPAC. He lost, and then went to jail.

This scared the bejeezus out of members of the AAMD. Some-one they knew and someone with whom a few of them had done

business was in jail. The other shoe fell in April 2005 when Marion True—the aptly named "True" in the celebratory words of Judge Noland in Indianapolis—was indicted in Italy on criminal charges accusing her of participating in a conspiracy to launder stolen art through private collections and create fake documentation. (Charges were eventually dropped as the statute of limitations expired.) Now not just a dealer, but a curator. And how about her director, the beloved John Walsh, and the Getty board, who seemed to be fully aware of what was afoot?

These were dark days for the American art museum community, and especially for the Met and the Getty. Each eventually capitulated to Italian demands for repatriation of truly major works, the *Euphronios Krater* on the part of the Met and the *Morgantina Aphrodite* on the part of the Getty, along with several dozen lesser but still important ancient pieces. This was much more than a brush fire of anxiety and angst, it was a public relations catastrophe. So in an effort to reclaim the moral high ground, the AAMD adopted the new 1970 guidelines. This was generally good, but they had gone too far. And the issue was now practical for me, since the new guidelines would have put most of what David Joralemon had to offer the Walters out of bounds.

I'm certain that there were many AAMD members who in 2008 were engaged in on-going conversations with major donors, their contemporary equivalents of the Blisses, Dominique de Menil, and Henry Walters, about the gifting of undocumented antiquities. What happened was that most, perhaps all, of my AAMD colleagues called a time out—a time out with no foreseeable terminus. They heard, I'm pretty certain, loud and quavering voices from their trustees and from their legal counsel.

But I was lucky: the Walters is small and a place where the director can still direct. I saw no reason to withdraw from the game that I had been playing for nearly thirty years. In the course of that

conversation with David Joralemon, the pieces to the puzzle of what I felt should be done or not done fell elegantly into place. These were pieces I had collected in that CPAC conference room over many hours over many months, and more recently during my visit to the Church of Saint Martin in Linard. The pieces drew on all that I had done and learned since the early '80s acquiring works of art and working in collections that were doing great things for the public and for scholarship with undocumented (read "looted") antiquities. So I accepted those one hundred works that David offered, along with the endowment gift.

And soon there was much more. I received call near the end of 2008 from a Walters Trustee, Juli Alderman, who had a second home in Santa Fe. There is a wonderfully jolly man out there named John Bourne with a spectacular collection of Pre-Columbian art, going back to his adventurous days as a youth, when in 1946 he was with the small group that discovered the frescoes at Bonampak in Chiapas, Mexico. (John continued to collect over the next sixty years.) I met John through this trustee and her husband, George, in 2000 and saw his collection in his magnificent home that was built a few years earlier for Gene Hackman on the outskirts of town. My only hope then was that John might eventually lend the Walters a piece or two, until that call from Juli Alderman. John had promised his collection of more than three hundred works to the College of Santa Fe, a new art school, with a promised cash gift on the order of $4 million to build an exhibition space and endow its operation.

Well, by the worst of luck for them and the best of luck for me, the recession was taking the college down with it, and John was desperate to find a new home for his "children." I was more than happy to provide this, and had already cleared the way on the ethical front just a few weeks earlier in my conversation with David Joralemon. With these two art and endowment gifts, I was able to

create the conceptual framework for a "Center for the Arts of the Ancient Americas" with two endowed positions.

I then formulated a written policy, which a friend dubbed the "Vikan doctrine," that gave expression to my recent actions. It was based on the Walters' commitment to three over-arching principles: Due Diligence, Transparency, and Good Faith Engagement. By this policy, the acquisition of a work of art would be conducted with full and rigorous investigation and documentation of the work's history, whether it be a proposed purchase, a promised gift, or a possible long-term loan. If acquired or accepted as a gift or loan, it would then be promptly published on the Walters' website and on the Object Registry of the Association of Art Museum Directors (set up as part of the new guidelines for acquisitions and gifts without documentation back to 1970). And finally, the Walters would promptly and openly respond to any plausible claim for repatriation of the work from a possible source country.

With this policy I was doing nothing more or less than what I had advised Walter Hopps to do with the Lysi frescoes over the phone that night in June 1983: Investigate, go public, and engage with the country of origin. But now, with the Internet, transparency is no longer restricted to certified letters to departments of antiquities and to scholars. The whole world is invited to explore the Walters' storerooms.

So I have again chosen the path of Dominique de Menil, that is, of someone who by their own discretion and sense of right makes their own rules. It suited her style and it suits mine. In one bold step, Dominique de Menil created a safe harbor for the looted Lysi frescoes that were at risk of dispersal or, perhaps, destruction. She protected and preserved them, and later, she arranged for them to be studied and made available to the public in a setting infused with a sense of the holy. This seemed to me then and seems to me still to be a better approach than, in this case, letting the Atlantic Arts

Partners' one hundred works sit in a dark warehouse somewhere in northern New Jersey, or allowing John Bourne's collection to be dispersed at auction and disappear into dozens of private homes and apartments across the globe.

ONE OF MY LAST OFFICIAL acts as Director of the Walters, on December 8, 2011, involved the repatriation of a spectacular gold monkey head, the size of a child's clenched fist, to the Cultural Attaché of the Embassy of Peru. Apparently part of an elaborate necklace, the monkey head was among loot taken from the famous Moche tomb site at Sipán in 1987. Soon it was sold to John Bourne, who, in the mid-90s, gave it to the Palace of Governors in his hometown of Santa Fe. It was seized by US authorities on behalf of Peru soon thereafter, but eventually returned to the Palace of Governor when its precise origin could not be demonstrated. (In 2011 the Palace of Governors was prepared to transfer the piece to the Walters on John's behalf—before the second Peruvian claim.)

Perhaps when she learned of my actions, Maria Kouroupas thought that I had returned the monkey head out of principle; and it's true that principle was involved, but so was an FBI Agent from the Criminal Investigative Division. In this case, as with the Linard reliquary, I felt that I had done the right thing. The necklace is a spectacular work of first importance to Peru, it had clearly come from a plundered site post-1970, and at least one other monkey head from the same set had recently been returned to Peru. Like the Elgin Marbles, John Bourne's gold monkey head *should* be sent home, so that a great work of art might once again be made whole.

Chapter Nineteen

The Mysterious Mr. Egrette

The story of "Renoir Girl" and her "Flea-Market Renoir" emerged with a big media splash in the late summer of 2012. A woman in northern Virginia, who portrayed herself as naive about art and all-but-destitute, claimed to have stumbled upon a tiny, elaborately framed painting at a flea market in West Virginia in late 2009. The work is a sketchy river view in bright pinks and greens and has a metal plaque on the frame with the name "Renoir." On the back is a sticker with the work's title, *Paysage, bords de Seine*. Renoir Girl claimed she found the painting in a box with a plastic cow and a Paul Bunyan doll, which is what had attracted her attention. As her story went, she paid $7 for the lot.

Eventually, after apparently forgetting about her purchase for more than two years, Renoir Girl decided to check out her flea-market Renoir—she said, at the urging of her mother. A regional auction house in northern Virginia confirmed that what she brought to show them in a plastic garbage bag was indeed by Renoir, and estimated its auction price in the $75,000 to $100,000 range. They told her that it was painted in 1879 on linen, and that it was likely dashed off by Renoir as a souvenir for his mistress on a napkin in a restaurant beside the Seine where they were dining. The auction

was scheduled for September 29, 2012, and Renoir Girl was all over the media, from *Good Morning America* to *The Washington Post*, whose reporter Ian Shapira covered this art-world fairy tale in depth. And we all wondered, where did that Renoir come from? Could it have been stolen?

Henry Walters didn't like the Impressionists, so this was not an issue for the Walters Art Museum. It was, however, an issue for the Baltimore Museum of Art, specifically because the Virginia auction house traced this particular Renoir back to a gallery in Paris where it was purchased in 1926 by Philadelphia-born lawyer and collector Herbert L. May. May was then married to shoe manufacturing heiress Saidie Adler of Baltimore, who was a major collector of modern art in her own right and who bequeathed most of her substantial collection to the BMA when she died in the spring of 1951. Knowing this, the staff of the BMA checked their files and felt confident, as the auction approached, that they had no record of such a Renoir ever having been in their collection.

But Ian Shapira decided to do his own research. He visited the BMA library, requested the Saidie May file, and in it found evidence that *Paysage, bords de Seine* was lent by Saidie to the museum in 1937. That revelation prompted the BMA staff to examine their temporary loan file, where they found that this particular Renoir did indeed belong to Saidie May, that it was part of her bequest to the museum, and that in the fall of 1951 it was in an exhibition called *From Ingres to Gauguin*. But most important, Shapira learned from that file that the painting was reported stolen on November 17, 1951. The theft took place between 4:00 p.m. on November 16th and 1:00 p.m. on the 17th, and there was no sign of forced entry.

Ian Shapira's revelation, along with the BMA follow-up, got full coverage in the *Post* on Thursday, September 27th; the auction was cancelled and the FBI stepped in and seized the painting. What caught my attention was the date the painting was reported stolen,

November 17, 1951. It took me back more than a quarter century to a mysterious package I received at the Walters on May 1, 1986. It was a book mailer, and the return address bore the name "EGRETTE" preceded by the initial "R" in capital letters, each stroke of which was squiggly, as if done by a very old person. Below that was "10 Church Street," which I recognized to be an address in lower Manhattan, and finally, "New York, N.Y. 10012." Inside was a handsome wooden carving, maybe six inches high and three inches wide, that I recognized immediately to be a rare Coptic devotional plaque of the 6th century. The object looked strangely familiar to me, so I went to the museum's photo files and started to flip through the several dozen cards with Coptic art. And there I found the photo of a wooden plaque that I initially took to be its twin but, with a closer look, it was obvious that the object in the photo and the object on my desk were the same. The card bore these words in red letters: "Missing, October 2, 1951"—just six weeks before the BMA Renoir disappeared.

The return address now deserved a closer look. This time I recognized it to be not the name "R. Egrette" but rather, the word "regret," and not at all by a shaking hand, but rather by a very precise and calculated hand wanting to look old and feeble, and anonymous. As for "10 Church Street," a little investigation revealed that the post office in that section of Manhattan has a different ZIP code from that written on the return address. This caused me to take the word "church" not as an address but rather as qualifier for the word "regret." The act of mailing seemed to be an act of repentance.

Not long thereafter I learned that the Department of Classical Studies at Johns Hopkins received a similar package from "R. Egrette" of "10 Church Street, New York, N.Y. 10012" the same week the Walters received its package. The Hopkins package contained objects from the same region and period, namely, Coptic Egypt. And these objects, too, went missing in October, 1951. So someone apparently had access to *two* Baltimore collections in the

fall of 1951. That he or she returned the works after thirty years indicated that knowledge of their origin was never lost, and the "regret/church" label, which obviously did not need to be there, indicated remorse and an apology of sorts. And the simultaneity of the two mailers suggested that someone was at last setting things right. This all made sense to me, since someone with security access in 1951 to those two museum collections (neither thefts involved objects on public display) likely had some seniority, so if one were to assume that person was then at least in their mid-30s, that would make him or her around 70 in 1986. Who was that person?

Fast forward now to the spring of 2013. Renoir Girl is finally forced to reveal her identity as she presents her legal case as the rightful owner of the flea-market Renoir. She is Marcia May Fuqua, then 51, an unmarried driving teacher with a bumpy employment history from the tiny town of Lovettsville, Virginia. She presents herself as a good-faith buyer with no knowledge of art history. But her story quickly unravels. She has forgotten what flea market she visited, and the only likely candidate, the "Harpers Ferry Flea Market," has no record of the transaction. And there is Marcia May's mother, Marcia Mae Fouquet (different spellings, similar pronunciation), then 84, who for decades ran an art school out of her home in Great Falls, Virginia, where her daughter was, according to former students, often there to help out. Certainly, daughter Marcia May knew something about art history.

But the most interesting part of the daughter's backstory is her mother's backstory. In the fall of 1951, Mom was a 23-year-old junior in art studies at Goucher College in Baltimore. And there was much more of interest: Daughter Marcia's brother Matt told Ian Shapira of the *Post* that their mother had the Renoir in her house for "fifty or sixty years" and that it came from "a museum in Baltimore." Matt also claimed that his mother wanted the painting returned to the museum because that would "put this behind us."

Mother died at age 85 in September 2013. Matt later stated, when deposed for the civil action initiated to determine ownership, that he had lied about the Renoir being around the house all that time. But forget that: On January 10, 2014, the day Federal Judge Leonie Brinkema of the Eastern District of Virginia ruled against Renoir Girl and ordered the painting returned to the BMA, a triumphant and vengeful Matt (who apparently hates his sister) opened up to reporters just outside the courthouse, seemingly oblivious to what he had said under oath just a few months earlier. The painting, Matt said, *had* been in his mother's house since the '50s. Did she steal it? No, he said, "it was a gift." It seems Mom was a beautiful woman and had plenty of boyfriends. And as for its return to the BMA, he said, "My mother wanted this."

Mother Marcia was living in Baltimore in 1951 at the time of the three thefts and was involved in the world of art, and Goucher's campus was then within a few blocks of the Baltimore Museum of Art. That does not, however, put her in the BMA after hours on the evening of November 16th, much less in art storage at the Walters and at the Hopkins Department of Classical Studies a few weeks earlier. A student simply would not have had privileged access to all three local collections. Certainly there is a believable end-of-life, making-it-right flavor to the public appearance of the Renoir in 2012 when Mom must have been aware her impending death. But what could be the comparable make-it-right moment for her or her family in 1986 when the "regret" packages were sent? While mother Marcia definitely was not the thief, she probably knew the thief. And now she's dead, so perhaps we will never know. But there is another intriguing piece that may be part of this puzzle, again, from 1986.

My first major Walters exhibition, *Silver Treasure from Early Byzantium*, opened in April 1986, two weeks before the "regret" mailer arrived. I was especially eager to borrow a silver bowl in the collection of the Baltimore Museum of Art for the show, but the BMA

staff could not locate the bowl, so we had to settle for a photograph. Then, on August 1st, three months to the day after the "regret" mailer arrived at the Walters, the BMA silver bowl suddenly turned up. It seems that the museum's registrars had just received a call from a former BMA employee saying that while cleaning out his garage, he opened a cardboard box and in it discovered a tin box containing a silver bowl that he said he did not recognize.

He did, however, recognize the accession number on the tin box as indicating the collection of the BMA, and so he made the call. How did that tin box get into that cardboard box in his garage? The explanation was odd in the extreme as was the fact that the bowl appeared at the exact moment when it was needed for the deliberations of the International Byzantine Congress, which converged on the Walters that very week to see the *Silver Treasure* exhibition. He claimed that when he left the BMA in the early '70s to take a job in Washington, DC, his successor at the museum packed up his materials and inadvertently included the tin box with the bowl, neither opening it up to check its contents nor recognizing the BMA accession number on the outside. The man had volunteered that it had taken fourteen years to discover the mistake because it was only when he retired from his Washington, DC, job that he had "time on his hands" and cleaned out his garage. What else, I wondered, might be in that garage?

What makes this strange story especially compelling in relation to the events of fall 1951 is that the individual in question is familiar to long-time Walters staff members as a skilled art packer whose expertise was welcomed in those years at the Walters as well as the BMA. Not only that, this person died in January, 1987, just six months after he returned the BMA silver bowl. And we know from internal records that he had personally transported that silver bowl between the BMA and the Walters in 1951, which suggests that he

should have recognized the bowl and its tin box. And finally, and most important, in 1951 he was Assistant Building Superintendent at the BMA, and this gave him privileged after-hours access. Then, a last tantalizing clue: the Walters "regret" package was sent from the ZIP code of New York University where this person had done his professional training in the '50s.

Just maybe there was a budding romance between the rising young superintendent at the BMA, then 35, and the attractive 23-year-old Goucher art student. Baltimore is a small town and they were both devoting themselves to modern art; it is likely they would have met. Recall that brother Matt, when interviewed by reporters outside the courthouse on January 10, 2014, suggested that the Renoir was a gift from one of his mother's many suitors. His girlfriend Jamie Romantic completed his thought with the claim (as if it were family lore) that one of her beaus had worked at the Baltimore Museum of Art. Why steal the Renoir? Undoubtedly, the BMA superintendent had heard the endearing story about that unusually small and sketchy painting in the current exhibition, From Ingres to Gauguin, that Renoir dashed it off over lunch for his mistress and soon-to-be wife. Perhaps he or perhaps both of them knew that this beautiful young woman appears in Renoir's famous *Boating Party* at the Phillips Collection in Washington, DC.

Assuming that what I think may be the case is true, that the BMA Assistant Building Superintendent of 1951 (age 35) and Mr. Egrette of 1986 (age 71) are the same person, I suspect that what drove him to take the Renoir off exhibition after hours on the evening of Friday, November 16, 1951, was the same urge that drove him to steal the Coptic votive from the Walters a few weeks earlier. It is that powerful feeling of connection to people of the past through the objects they created and touched. Dominique de Menil and Peg Goldberg understood that feeling, and so do I. And add to that,

for the painting there was the magic of identification, of the BMA superintendent with Renoir and Marcia with his mistress. This is the stuff of compounded infatuation. Perhaps this was a surprise gift for Christmas in 1951: A work of art with both a message and a secret that would bind the two for more than sixty years.

Afterword

Fanatical iconoclasm in the manner of the Islamic State is nothing new. The Byzantines of the 8th and 9th centuries were very good at it, and were ruthless as well. Not only did they systematically destroy thousands of sacred images; they tortured and killed scores of icon painters. Ironically, the mosaics in the Church of *Panagia* Kanakaria survived Byzantium's Iconoclastic Controversy because Cyprus was then under joint sovereignty with of the Umayyad Caliphate.

The destruction of cultural treasures in Mosul (ancient Nineveh) and Palmyra at the hands of ISIS in the spring and summer of 2015, as seen worldwide on television, was accompanied by the beheading of Khaled al-Asaad, the archaeologist overseeing the ancient site of Palmyra. The horror and frustration that followed intensified the debate between museum professionals and archaeologists over how best to deal with antiquities looted from regions in military conflict. The prevailing view, promoted by the archeological community, is that America's best response is to exclude at our borders all cultural property thought to originate from those troubled regions. This, plus the recent tightening of the AAMD's acquisition policies and the UN's resolution banning trade in Syrian antiquities since the start of the civil war, has constricted the flow of significant artworks from Syria westward to just a trickle. The contrast with the massive

outflow of major Christian works—icons, frescoes, and mosaics—
from northern Cyprus in the wake of the Turkish invasion of 1974
is striking.

But imagine what would have happened had this hard line pre-
vailed in the '80s. What would have been the outcome had Domi-
nique de Menil known, when her medieval curator showed her the
Petsopoulos photographs of Lysi, that there was no chance those
frescoes would clear US Customs? I can envision two scenarios, and
neither ends well. Archaeologists might wish to believe that the fres-
coes would never have been ripped from the walls of the Lysi church
in the first place and would have survived to this day. But I doubt it.
With the forced evacuation of the ethnically Greek Christians from
the north in the later '70s, their ancient churches were abandoned to
the mercy of local Muslim populations that were hostile, not simply
indifferent, to their survival. And they were especially hostile toward
sacred Christian images. I suspect the result in this scenario would
have been the eventual destruction of the frescoes, perhaps not for
financial gain, but as a result of local, individual acts of religiously
motivated vandalism.

The other scenario would suppose that European import laws
would not be as strict as those of the US and that the Lysi fresco
fragments would have ended up in Dikmen's Munich apartment
anyway, even with American buyers out of the game. In that case,
I'm certain they would have been dispersed to private collectors all
over the world. The Lysi frescoes would then effectively remain out
of the public eye in perpetuity and unavailable to scholars. Thanks
to Dominique de Menil and the more flexible rules of that day, the
Lysi frescoes were made whole again and studied, exhibited, and
eventually returned. They are now proudly displayed in the Byzan-
tine Art Museum in Nicosia where thousands of Cypriots are able
to enjoy "their" frescos, still hoping that someday they may be rein-
stalled in the Lysi church.

To be clear: We were not in the right place in the '80s when it came to dealing with looted art from war zones. But then, we're not in the right place now, either. The pendulum has simply swung too far, and we have lost sight of the fate of the works themselves and of the greater public good. The cradle of civilization is our shared cultural heritage, and in times of extraordinary risk, we should not shrink from dealing with bad guys—today's Dikmens—to save this artistic patrimony for the sake of everyone around the globe and for our descendants. This calls for greater nuance, imagination, and courage than I'm now seeing.

It is true that despite the 1970 UNESCO Convention, CPAC, and the more proscriptive AAMD guidelines, Byzantine antiquities from northern Syria of the sort Henry Walters acquired in Paris and the Blisses bought in Beirut decades ago, were still being actively traded before the rise of ISIS. It is also true that the most abundant Byzantine antiquities in that region are in the *Massif calcaire*, with its magnificent Shine of Saint Simeon Stylites, an area that has remained outside ISIS control. This means that current looters may have no relationship whatsoever with ISIS. So why, then, apply a blanket restriction on these works at our borders, forcing them back onto the black market or into the hands of players within the cynical and brutal Assad regime—or of ISIS fanatics? Why not, in the manner of Dominique de Menil, instead provide them safe harbor with the clear and explicit intention of repatriation once the region returns to stability? This is not an easy thing, for sure. But it's the right thing.

Index

W

Y

Z

About the Author

GARY VIKAN was Director of the Walters Art Museum in Baltimore from 1994 to 2013; from 1985 to 1994, he was the museum's Assistant Director for Curatorial Affairs and Curator of Medieval Art. Before coming to Baltimore, Vikan was Senior Associate at Harvard's Center for Byzantine Studies at Dumbarton Oaks in Washington, DC. A native of Minnesota, he received his BA from Carleton College and his PhD from Princeton University.

An internationally known medieval scholar, Vikan curated a number of critically acclaimed exhibitions at the Walters and led the contextual installations of the museum's collections. He enacted a number of important changes, including the elimination of the museum's general admission fee and the provision of open access to all of its digital assets. During his position as director, Vikan also led the effort to endow nearly two dozen museum positions. Vikan has taught at Johns Hopkins University, Carleton College, Goucher College, and at the Salzburg Global Seminar. From 2006 to 2011 Vikan had a weekly radio program on Baltimore's NPR affiliate called "Postcards from the Walters."

Vikan has served on numerous boards internationally and in the Baltimore region. He was appointed by President Clinton in 1999 to his Cultural Property Advisory Committee and was knighted by the French Minister of Culture in the Order of Arts and Letters in 2002. Vikan received Carleton College's Distinguished Achievement award in 2008; he received an honorary Doctor of Humane Letters degree from the Maryland Institute College of Art in 2010.

In 2013 he stepped down from the Walters directorship to write, lecture, and teach; to provide consulting services as Vikan Consulting LLC

to cultural non-profits, collectors, and dealers; and to pursue projects at the intersection of the arts and sciences.

Vikan's recent books include *Early Byzantine Pilgrimage Art* (2011); *Postcards from the Walters* (2012); *From the Holy Land to Graceland: Sacred People, Places, and Things in Our Lives* (2013). Vikan lectures extensively on topics as varied as the Face of Christ, Elvis Presley, the Shroud of Turin, looted art and cultural property policy, neuroaesthetics, and art forgeries.